Wicked
SACRAMENTO

Wicked SACRAMENTO

WILLIAM BURG

THE
History
PRESS

Published by The History Press
Charleston, SC
www.historypress.net

First published 2019

Manufactured in the United States

ISBN 9781467140591

Library of Congress Control Number: 2019935358

DEDICATION

This book is dedicated to the memories of Catherine Taylor (1960–2018), Al Balshor (1924–2015) and Ali Youssefi (1983–2018). As director of the California State Railroad Museum and district superintendent of California State Parks, Cathy Taylor was a respected leader in her field. Her guidance and energy inspired me as a young volunteer docent (among railroad museum volunteers, thirty-four years old is considered very young). Cathy later became a friend and mentor as I transitioned from a museum volunteer to a professional historian.

I met Al Balshor, lifelong Sacramentan and guiding force of the Southside Improvement Club, while writing *Sacramento's Streetcars* in 2005. He convinced me to write about Southside Park and began my journey exploring the history of the West End. His dedication to community service, enthusiasm for Sacramento and delight in telling the stories of Southside inspired generations of Sacramentans.

Ali Youssefi was a housing developer who specialized in projects combining historic buildings and affordable housing. Working with his family firm, CFY Development, Ali's signature project was Warehouse Artist Lofts located in the Lawrence Warehouse on R Street. Ali died at age thirty-five, with two projects—the 700 block of K Street and the Bel-Vue Apartments. unfinished. Because some of the stories in this book took place in those buildings, I was looking forward to sharing them with Ali once this book was published. In his absence, I share these stories with the public and encourage readers to visit these surviving places to get a glimpse into the lives of Sacramentans past and remember the efforts of those who have worked to retain and restore our city's architectural and cultural legacy.

CONTENTS

ACKNOWLEDGEMENTS

*M*ost of the photos in this book and collections used for research come from the Center for Sacramento History (CSH), Sacramento's city/county archive. Royalties will benefit CSH and its programs via the Sacramento History Alliance. I owe enormous gratitude to Marcia Eymann, manager of CSH and Sacramento's city historian, for access to this invaluable treasure trove, and archivists Kim Hayden, Dylan McDonald and Rebecca Crowther for their help with retrieving items from the farthest corners of the archives.

Other archival sources include Sacramento Public Library (including the Sacramento Room), the California State Library's California Room, the California State Archives and the Lavender Library Archives and Cultural Exchange (LLACE). Maryellen Burns provided her interview with Ted Pantages. I interviewed Marion Uchida, Gail Yoshioka Ouye, Yukali Shirai and Priscilla Ouchida, all of whom also provided photos from their personal collections. Information on the Hyers sisters came from the research of Susheel Bibbs.

Additional photo sources include Sacramento Public Library, Wisconsin Historical Society, the National Archives, California State Archives, Keith Burns, Chris Egan, JD Doyle and the West Sacramento Historical Society. Thanks also to Vivian Gerlach, Maryellen Burns and Temple Kirk, who read drafts and offered comments, and Harley White Jr., who shared my enthusiasm for bringing stories of the West End to the public and opened my ears to jazz.

Thanks to Nicholas Heidorn, whose research on Luella Johnston provided useful background information for this book and resulted in the rededication of the city council chambers in Sacramento's historic city hall, where Johnston served as city commissioner, in her honor.

Thanks to the volunteers who built and staffed the West End Club at ArtStreet, a three-week art and culture festival held in Sacramento during February 2017. Many of the stories in this book were first presented at the West End Club, a combined art installation, interpretive history display and nightclub inside ArtStreet, and at Art Hotel, a smaller event held in February 2016 in the lobby of the Marshall Hotel, former home of the Clayton Club. These events delayed completion of this book by two years but helped raise awareness of our city's long-neglected cultural riches, including its lost legacy.

Introduction

SACRAMENTO IN LIGHT
AND SHADOW

icked Sacramento is a crime story. In the first half of the twentieth century, Sacramento's civic leaders went to enormous lengths to eliminate crime and wickedness from its waterfront neighborhood, which was known as "the lower part of town," "the tenderloin" and, later, "the West End." This neighborhood included buildings dating back to the gold rush and a diverse multiracial population. A social movement called the Progressives led this effort, but concealed within their social-reform agenda was the hidden crime of racism.

The racism of social reformers was not expressed through Ku Klux Klan–style physical violence and terror. In fact, many Progressives were active opponents of the Klan, including *Sacramento Bee* editor/owner Charles K. McClatchy, who exposed Klan members in the *Bee* and criticized them via his editorial bully pulpit; the Klan did not gain a firm foothold in Sacramento during the Progressive Era. However, McClatchy was an active supporter of his brother Valentine McClatchy's efforts to block immigration from Japan and exclude Japanese immigrants from owning land in the United States. Progressive racism was expressed via legislation and official government policy, not through terrorism by private groups. Why break the law to reinforce white supremacy when the laws themselves could be written to carry out racist objectives?

Restrictions on immigration, eugenics laws and even Prohibition were intended to segregate communities of color and reinforce the supremacy of an American cultural identity that was defined as a white identity. To

Charles K. McClatchy, editor of the *Sacramento Bee,* used his newspaper to shame the Ku Klux Klan but permitted his brother Valentine the same bully pulpit to promote anti-Japanese and other anti-immigrant legislation. *Center for Sacramento History.*

a limited extent, European immigrants could acculturate, shedding their ethnic identity in the American "melting pot," often abandoning their heritage and family names in the process, but non-European immigrants and African American migrants were considered unable to assimilate.

Progressives used scientific and pseudoscientific principles to address social problems—ranging from clean water and zoning codes to prohibition of prostitution and alcohol—as issues of social hygiene. Many businessmen considered Japanese, Chinese, Latino and African American neighborhoods a barrier to financial investment and population migration to Sacramento, just as prostitution, dancing and drinking deterred the sort of migrants that Sacramento's business class sought to attract. Terms like "white slavery," used to describe women forced into prostitution, excluded women of color from consideration. Public outrage about obscene dances originated from African American influences on popular music and the resulting concerns about interracial fraternization. Prohibition was a method of economic discipline exercised upon European populations considered outside the realm of whiteness in the early twentieth century, including southern and eastern Europeans and Catholic and Jewish populations. Even though many of these groups shared many principles with the Progressive wing of the Republican Party (and some, especially African Americans, were party members), they were excluded from political power due to racial prejudice.

In the era following World War II, the Progressive Era and Prohibition had ended, but the impetus for civic reformers to clean up the West End was still strong. Due to a federal policy called redlining, communities of color presented a new problem to Sacramento's civic leaders. Neighborhoods were rated for eligibility for Federal Housing Administration loans based on several factors, but the most important factor was the race of a neighborhood's residents. The very presence of people of color was bad for property values and thus bad for tax revenues. Because these properties were located in Sacramento's urban center, and also the point of entry to the city from the Bay Area, reclaiming this land from the people who lived there became a high priority for Sacramento's businessmen. Redevelopment became the weapon used to demolish neighborhoods, but the Progressive language of civic reform was used to justify the demolition of these neighborhoods and the displacement of their residents.

In many ways, the West End was a wicked place, a location for innumerable brothels, bars, dance halls, gambling dens, burlesque and strip clubs and other illicit forms of entertainment. But they would not have functioned

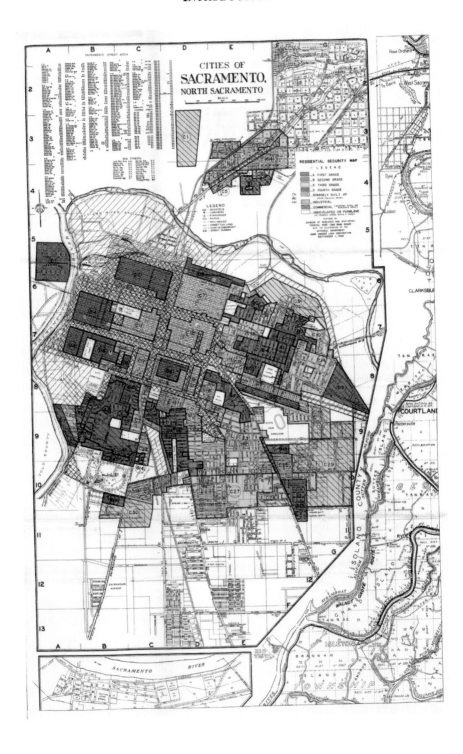

without the active participation of Sacramentans of every social class. The West End's crimes were tolerated because they were limited to parts of town that the wealthy seldom visited—except when they wanted to partake in the sins offered for sale there. For others, the West End was home, and its wicked institutions were a part of life that was accepted when it could not be resisted. For the people whose race made them unacceptable to civic reformers, existence was a form of resistance. Some survived, attempting to avoid notice. Some persisted, seeking social reform or redress for their own communities. Some thrived, finding success and opportunity as the world changed around them. Some escaped from the West End or from Sacramento. In addition to the stories of the social reformers and the criminals, this book also shares the stories of the people who lived in a neighborhood often erased from official histories or downplayed as an irredeemable slum.

Wicked Sacramento is organized into two parts. Chapters one through five describe the Progressive Era (from around 1900 through the 1920s), ending with Prohibition, the high-water mark of the Progressive movement. Chapters six through nine detail the 1940s and 1950s, from World War II through the beginning of the redevelopment era. *Prohibition in Sacramento*, by Annette Kassis, covers Prohibition in greater detail, and Kevin Wildie's *Sacramento's Historic Japantown* provides more detail about the origins of Japantown and efforts to save it.[1] My earlier books, *Sacramento's K Street* and *Sacramento Renaissance*, tell the story of downtown Sacramento during its growth in the nineteenth and twentieth centuries and the displacement of downtown populations during the redevelopment era. This book focuses on the individual stories of Sacramento's social reformers, the problems and the people they sought to eliminate and the communities of color trapped between these two groups. What did Sacramento gain and lose in this battle for a city's soul?

Opposite: In the 1930s, federal redlining maps indicated credit risk to assess suitability for home loans. Race became a major factor in assessing credit risk; white neighborhoods were low-risk, marked in blue or green, while neighborhoods of color were high-risk, marked in red. The West End is the redlined area on this map between Capitol Park and the Sacramento River. *Redlining Archives of California's Exclusionary Spaces*.

1

THE PROGRESSIVE CRUSADERS

*H*istorian Gerald Woods characterized Sacramento as the middle ground between the straight-laced Midwestern propriety of Los Angeles and the freewheeling licentiousness of San Francisco. The state's capital was the battleground where statewide policy on social reform and vice was crafted.[2] Sacramento's reformers, like other Progressives of the early twentieth century, mostly consisted of upper-middle-class professionals (and their spouses) who dedicated time and effort to social issues. Many were old enough to remember when Sacramento was the second-largest city in California and viewed social corruption, vice and urban decay as the restraints that held their city back from its rightful place of prominence. Some viewed Sacramento's growing ethnic and racial diversity as a primary element of this decay and considered the removal of Sacramento's communities of color as important to social reform as eliminating prostitution, gambling or alcohol. Racism was reascendant in Progressive America, and it was given pseudoscientific legitimacy by advocates of eugenics. This created and reinforced social divisions and barriers to economic power based on racial formation, sexuality and the boundaries of whiteness.

SACRAMENTO IN 1910

In the first two decades of the twentieth century, Sacramento was a city on the edge of change. Its rowdy gold-rush legacy was long past, its role as the

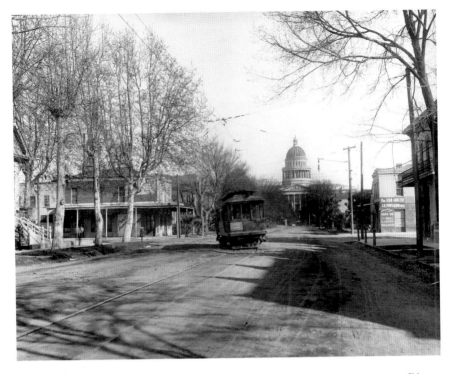

The "lower part of town," later called the West End, extended from the Sacramento River to the California State Capitol. *Center for Sacramento History.*

western terminus of the Transcontinental Railroad had been superseded by Oakland and its place as second-largest California city had long been lost to Los Angeles. Despite these setbacks, many Sacramentans felt that their city was poised for greatness if they could overcome the vice and corruption that they felt dominated the city's urban core. Sacramento's city limits, established in 1849, ran from the Sacramento River to Thirty-First Street (now Alhambra Boulevard) and from the B Street railroad levee to Y Street (now Broadway)—an area of about five square miles. By 1910, Sacramento had lost much of the momentum gained during the gold rush and completion of the Central Pacific Railroad, as the railroad's founders relocated to San Francisco and reorganized as Southern Pacific. The Atchison, Topeka & Santa Fe Railroad (Santa Fe) broke Southern Pacific's monopoly on California in 1885, triggering enormous population growth in Los Angeles and Oakland. Both cities usurped Sacramento's previous position as California's second-largest city. By 1910, Sacramento was still larger than San Diego and San Jose but had barely a tenth of the population

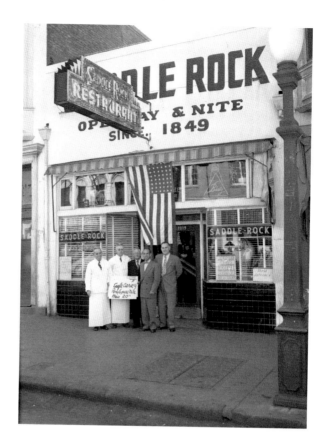

Sacramento city commissioner Ed Carraghar owned the Saddle Rock, a bar and restaurant on Second Street. Carraghar often sympathized with other nightlife establishments, bringing him into conflict with Progressive commissioners. *Center for Sacramento History.*

of San Francisco. Constrained by levees, Sacramento's growth never quite stopped, but it lacked the explosive expansion of Southern California and the Bay Area.

In 1910, the mayor's office, located at the old water works at Front and I Streets, was occupied by Marshall Beard, the last "Strong Mayor" of Sacramento. The 1893 "Strong Mayor" charter instituted a full-time executive mayor and a legislative board of trustees. This system was promoted by nineteenth-century industrialists who felt that more mayoral power encouraged businesslike efficiency and economy. Beard was sometimes called "Boss Beard," implying hidden political power, but many felt that the real power was held by board of trustees president E.P. Hammond and E.J. Carraghar, chair of the finance committee. Under the "Strong Mayor" system, many civic-minded residents felt the city's best interests took a backseat to big business. The big players in 1910 were Pacific Gas & Electric (PG&E), which held Sacramento's streetcar franchise and

provided its electricity, and Southern Pacific Railroad, Sacramento's largest employer. The Southern Pacific shops, the main repair and supply facility for their railroad network, produced everything from hand tools to steam locomotives. Local reformers felt Southern Pacific had too much influence on city politics and their monopoly on transportation held Sacramento back while San Francisco reaped the benefits.

Many Sacramentans hoped that a new transcontinental railroad, Western Pacific, could break Southern Pacific's monopoly and spur a real estate boom like the Santa Fe did in Los Angeles and Oakland. Western Pacific's arrival did not create a real estate bubble like the one that turned Los Angeles from a quiet ranching town into California's second-biggest city, but the opening of the Western Pacific depot in August 1910 was as welcome as the jobs at the Western Pacific Jeffery Shops located near the streetcar suburb of Curtis Park.

Downtown, a wall of warehouses and wharves lined the Sacramento River from I Street to R Street. Front Street was a maze of railroad tracks used to transfer goods from Sacramento's granaries, canneries, breweries, lumber mills and other industries to riverboats and barges. The riverfront

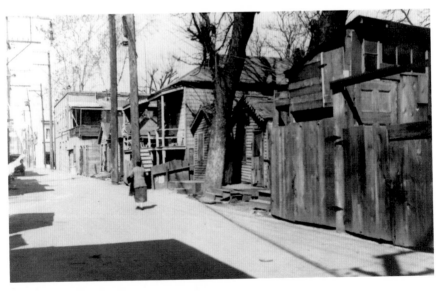

This alley in Japantown demonstrated the ingenuity of those adapting to life in the United States, who created alley residences to best utilize the limited spaces where they could live. Even in California, where segregation was de facto rather than backed by law, housing options for immigrants were sharply limited, especially for immigrants from Asia. *Center for Sacramento History.*

was Sacramento's working heart, from the Southern Pacific shops at the north end of the city to the Friend & Terry lumber mill on Front and V Streets. A second industrial corridor ran along R Street, route of the old Sacramento Valley Railroad, and included the Buffalo Brewery, located at Twenty-First Street, which was formed by the elite of Sacramento's brewing families. Nearby wineries on R Street, connected by the railroad to vineyards in rural Sacramento County, worked with the breweries to satisfy a thirsty regional market.

THE LOWER PART OF TOWN

In 1910, the California state capitol lacked its enormous complex of state buildings, but Capitol Park's grounds included the grand pavilion of the California State Fair, recently superseded by new grounds outside the city limits at Stockton and Broadway and reached by PG&E streetcars. Northern Electric's interurban and streetcar line ran up M Street to the riverboat docks and through a residential neighborhood formerly home to Sacramento's most illustrious names, including Stanford, Crocker, Huntington and Hopkins—Central Pacific's "Big Four." Many of these grand mansions were subdivided into apartments and inhabited by Sacramento's working class, including many immigrants. The largest immigrant community was in Japantown, sometimes called "O-fu" by its residents, centered on Fourth and M Streets. The 1910 city directory even included a special Japanese business section. The Chinese neighborhood, "Yee Fow" (or "Second City"), second only to San Francisco's Chinatown in size, was located along I Street adjacent to China Slough, a body of water that had been filled by 1910. Sacramento's African American and Mexican communities were centered along O and L Streets. Thousands of migrant farm workers and railroad "boomers" lived in boardinghouses and hotels close to the river. Proximity to work, social pressure and racism limited the options for places to live for many ethnic groups, making this neighborhood a crowded place. The 1906 San Francisco earthquake and fire also drove refugees to Sacramento, and many decided to stay.

K Street was Sacramento's shopping and entertainment district. As the only city between Oakland and Reno with large department stores, Sacramento was a regional destination. Local streetcars and interurban trains shared the street with pedestrians, bicycles, horse-drawn carriages

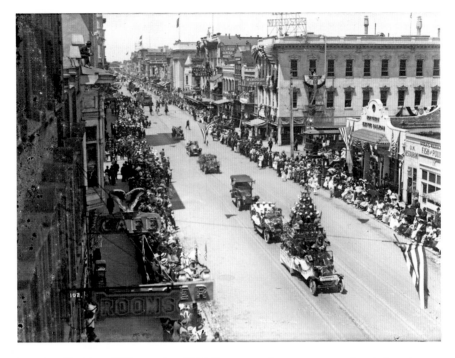

Parade at Eighth and J Street, circa 1910. Sacramento boosters tempered optimism about their city's future with fears brought on by the greater successes of other California cities. *Center for Sacramento History.*

and wagons and automobiles. Between the department stores and specialty retail shops were vaudeville theaters, dance halls and new moving-picture theaters. Restaurants and bars satisfied Sacramentans' hunger and thirst. K Street also featured hotels catering to travelers and visitors and apartments for downtown residents. Sacramento's business district also had its underside. Reformers of the era criticized Mayor Marshall Beard as being too tolerant of vice in downtown Sacramento, along with accusing him of graft and corruption in exchange for votes.

In November 1910, Sacramento native Hiram Johnson was elected governor on a Progressive platform of civic reform, voter participation and reducing the power of big businesses like Southern Pacific, which dominated California (and Sacramento) politics. Johnson's Progressives introduced initiatives and referendums to California voters. Allied with President Theodore Roosevelt, who adopted many Progressive ideas in his platform, Johnson and his administration had ties with national Progressive movements; as a native son, he had many Sacramento supporters. Johnson

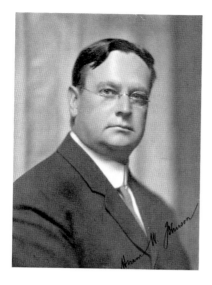

Sacramento native Hiram Johnson became governor of California on the "Lincoln-Roosevelt League" ticket, allying himself with Progressives after making a name for himself fighting political corruption in San Francisco. *Center for Sacramento History.*

also campaigned on securing voting rights for California women, a promise delivered by California voters in 1911, nine years ahead of federal women's suffrage. In 1912, Johnson became one of the founders of a national Progressive Party.

THE ANTI-JAPANESE MOVEMENT

The origins of Asian racial exclusion in California began during the gold rush and focused on Chinese immigrants, who faced discrimination, segregation and violence starting from their earliest arrival in California and culminating with the Chinese Exclusion Law in 1882.[3] Just as Chinese immigration was barred, Japanese immigration increased. At first, Japanese laborers were welcomed due to the need for inexpensive labor. Japanese workers were soon subject to the same racism and segregation as Chinese workers, and labor leaders like Dennis Kearney, who supported Chinese exclusion measures to limit competition against white labor, began campaigning against the Japanese in 1892.

The first major efforts at Japanese exclusion occurred following the San Francisco earthquake and fire of 1906. In the wake of the disaster, attacks upon Japanese people, including immigrants and visitors, dramatically increased, with no arrests of white attackers but several arrests of victims for attempting to defend themselves. The Asiatic Exclusion League, formed in

1905, called for a boycott of Japanese stores and convinced the San Francisco Board of Education to segregate Japanese children into the "Oriental School" established in 1884 for Chinese students. Federal intervention meant to block this segregation—and avoid an international incident with Japan—was met with public protest in San Francisco, which defied the order to not segregate Japanese children.

President Theodore Roosevelt, national leader of the Progressive movement, hoped to avoid legislation that closed the doors on Japan in the same manner as China, as he did not wish to offend Japan. Following the Japanese navy's defeat of the Russian navy at the Battle of Tsushima in 1904, Japan became an important military and economic power. Roosevelt was sympathetic with the exclusionists and negotiated a "gentleman's agreement" with Japan in 1907–8 that unofficially halted Japanese immigration. In 1913, the California legislature passed the Alien Land Law, which forbade "aliens ineligible to citizenship" (meaning Chinese and Japanese immigrants) from owning land in California.[4]

Although the Progressives were primarily Republicans, racial exclusion had bipartisan support. California Democrat Anthony Caminetti called for limiting immigration despite being the son of Italian immigrants. Born in Jackson, California, he served in the California state senate and assembly, then for two terms in Congress, becoming the first native Californian and second Italian American to serve in Congress. After losing his Congressional seat to Hiram Johnson's father, Grove Johnson, Caminetti served two more terms in the state senate, and in 1913, he was appointed the U.S. Commissioner General of Immigration. During his tenure, American immigration laws were strongly tightened, especially against Asian immigrants, and Caminetti became a major figure in national efforts to restrict immigration.

Caminetti's hostility to Asian immigration represents an element of racial formation: the process of enculturation as a social construct. Italians of this era were generally not considered "white" in the same manner as northern Europeans. To validate his claim on whiteness, and thus Americanism, Caminetti married Ellen Martin, another California native and a descendant of American president James Madison. His support of Chinese and Japanese exclusion helped establish a racial hierarchy that moved Italian Americans closer to whiteness and further from the "other" represented by immigrants and migrants of color. Per historian Peter Vellon, "[Caminetti] served as a glaring example that Italians could be the *excluders* rather than the *excludees*."[5]

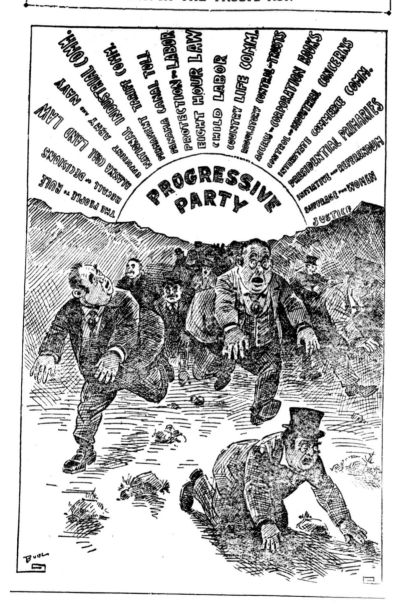

The Progressive movement was a statewide effort to reduce political corruption, regulate big business and promote direct democracy and woman's suffrage. As part of the Republican Party and briefly as an independent political party, Progressives had a strong influence on Sacramento and California politics. *Center for Sacramento History.*

Valentine McClatchy was the son of Irish immigrant James McClatchy, who, like Caminetti's parents, came to California during the gold rush. McClatchy founded the *Sacramento Bee* newspaper, and his sons Charles and Valentine co-owned the paper as editor and publisher. The McClatchy family were Democrats and Catholic (in contrast to most Progressives, who were typically Republican and Protestant), but they shared common political ground, and, as with the Caminettis, that common ground was valuable. Irish communities, like those of Italians and many other European immigrants, faced discrimination but used similar enculturation strategies; becoming American often meant finding an "other" to demonize. Valentine McClatchy became involved in the anti-Japanese movement in 1915 and retired from the *Bee* in 1920 to form his own organization, the Japanese Exclusion League of California; he published pamphlets about the dangers of allowing the Japanese to remain in the state.[6]

Joseph Manning (known as "J.M." or "Jack") Inman, an attorney from Inyo County who moved to Sacramento after the 1906 San Francisco earthquake, served as president of McClatchy's exclusion league and served in the California state senate as a Republican. The Japanese Exclusion League, and other anti-Japanese groups throughout California, called on the federal government to replace Roosevelt's "gentleman's agreement" with a strict, formal policy barring emigrants from Japan from entry to the United States. They also called for a constitutional amendment providing that no child born in the United States could become a citizen unless both parents were of a race eligible for citizenship, effectively denying the children of Asian immigrants any hope of becoming U.S. citizens.

Efforts by federal appointees like Caminetti to pursue exclusionist goals at the federal level were tempered by diplomatic efforts to retain friendly relations with Japan, a growing international power. Official protests by the Japanese government in response to exclusionary policies were interpreted as threats to U.S. sovereignty and used to justify even greater restrictions on immigration. Editorials by McClatchy and Japanese Exclusion League publications called Japan "the Germany of Asia," comparing Japan to the recently defeated aggressors of the Great War.[7]

EUGENICS: THE PSEUDOSCIENCE OF RACE

Labor leaders like Dennis Kearney often based opposition to immigration in economic terms, as competition for limited jobs that undercut wages, while others based their opposition on claims of white superiority. In the Progressive Era, some theorists applied contemporary scientific ideas about evolution to the racist mindset. This field of study was called eugenics and was intended to create "better" people through selective breeding and sterilization. In the United States, in addition to eugenics arguments that claimed it could eliminate hereditary disease and mental illness, "better" was defined by the boundaries of whiteness; to advocates of eugenics, the characteristics of non-European people presented a set of undesirable traits to breed out of the human genome.

Charles Matthias Goethe, a native Sacramentan born in 1875, graduated from Sacramento High School in 1891 and joined his father's bank, the Goethe Bank, becoming its president in 1906. He married Mary Glide, daughter of powerful Sacramento businesswoman Elizabeth Glide, and in addition to his banking and investments, became deeply interested in the natural world, agriculture and eugenics. On a 1902 train ride to San Francisco, Goethe noted racial differences between children he observed from his seat: "Twas a vivid example of the difference between the Anglo Saxon and the Latin races. 'Twas only a crowd of children but what a story of Teutonic progressiveness [and] South of Europe [decadence]." In the 1920s, Goethe founded several eugenics-based organizations and joined organizations like the Japanese Exclusion League.

Goethe became a member of the city's first planning commission in 1912 and its chairperson in 1913. He was also involved in efforts to limit prostitution in Sacramento and was appointed to the vice committee by the city commissioners, a special executive committee formed to eliminate Sacramento's red-light district. The sexual behavior of young women became an issue of serious concern to Progressives, as dramatic changes in society opened new doors to the young women of the twentieth century, and traditional ideals about femininity collided with the world of work.

In an industrial city like Sacramento, women became an increasingly important part of the labor force in factories and canneries and the service sector in downtown department stores and retail establishments, but women's involvement in sex work was perceived as an active biological and eugenic threat. Progressives had obvious fears about the effects of loosening morals and the dangers of sexually transmitted diseases. To the eugenic

Sacramento's city hall, built in 1911, replaced the old city hall and waterworks at Front and I Streets, representing a transition from Sacramento's industrial waterfront to a city rapidly expanding eastward and transitioning to a new form of city government. *Center for Sacramento History.*

mindset, the greatest risk was to the U.S. population's gene pool through interracial sex and uncontrolled sexual contact with people whom eugenics advocates considered genetically inferior. Goethe's work in this area brought him into contact with Progressives who focused on social work, education and women's issues.[8]

THE 1911 SACRAMENTO CITY CHARTER: A PROGRESSIVE TRIUMPH

Progressive real estate developer Clinton L. White defeated "Boss" mayor Marshall Beard in 1908, but Beard was reelected as mayor in 1910, a move that prompted Progressive reformers to call for a new city charter. This charter replaced the 1893 "Strong Mayor" charter, which was based on an executive mayor and board of trustees, with a commission system. Five commissioners—covering public works, streets, public health and safety, education and finance—were elected at-large instead of being ward-based trustees. The commissioners were nonpartisan—an effort to remove

party "machine" politics from city government. Women's groups, civic organizations and Governor Hiram Johnson supported this new charter, which passed in 1911. The newly elected commission occupied a modern, new city hall located at Tenth and I Streets, a mile away from the old city hall building on Front Street.

This commission system also changed how the city awarded contracts and was intended to curb abuses of authority and corruption. In 1910, city cemetery superintendent D.J. Mannix came under fire because caretakers, hired by a private contract, at the City Cemetery refused to allow poor families to maintain their relatives' gravesites, instead insisting that they pay a fee or let the graves go unmaintained. Trustee Ed Carraghar was outraged when a fifteen-year-old constituent appealed to him for assistance maintaining her family plot. Under the commission system, maintenance of cemeteries became a municipal role overseen by a commissioner, and the offending contractor was soon unemployed—as was Superintendent Mannix.[9]

The commission system had its own problems. A candidate could be elected to run a city department without qualifications or experience in that area if they had sufficient political support. Businesses like PG&E and Southern Pacific still held great influence over Sacramento politics. In 1921, the commission charter was replaced by a council/manager system. However, the commission charter did result in a Sacramento milestone: in 1912, Luella Johnston became a city commissioner and the first woman elected to city office in Sacramento—or anywhere in the state of California.[10]

LUELLA JOHNSTON

Born in New Hampshire in 1861, Luella Buckminster moved to San Francisco with her mother in 1869, after her father died during the Civil War. Luella became a schoolteacher and married printer Alfred Johnston in 1884 and relocated to Sacramento. Alfred's company flourished, and Luella, an educated and wealthy woman, became active in Sacramento social circles. Because California women did not yet have the right to vote, and women's participation in politics was discouraged, her early social activities were primarily literary- and entertainment-related. In 1899, she became president of the Tuesday Literary Club, a reading group formed in 1896, transforming the club into a political and lobbying organization. After

Luella Johnston, the first woman elected to a city council in California, remained active in civic life after the end of her term. This photograph shows Johnston in 1955. *Sacramento Public Library*.

dropping the word "Literary" from their name, they embraced the ideals of the Progressive platform, including limits on saloons, enforcement of public morals and women's suffrage. In 1904, Johnston formed the Woman's Council, a coalition of thirty women's clubs, to coordinate these efforts. Her teaching experience gave her authority surrounding public education policy.

In 1906, Alfred Johnston died, leaving Luella as the principal director of her husband's printing business. This access to printing facilities became a useful tool to produce letterhead, signs and other materials to promote her causes. When California women won the right to vote in 1911, Johnston wasted no time, becoming the first to apply as a candidate for the new city commission. Despite her established name and impeccable qualifications, local media did not take her seriously, but she ran a serious campaign as a reformist law-and-order candidate. Thanks to her organizing and persuasive oratory skills, political experience and access to her own personal printing facilities, Johnston was elected to the Sacramento city commission in 1912, becoming the first woman elected to city office in the state of California. Women had previously won elected office in California, but it was solely limited to county education offices; Johnston was the first elected official with direct control of a city government.

Once in office as commissioner of education, Johnston also continued her work in other areas of city government, but due to the structure of the new charter, she was the first commissioner to run for re-election (in 1913). During her year in office, she made powerful enemies, including

the dominant business interests, Southern Pacific Railroad and Pacific Gas & Electric. Local bars and liquor interests already considered Johnston an enemy; this group included Ed Carraghar, a fellow city commissioner, longstanding member of Sacramento's Democratic Party political machine and owner of the Saddle Rock saloon. Despite a well-managed re-election campaign, she was voted out of office in 1913. She had a strong showing in the recently annexed suburban neighborhoods but fared poorly within the old city limits and the West End, perhaps because the livelihoods of many in those areas were threatened by her attempts to clean up their businesses.[11]

SPOONING AND RAGGING

In addition to her role as commissioner of education, Luella Johnston was responsible for city parks and often found herself playing the role of guardian of public morals. Newspaper stories reported that young couples engaged in "spooning" in city parks. It is safe to assume that this term refers to sexual liaisons based on the context provided by articles like this, published in the *Sacramento Union* on July 28, 1912.

UP-TO-DATE SPOONING

Spooning in the city parks and "squares" of Sacramento hereafter will be done under police surveillance, by direction of City Commissioner Mrs. Johnston, says the Stockton Mail.

Pshaw, neighbor, that's hardly the beginning of the story of this great reform. Attend an attentive ear. The park policemen in Sacramento are all required to have certificates of graduation in a course of eugenics. They must know Mrs. Browning's "Sonnets From the Portuguese" by heart, in order to be of immediate assistance to lovers in distress. They are all young and handsome but wear broad gold bands on the engagement finger to indicate that they are not themselves in the market. Instructions in up-to-date methods of courting are given in classes on Saturdays and Sundays. Cards containing addresses of clergymen and time table to Reno furnished on request.

But this is only a crude outline of the great reform instituted by the new administration. No account of it would be complete without mention of the "erometer" with which every park cop is equipped. The name is derived from

"Eros" the god of love, and "meter," measure. It is made in the form of a bracelet to fit tightly over the wrist of a man or woman. Inside a hollow tube is a tiny slip of paper, and an electric needle which responds to every deviation of the pulse. The presence of the beloved one will send the pulse soaring, as everyone knows. If he or she be cold to the ardent wooing of the infatuated one, the pulse of course will remain normal, if not subnormal.

It is the duty of the park cop to approach suspected lovers and politely request permission to adjust an "erometer" bracelet upon the wrist of each. Then he must retire to a respectful distance for a specified length of time, graduated according to the age of the subjects. At the end of that time, he removes the bracelets, examines the records of the little needle under a microscope, and acts according to the information revealed. If the needle has been running on the high in both bracelets he immediately advises the twain that licenses may be obtained at the office of the county clerk. He is forbidden, however, to give advice concerning furniture stores. "See ads in morning paper" is the most he is permitted to say in that regard.

If the tell-tale "erometer" shows that one is in love while the other is cold to the wooing, the Cupid cop hands a lemon to the unfortunate lover who is wasting his or her time. This hint is generally understood, although some disappointed ones have been known to shy the lemon at the policeman's head. Allowances are always made for such outbreaks, however, and it is not proper to make arrests in these circumstances. Bring your best girl with you to Sacramento, neighbor, and court her under scientific conditions.[12]

This playful description of young people's sexual activity, and the absurdly scientific approach described, are indicative of the Progressive mindset, approaching civic problems through "scientific" methods backed by legal enforcement. The comment regarding eugenics implied that sex in city parks was permissible, but sexual encounters that crossed racial lines were not.

Even if spooning was permissible under cover of darkness, public displays of sexual abandon were not. In 1911, the *Sacramento Union* published an exposé about girls as young as twelve performing obscene dances at the Oak Park recreation grounds (the facility later known as Joyland and, eventually, McClatchy Park), including the "Chicken Dance," "Grizzly Bear" and "Turkey Trot," unchaperoned and in the company of prostitutes visiting Oak Park, far from their accepted territory in the tenderloin. Collectively, these dances were called "ragging." In 1912, shortly before Johnston's city commissioner campaign, the Tuesday Club discussed whether they should pass a resolution condemning the practice. Instead of taking a formal

position, they forwarded the question to the Women's Council, Johnston's coalition of Sacramento women's clubs. Later that week, the even larger Northern District of the California Federation of Women's Clubs decided against taking a formal stand, calling the problem a "tempest in a teapot." Mrs. Bradford Woodridge of Roseville gave a statement to the *Union*:

> *I do not approve of "ragging" personally, but I believe it is not the dance so much as the music played at many of the public and private dances that is at fault, since the strains of "Oceans Roll" and other such rollicking, "raggy" music will often swing the youngsters into such a dance, whereas if clean waltz music was played, the steps would be modest and conform to every requirement of good conduct.*

Sacramento ministers took a less tolerant stance. Charles E. Farrar, of St. Paul's Episcopal Church, representative of a committee of ministers investigating "naughty dancing," inspected dance classes at Sacramento High School to ensure that children were not taught inappropriate styles as part of their physical education classes.[13] Charles Bliss, commissioner of public health, responded to the ragging controversy by prohibiting alcohol in dance halls within city limits; this was enacted in late 1912 and called "the Bliss Ordinance." This received praise from members of local churches, including Reverend Edwin Smith, of Oak Park Methodist Church, a representative of the ministers' committee that investigated the ragging controversy.

Many Sacramentans were less enthusiastic about the dancing ban. On December 1, 1912, the *Union* reported that a local wag had sent Commissioner Bliss a pair of turkey legs with a note reading, "Bliss—So that you will be sure of us complying with the law with regard to your ordinance prohibiting turkey trots, and to save the city the expense of having officers at dances to prevent us dancing turkey trots—the only way we know how—we enclose herewith our legs. Trusting that you will appreciate us trying to help you in this matter, we beg to remain, THE LEGLESS TURKEY TROTTERS."[14]

THE DEVIL'S BALL

A year after the ragging scandal, a deadly incident brought the issue back into public view. On the night of June 17, 1913, a car speeding toward

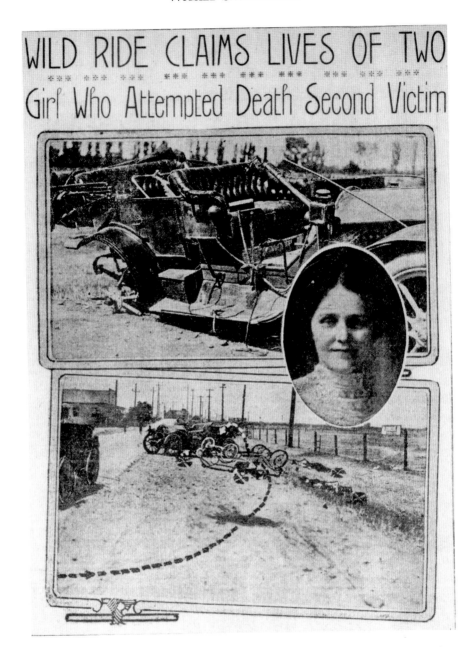

WILD RIDE CLAIMS LIVES OF TWO
Girl Who Attempted Death Second Victim

Sacramento Union photos of Grace Benson, who poisoned herself at the "Devil's Ball," and the crash scene where she and driver Guy Pierce died while he was attempting to bring her to a hospital. *Center for Sacramento History.*

Sacramento from Mills Station, near present-day Rancho Cordova, flipped over while trying to avoid a vegetable wagon near the Southern Pacific tracks at Brighton. The driver, Guy Pierce, and a passenger, Grace Benson, were killed, while another passenger, Herbert Woodall, was seriously injured. The cause for their haste, which resulted in the accident, was a suicide attempt by Benson while attending a party at Mills Station.[15]

The Mills Station party, known as the "Devil's Ball," was one of many organized by "Blackie" Thomas, a Sacramento dance promoter. After the Bliss Ordinance, he moved the parties outside city limits to avoid city prosecution. These events were described as wild orgies and "carnivals of bestiality." News of the tragedy at Mills Station spread as far as Tacoma, Washington, where a local paper described the Devil's Ball as "a night of riotous abandon in which young girls and older women yielded themselves to…shocking indecencies." They drew a crowd from downtown Sacramento's recently restricted venues; as the *Union* put it,

> *The principal revenue at the places is collected from the tenderloin element, which composes the late arrivals. The intemperance, seduction, lewdness and debauchery of the night life of the city is spread. This is what the authorities are seeking to prevent. The dance halls of the city have been toned down and the police have driven out the "chicken dances" which were a step removed. The contamination has been driven to the outskirts of the city and to the road houses of the county. The Mills Station dance was advertised about the city for two weeks as the "Devil's Ball," it was well known that it was scheduled to surpass all previous attempts at records for consumption of liquor and lewd dancing.*[16]

"Blackie" Thomas pled guilty to charges of "outraging public decency" and was sentenced to thirty days in jail. Calls were made to expand the city's prohibition on dancing and alcohol to the entire county, but on the same day, the balance of power shifted on the Sacramento City Commission. Luella Johnston was not re-elected as a commissioner, and her replacement as commissioner of parks and education was Ed Carraghar, owner of the Saddle Rock café and friend of local liquor interests. Commissioner Charles Bliss remained on the commission, holding to the Progressive line, but they now faced new challengers in their battle, including Black Progressive voters.[17]

THE WEST END CLUB

*S*acramentans whose knowledge of Sacramento's old waterfront neighborhood came solely from newspaper reports might get the impression that it was just a vice district, but it was also home to multiple diverse neighborhoods, including those housing many members of Sacramento's African American community. Regardless of whether they were law-abiding or criminals, their presence was offensive to the eugenic mindset and incompatible with their vision of a tidy and hygienic Sacramento. People of color, law-abiding or not, were considered as undesirable as drinking, prostitution and dancing.

Despite its small size, Sacramento's Black community responded to these offenses via protest and legal proceedings, seeking redress against the crimes committed against them. Some were rebuffed or ignored because white civic reformers could not overcome their own prejudices or were unwilling to risk alienating racist voters to support Black enfranchisement, but as the Black community's experience grew, so did their victories.

Historian Clarence Caesar described the era of Sacramento's African American community from 1880 to 1940 as "the settled years," in contrast to the gold rush and Civil War eras and the later Civil Rights era. In the "settled years," Sacramento's African American community numbered about one thousand people, or approximately 1 percent of the population. This small community had limited economic power, so they survived by forming organizations for mutual support, including religious, fraternal and social organizations. One of these organizations, the West End Club,

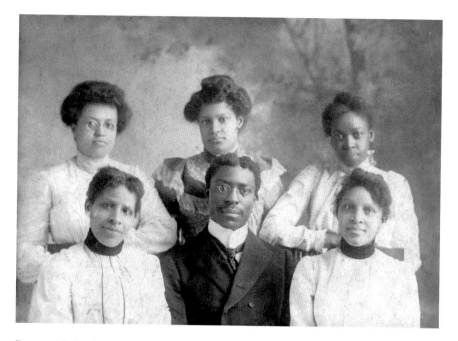

Reverend J. Gordon McPherson was pastor of Shiloh Baptist Church and publisher of Sacramento's first Black newspaper, *Sacramento Forum*. *First row (left to right)*: Lucy Ray, Reverend McPherson and Maud Ray; *second row (left to right)*: two unidentified women and May Russell. Photograph taken around 1906. *Center for Sacramento History*.

operated in both legal and illegal spheres but shared the common objective of economic security and political power. This organization also brought the name "West End" to Sacramento.[18]

Two congregations, those of St. Andrew's African Methodist Episcopal Church, established in 1850, and Siloam Baptist Church (later Shiloh Baptist Church), established in 1856, were the foundations of this community, which engaged in civil rights activism in response to racism and prejudice in California in the 1850s and 1860s. They became a vanguard for California civil rights, often finding common ground and organizing effective resistance with Sacramento's Chinese community, another frequent target of racist policies. The California Republican Party, established in Sacramento on an antislavery platform, became an avenue to political power for Black Californians following the Civil War. By the 1870s, this small community included multiple churches, social organizations, schools and even an armed militia, the Sacramento Zouaves.[19]

St. Andrew's African Methodist Episcopal Church, a cornerstone of Sacramento's African American community since the gold rush, was located at Seventh and G Streets until it was demolished for a county parking structure in the 1950s. *Center for Sacramento History.*

THE SACRAMENTO ZOUAVES AND CAPTAIN ROBERT J. FLETCHER

While no Black military units from California served in combat during the American Civil War, several formed during and after the war. The first known organization in Sacramento was Company A, formed in 1863 by Captain Alexander Ferguson, a Black ex-sailor, and consisting of twenty-five men. The city's first formally established Black militia was the Sacramento Zouaves, trained by Civil War veteran and Sacramento postmaster Captain William Crowell, in 1867. The Sacramento Zouaves' first public appearance was during the emancipation celebration on January 1, 1868, in Sacramento.[20] An early member of the Zouaves, Robert J. Fletcher, became a well-known Sacramento citizen.

Born in Brooklyn, New York, around 1844, Fletcher was raised by his aunt on the Caribbean island of St. Thomas. During the Civil War, he learned he was an American, much to his surprise, as he grew up assuming he was born on St. Thomas. Fletcher returned to the United States and joined the navy, serving aboard the *Vanderbilt* under Admiral Wilkes. His travels after the war took him to Panama and the island of Tobago, where he worked in a British hospital as an orderly and trained as a nurse.

In 1869, Fletcher traveled to San Francisco and then Sacramento, where he married Emma Scott and became a member of the Zouaves. Judging by his performance in companywide shooting contests, Fletcher was a skilled rifleman. For a portion of the 1870s, he lived in San Francisco, helping establish another Black militia company, the Sumner Guard, before returning to Sacramento and taking the position of first sergeant in the Zouaves under Captain Sims Emory and Lieutenant Isaiah Dunlap. The Zouaves were more than a paramilitary organization; they also served a political purpose, encouraging Black voting and civic participation.[21]

By 1879, Fletcher had succeeded Emory as captain of the Zouaves and led their procession accompanying President Ulysses S. Grant in a grand parade down K Street during President Grant's visit to Sacramento in October 1879. Fletcher was active in the Republican Party from the 1870s through the early 1900s and a member of the Eureka Lodge, Philomathean Lodge and the Odd Fellows. Fletcher's profession was chiropodist (a medical professional primarily dealing with the feet), and he was possibly the only Black medical professional in Sacramento at the time. In 1895, he served as personal nurse for Lieutenant Governor Spencer Millard.

In November 1893, Fletcher was attacked by two white men near Thirteenth and K Streets, reportedly the same men who attacked and robbed several other Black men during the same week. One of the men was armed with a pistol, but Fletcher successfully resisted them. There is no report that his assailants were ever caught.[22]

Even with such a remarkable life, in 1907, Fletcher met someone even more remarkable; opera star Anna Madah Hyers. It is unknown whether Fletcher divorced or if his wife, Emma, died, but on December 23, 1907, he married Hyers, a Sacramento native whose travels and adventures rivaled his own. Anna was born in 1855 in Troy, New York, and raised in Sacramento, where her sister Emma Hyers was born in 1857. The Hyers sisters were singers of extraordinary talent. Their first performance at the Metropolitan Theatre in Sacramento in 1867, at the ages of eleven and nine, began a musical career that took them around the world. Managed by their

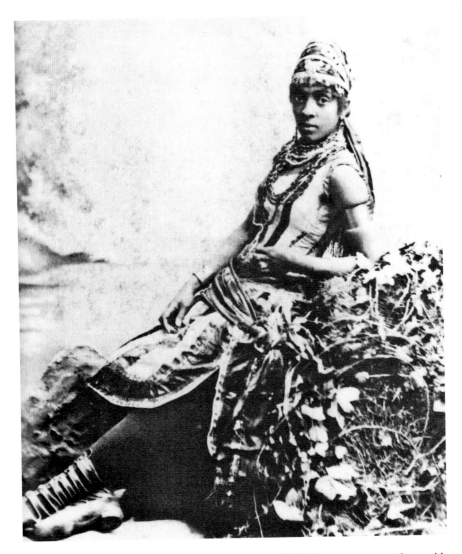

Anna Madah Hyers, a Sacramento native, achieved worldwide fame as an opera singer with her sister Emma and retired to Sacramento after her travels. *Susheel Bibbs collection.*

father, Samuel Baltimore Hyers, they traveled to Boston in 1872 to perform at the World Peace Jubilee—the first major musical production in the United States in which interracial performers shared a stage. Three years later, they formed a theater company to produce their own musical dramas.

These productions, including *Out of Bondage* and *The Underground Railway*, were first and foremost musical entertainment, but they also represented a

reaction to the portrayal of African Americans in theater via the stereotypes of minstrel shows. The career of the Hyers sisters spanned decades, but the sisters retired shortly before 1900. Emma Louise Hyers died in 1901, and Anna Madah returned to Sacramento, where she met Fletcher. After settling in Sacramento, she occasionally sang and played organ for church functions but no longer performed the grand operas of her youth. Robert Fletcher died in 1922, and Anna Madah died in 1925. Fletcher's daughter, Maud Flood, carried on the family business of chiropody.[23]

SACRAMENTO'S BLACK JOURNALISTS: MCPHERSON, FLETCHER AND COLLINS

Sacramento's first Black-owned newspaper, *Sacramento Forum*, published its only issue in 1906, before its publisher, Reverend J. Gordon McPherson of Shiloh Baptist Church, moved to San Jose. Robert Fletcher and Baptist minister J.M. Collins assisted in the production of McPherson's paper. In 1915, Collins started his own Black newspaper, the *Western Review*, and the *Sacramento Union*, long associated with Republican politics, published guest editorials by Reverends Collins and McPherson.[24]

In April 1910, the *Sacramento Union* reported that P.J. Clyde Randall, a Black attorney who previously practiced law in Macon, Georgia, had relocated to Sacramento.[25] Not long after arriving, he founded his own local newspaper, the *Sacramento Enterprise*. In July 1910, Randall, a Spanish-American War veteran, published a guest editorial in the *Sacramento Union* titled "Jim-Crowism Marks Meeting of War Veterans" that criticized a planned gathering of Civil War and Spanish-American War veterans because Black and white veterans were to meet in separate places. In November 1910, Randall penned a longer guest editorial for the *Union* describing the state of Black residents of Sacramento and entitled "The Negro in Sacramento":

> *The negro in Sacramento, as a people, is most likely less in numbers than any of the other classes that go to make up the city's population. Both the Japanese and Chinese very greatly outnumber the negro. The Portuguese also does, and very likely the Greeks. If the high-turbaned, tall Hindus continue their recent influx they, too, will outnumber the American negro here. He, the negro, is a natural born pure American. Instinctively he is such. So he is by training, sympathy and devotion. The American*

institutions and government are his ideals; neither does he claim nor know any other than the American flag and country, nor has his blood been freely given, upon the battle line as a patriotic soldier of unquestioned bravery for the establishment, preservation and enlargement of any other nationality. If it is a patriotic as it is a sacred principle that without the shedding of blood there is no remission of sins, we may exclaim with Kipling:

"If blood be the price of liberty
If blood be the price of liberty,
If blood be the price of liberty,
Lord God he has paid in full."

Randall's editorial also described multiple businesses—both Black- and white-owned—where Black Sacramentans were employed and named Black community organizations and their accomplishments. He also had the following to say about social clubs:

If the whites can have a place for social recreation and companionable pastimes, Grant Cross and William Snow thought to benefit their own race

The building at 209 L Street was the original headquarters of the West End Club around 1909. A few years later, the L Street Arena opened in a former warehouse located behind this row of storefronts. *Center for Sacramento History.*

with such, hence was established the commodious Douglass Improvement club at 209 L Street. Grant Cross has seen the institution duly incorporated, and is running it in an up-to-date social club way.

Randall, like McPherson, did not remain in Sacramento for long, moving to Oakland within a few years, but the *Forum, Enterprise* and *Western Review* gave this small community a means of communication and a platform for their leaders' views. They also gave their editors the necessary experience to convince the *Union*, connected by party affiliation, to provide with them column space and a wider audience.

GRANT CROSS AND WILLIAM SNOW: NIGHTCLUB ENTREPRENEURS AND CLUB MEN

The Frederick Douglass Improvement Club mentioned in Randall's editorial, founded by Grant Cross and William Snow in 1910 and later reorganized as the West End Club, was the first of several organizations that blurred the line between political activism, fraternal support and nightlife in Sacramento. Both founders were recent migrants to Sacramento whose talents and business skills energized the "settled" community of Sacramento.

Grant Cross was born around 1873 in Illinois, the third son of J.G. and Mary Cross. According to census records, they were originally from Alabama, but their travels took them to Illinois and Kansas. Grant kept traveling west. His name and description in the 1896 San Joaquin County voter register described him as "5' 5 ¾" tall," Black, with a scar on the right side of his forehead, working as a laborer. His travels took him to Red Bluff by 1901, when a reporter from the *Red Bluff Daily News* stated that Grant, also known by the nickname "Skewball," challenged Jack Kennedy to a footrace from Crittenden Street to Morin & Wilson's Saloon, a distance of four blocks. Considering the headline, "Foot Race to Relieve the Monotony," residents of Red Bluff were clearly hard-pressed for entertainment in 1901, and the race gathered a large crowd. Kennedy started off in the lead but slowed after the third block and was overtaken by Skewball, who claimed the prize of one dollar. This footrace suggested Grant's competitive streak, talent at sports and willingness to be the center of attention. The second and final mention of his name in the *Red Bluff Daily News* was the announcement of his marriage to Rose Howell, a fellow resident of Red Bluff, in November 1901. Their

wedding license indicates that the marriage place was Sacramento, the big city closest to Red Bluff, where Grant sought opportunity—or at least relief from the monotony.

For the first years of their stay in Sacramento, the Cross family lived in apartments near the Sacramento waterfront, and Grant found work as a waiter, porter and cook. In 1910, he lived at 1616 Sixth Street with Rose, his son Franklin (born in 1902) and his sister-in-law Mattie Howell. Judging by his frequent mention in Sacramento and San Francisco newspapers under both his given name and "Skewball," Cross was a well-known personality whose social circles included state legislators and bartenders. Like most Black voters of his era, he registered Republican and for a while joined the Progressive Party.[26]

In 1910, the *Union* reported that Grant filed articles of incorporation for a fraternal organization, the Frederick Douglass Improvement Club, with Harvey Cross (a barber, apparently not related to Grant) and William Snow. Named after the famous abolitionist and social reformer, this club served multiple purposes, combining social and political agendas. In the 1911 city directory, William Snow was listed as the president of the Douglass Improvement Club, with Cross listed as secretary. The club was located at 209 L Street. Snow described their organization as "along the same lines as the Sutter Club," with a similar state charter. Sacramento police chief William Ahern agreed with Snow's assessment and stated he was glad for their existence, if only because he preferred black and white saloons remain separate from each other.[27]

William Snow was born in Fort Worth, Texas, in the early 1870s. Five feet and ten inches tall with gray-green eyes, he was a professional gambler prior to forming the Douglass Improvement Club. The only known photograph of Snow was taken during his arrest on August 22, 1915, for shooting Bill Williams at Snow's billiard parlor. Williams and another patron began fighting, exchanging words, blows with pool cues and thrown pool balls. When Williams attempted to throw a ball at Snow, Snow calmly drew his revolver and shot Williams in the arm. After police determined that Williams was not seriously injured, Snow was released, and Williams did not press charges; the well-placed bullet defused the situation.

Based on newspaper reports, the Douglass Improvement Club was a private gambling and sporting club. In February 1911, the club members formed a baseball team to compete with other local baseball clubs. In March 1911, Cross and local bar owner Ed "Gugie" Welch paid the bail for eleven women arrested for vagrancy; the reason they paid the bail is unknown.

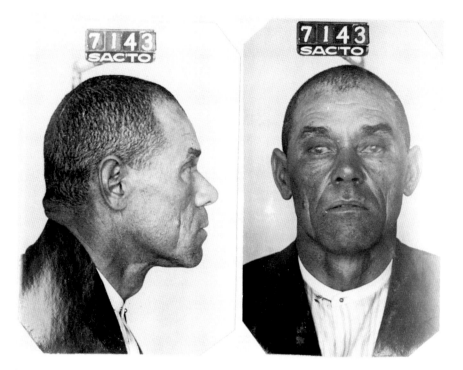

West End Club/Eureka Club president William Snow after his 1915 arrest for shooting a belligerent customer at the Eureka Club. The customer later dropped the charges. *Center for Sacramento History.*

Another account from 1913 indicates that two women were arrested and sentenced to thirty days in jail after being caught inside the Douglass Improvement Club. The club attracted negative attention from newspapers and police focused on fights, alcohol and gambling at the club. Although these activities also figured prominently in the social agenda of similar men's clubs, articles about gambling and drinking at the Elks Lodge, Sutter Club or Odd Fellows' Hall seldom made the newspapers.

Cross and Snow found an ally in bandleader and dancing instructor John Creighton Churchill, who operated a dance hall out of his home at 424 M Street. This stately 1860s mansion was originally built for Joseph Johnson, a superintendent of the Sacramento Valley Railroad and a partner in the Huntington & Hopkins hardware store. Churchill was a leader in the Sacramento Musician's Union, and his children, John Jr., Percy and Frank, were all performers in "Churchill's Orchestra." Churchill was a native of Ohio born in 1858, and at least one newspaper account identified him as a "Professor," although it is unclear whether this term was intended in the

academic or the vernacular sense—"professor" was a term often used to describe a piano player who performed in brothels. Churchill opened his doors to the Douglass Improvement Club and their events, making the Churchill Dance Hall one of several favored venues for Douglass events.

In 1913 and 1914, the organizers of the Douglass Improvement Club reorganized and refiled new articles of incorporation as the Peerless Social Club, then reincorporated as the West End Social Club. According to the *Union*, Grant Cross was involved in this new club but not one of its initial signatories. Ross Robinson, the chairman of the new club, owned a barbershop at 1018 Fourth Street. At about the same time, another social club, the Eureka Social Club, was established, with many of the same principals involved. The dance of organizations and titles is confusing, and the historical record is incomplete, but the common addresses and names of these organizations and members implies a common membership. Based on newspaper reports, the West End Club focused on sports and politics, while the Eureka Club formed a "clubhouse" relocated in 1914 from their earlier quarters at 209 L Street (in front of the Art Dance Hall) to 326 L Street, above the Nippon Theatre, a Japanese-owned movie theater. This was the location managed by William Snow, who enforced discipline on unruly patrons with his revolver.

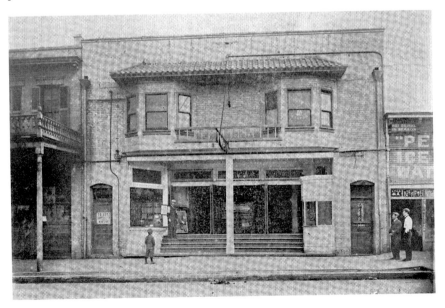

The Nippon Theatre, located at 326 L Street, was owned by Yusuke Nishio. The Eureka Club occupied the upper story above the movie theater. *Priscilla Ouchida collection.*

THE WEST END CLUB AND BLACK POLITICS OF 1914

During this era, most African American voters in the United States were members of the Republican Party due to the Republicans' longstanding association with the abolition of slavery. However, in the early 1900s, schisms appeared in the national Republican Party. Because of the Republican Party's association with Black voters, southern states were Democratic strongholds. Some Republicans wanted to end their association with Black voters and woo Southern whites to the Republican Party. This resulted in a schism between "Black and Tan" Republicans (Black Republicans and those who supported a multiracial party) and a new faction called the "Lily Whites." Most of these efforts played out in southern states, where larger Black populations meant more ability for "Black and Tan" Republicans to organize. Even in large cities like Los Angeles and San Francisco, Black populations in California were still small, but racial fears were high among white voters. The small Black middle class in California often embraced political ideals similar to those of Progressive voters, and some (including P.J. Clyde Randall and Grant Cross) also joined the Progressive Party until it became clear that they were no longer welcome as Republicans. The term "Black and Tan" outlived its political meaning; it was also a term used to describe mixed-race nightclubs like the West End Club.[28]

A *Sacramento Union* article titled "West End Club Out for Tango and Beer: Negroes Enjoy Themselves at Candidates' Expense" provides an image of the white perception of Black voters. Republican candidates for county offices, including Dr. J.D. Arbogast, coroner William Gormley, John Ing and Charles Hoffman, attended a meeting of Sacramento's Black Republicans hosted by the West End Club at Churchill Dance Hall in July 1914. The candidates were described as "embarrassed and forced to seem happy, jolly, and hail-fellow-well-met" in a meeting of Black voters who were portrayed by the reporter as more interested in free beer and live music than the candidates' positions. The music provided at the event was described as the product of "three near musicians." It is clear from the context of the article that Black voters were not taken seriously, and it implied that their loyalties could be cheaply bought. However, there were other factors unconsidered by both *Union* reporters and the candidates. Local women's groups were lobbying to move a polling place from Churchill Dance Hall to a portable polling site based on the supposed unsuitability of the Churchill as a place for white women to visit. Loss of this polling place would have made voting less convenient for West End residents. Because

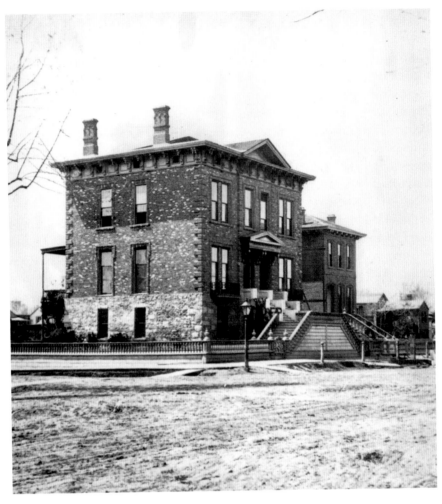

This mansion at 424 M Street was built for railroad manager Joseph Johnson. By 1900, it was the Churchill Dance Hall, owned by bandleader John Churchill, and a frequent venue for events sponsored by the West End Club. *Center for Sacramento History.*

these candidates were in the best position to return the polling place to the Churchill or another permanent location, it would have been in the West End Club's best interest to lobby them directly, offering the support of their members and community. In addition, both the West End Club and the Eureka Club had applied for liquor licenses pending hearings a few weeks later. The support of white political candidates would have meant much to the West End Club members in regard to obtaining and retaining liquor licenses and dance permits.

In addition to addressing the specific issues of their community, the West End Club's actions suggested an agenda that represented an alternative for California Progressive politics. This included greater economic opportunity for the Black community, greater tolerance for live entertainment and sale of alcohol and, to a limited extent, social interaction that crossed racial lines. All of these elements were unacceptable to white Progressives, whose response to the West End Club was a dismissal of their importance in local politics, rejection of their applications for liquor licenses and prosecution for hosting racially integrated events.[29]

The Eureka and West End Clubs were both denied liquor permits by the chief of police in August 1914. During the fall and winter of 1914–15, multiple raids were made at West End Club venues, including the Eureka Club, Serra Hall at Sixth and L Street, the Churchill and Ross Robinson's rooming house at 1223 Fourth Street, resulting in arrests for gambling, conducting a house of prostitution and illegal sale of liquor; Robinson and Snow were among those arrested. Robinson, a founding member of the West End Club, claimed in the *Sacramento Union* that he was unfairly targeted for harassment:

> *Why do the police pick on me? I know and they know there are at least 30 houses of ill fame being conducted in this city between Front and Tenth Streets. These girls that were arrested in my house pay me $10 a week for room and board. I have a Chinese cook to prepare their meals. They have their own rooms and I do not know who their friends are or who they entertain in their rooms. I cannot understand why the police keep picking on me when other people are allowed to conduct such a house as I do.[30]*

The raid of the Churchill also resulted in Commissioner Charles Bliss calling for revocation of their dance hall permit—not because of the sale of alcohol, but because both Black and white customers frequented the Churchill. The manager of Serra Hall, Tony Sliscovich, was informed that "intermingling of the races on his dance floor will not be allowed." Commissioner Ed Carraghar spoke in defense of the venue, stating that it was only just that Black Sacramentans have the same sort of facilities as white social clubs. A week later, Sliscovich was arrested at Serra Hall for gambling, along with a group of "Nine Greeks and Americans," including a young man named Frank Nisetich, a Slavonian immigrant. Grant Cross was fined forty dollars for the sale of liquor, and his dance hall license for Serra Hall was revoked. With the closure of Serra Hall, events planned for that

This building at Sixth and L Streets was originally Westminster Presbyterian Church. In 1903, it was renamed Serra Hall, a lecture hall, performance space and site for African American dance events hosted by the West End Club. *Center for Sacramento History.*

site were moved to the Churchill, and in the summer of 1915, Serra Hall became a Salvation Army citadel.[31]

Investigations into the Churchill brought some objections from the public, including an anonymous letter in the *Sacramento Union* claiming that the administration of justice was arbitrary and selective in Sacramento and unfairly enforced across racial lines:

> *One peculiarity of the administration of justice in Sacramento is that it establishes arbitrary classes and in spite of the boast of the chief of police recently that there was no discrimination in the enforcement of the law, it is doubtful if discrimination has been carried so far in any city of the land. Because one place caters to "white men" of all races and shades it is permitted to operate freely. Because another violates the arbitrary rulings of the police officials, which were made without the shadow of law and in violation of the principles of the United States constitution, the commissioner of public health and safety will close it.*

The cases against the Churchill and other West End venues were based on liquor and gambling charges, but testimony from city commissioners focused on multiracial audiences at Churchill and Serra events that were prohibited

by city ordinance. Again, Ed Carraghar spoke in defense of the Churchill at repeated hearings, asking for a delay for more investigation, but during a final vote on June 29, 1915, Carraghar joined the rest of the commissioners in a unanimous vote to revoke the Churchill's license.[32]

Only two weeks after the Churchill hearing, a new police chief, Ira Conran, recommended to the commission that the Eureka Club be granted a liquor license despite the previous chief, William Johnson, and Commissioner Charles Bliss denying a license only a year before. The license was granted on July 15 with the condition that women could only visit the club once per week, and white women were never allowed to enter. Another positive step for the West End community was the reopening of the Churchill as a polling place despite the Women's Christian Temperance Union's objections. County Supervisor Robert Callahan denied the WCTU's request based on the Churchill's central location and because it was no longer a dance hall. Callahan, like Ed Carraghar, was a Democrat, the party in opposition to the Republican Progressives. It is unknown what caused this, but in 1914, Grant Cross changed his political party affiliation from Progressive to Democrat. This change of party allegiance did not end raids of West End clubs; on September 18, 1915, police raided Ross Robinson's barbershop on Fourth Street, where Grant Cross and several other men were arrested for gambling.[33]

The largest point of contention for Sacramento police and the city commissioners regarding the issuance of liquor licenses was the presence of white women at these venues. The term "white" in this context is instructive, because in the early twentieth century, not all persons of European origin were considered white. Women of Italian, Greek, Portuguese or Slavonian ancestry, all represented in Sacramento's immigrant communities, might not have been considered "white" at a function held by the Tuesday Club—if they were permitted to attend at all. The same women became white the instant they entered a Black dance hall. The limitation of this prohibition to white women also contained a loophole: women who were neither Black nor European, including Asian women and Latinas, were theoretically not prohibited from attending these clubs. By the same measure, women who fit this situational definition of whiteness but rejected its limitations were sometimes prosecuted for their social transgressions; in January 1912, two white women, Ruby Doyst and Pearl Corbett, were sentenced to thirty days in jail for entering the Douglass Improvement Club on L Street. The official charge was "vagrancy," but the real crime may have been their attempt to step outside the acceptable boundaries of whiteness.[34]

PROTEST OF THE CLANSMAN

Between 1908 and 1915, Sacramento's African American community dealt several times with theatrical productions of *The Clansman*, based on a novel by Thomas Dixon Jr. about Reconstruction in the South and the rise of the Ku Klux Klan. Featuring heroic portrayals of Klansmen and shocking, sinister caricatures of African Americans (usually portrayed by white actors in blackface), productions of *The Clansman* were protested in many cities. When *The Clansman* was produced in Sacramento at the Clunie Theatre in November 1908, Sacramento's African American congregations discussed raising formal objections or attempting to have the play cancelled but decided against a formal objection. Newspaper accounts attempted to minimize the racism of the play by pointing out that the production had "much in it of historical interest to the younger members of the race" and claiming that, in the *Union*'s view, protests in Seattle, Portland, San Francisco and Los Angeles against the play "have not done the Afro-American race any good." The small size of Sacramento's Black community meant that meaningful protest was difficult without sufficient organization.[35]

In 1910, the play returned to the Clunie and was met with limited local protest, but these protestors' efforts were not sufficient to prevent the performance of the play. In 1911, when *The Clansman* came to the Diepenbrock Theatre on J Street, Reverend R.H. Herring of St. Andrew's African Methodist Episcopal Church filed an emphatic protest with Sacramento mayor Marshall Beard against the production. By this time, several southern and eastern cities had suppressed the play due to concerns about race riots. In the words of Reverend Herring:

I cannot condemn too strongly the production of this play, "The Clansman." Everything that is cruel and despicable against the negro race has been brought out and introduced in the drama. The negro is shown as something a little lower than beasts, and in all fairness we think that we are within our rights in asking the city to help us in this matter.

I think we have suffered enough in the past, without having this highly overdrawn picture of one-time conditions in the South thrust upon us without uttering a word of protest. We love peace. Our people in Sacramento are hard-working, law, abiding citizens and taxpayers. We are not asking much, and we would like to see this prejudiced drama substituted with something more wholesome and true to life.

I will see Mayor Beard who I am sure is a friend to our people and fair-minded, to learn if something cannot be done to convince the management of the Theater Diepenbrock that the play should not be given.[36]

Despite Reverend Herring's appeal, Mayor Beard was unmoved, and the Diepenbrock put on its performance of *The Clansman*. The *Union* reviewer reported that the local Black community felt the play did not represent conditions in the South and did them an intolerable injustice but went on to describe the intense drama, merry comedy and gripping action of the play and its realistic depiction of settings like "The Great Cave of the Ku-Klux."

In 1915, *The Clansman* returned in a new form—as a feature-length motion picture produced by D.W. Griffith and known as *The Birth of a Nation*. Due to the growing political experience and organization of Sacramento's Black community, this time, their response was larger and more direct. Commissioner Ed Carraghar was visited by a delegation of twenty-four men and women instead of just a single pastor. By this time, even Governor Hiram Johnson, previously credited with endorsing the film, had retreated from that position, stating that "he has never approved the work and has always thought it could be productive of only prejudice and ill-feeling." This time, the protest was met with a limited concession from the city commissioners; the film could be shown but in edited form, with the most objectionable scenes removed. The edited film was met with subdued enthusiasm by local media. Even this minor concession, given the context of the times, represented a victory in an era of rising prejudice. In the pages of *The Western Review*, Reverend Collins heralded the community's position as "an earnest and manly stand."[37]

The political power of Black Sacramentans, while still small, was caught in the current of larger state and national events. In part due to the resurgence of the Ku Klux Klan, often attributed to the popularity of *The Birth of a Nation*, racism was on the rise in America. The 1910s and 1920s were also the era of the first racial exclusion covenants used to prohibit the purchase of homes in new suburbs to anyone except whites. In response to these challenges, organized political protests led by churches and community groups were necessary for survival, even if they were unable—due to lack of numbers and resources—to create major political change. The remainder of the decade brought other signs of incremental change: 1918 brought the election of Frederick Roberts of Los Angeles, the first African American member of the California State Assembly, to the California legislature, and the following year, Sacramento had its first Black candidate for public office.

SACRAMENTO'S FIRST BLACK CANDIDATE, REVEREND T. ALLEN HARVEY

Reverend Thomas Allen Harvey arrived in Sacramento from San Jose in 1916 and rapidly established two major institutions in the Black community: the African Methodist Episcopal Zion Church, now known as Kyles Temple AME Zion, and the first Sacramento branch of the National Association for the Advancement of Colored People (NAACP), one of the earliest NAACP branches on the West Coast. After originally preaching at St. Andrew's AME, Reverend Harvey formed the Kyles Temple congregation in August 1917, laying the cornerstone for its church— the first African American congregation in a Sacramento suburb—in Oak Park at Thirty-Sixth Street and Broadway in April 1919.[38]

Reverend Harvey became the first president of the Sacramento NAACP in 1916. In 1917, he gave the keynote speech at a function for 418 Black soldiers passing through Sacramento on the way to Camp Lewis, Washington. In 1918, he won the first racial discrimination suit in Sacramento history, winning an award of fifty dollars after being refused service at the W.L. Bigelow Restaurant at 3008 Thirty-Fifth Street. In 1919, Reverend Harvey gave another soldiers' address to African American veterans of World War I, and the local NAACP chapter brought speakers, including James Weldon Johnson of New York, to address the issue of lynching during the 1919 "Red Summer."[39]

Reverend Harvey first expressed an interest in running for city commissioner in March 1919 as a candidate for commissioner of public works. His platforms included a competitive franchise for local streetcar companies and a reservoir-based water treatment system. He also took a position on saloons, reinforcing the idea of Black Progressive tempered tolerance for saloon interest, as quoted in the *Sacramento Union*,

> *Everyone knows how I stand on saloons. Nevertheless, I believe in the saloon man being given a fair deal. I am not catering to the church vote to the exclusion of others. I want the support of all fair-thinking men and believe that when the votes are counted I shall not stand at the bottom of the list of seven.*[40]

Faced with six other competitors, who were all white men, Reverend Harvey recognized that he faced an enormous challenge but he felt he was up to the task, citing his experience in the Spanish-American War:

I am a colored man. I was at San Juan Hill with Colonel Roosevelt and when those Spanish bullets were zipping round we were all Americans. It should be the same today.[41]

True to his word, Reverend Harvey did not place last. In the May 1919 election results, he was fifth out of seven candidates, winning 196 votes out of 8,441 cast. Harvey's experience demonstrated that elected office was still too high a hurdle for Sacramento's Black community in 1919. He did not allow this setback to limit his political ambitions, as he ran for city council under the city's new charter in 1921, or slow his efforts at creating civic institutions. Three months later, he formed an organization for Sacramento's African American veterans, the Crispus Attucks Soldiers' and Sailors' Club, and in 1920, he served in Sacramento's Independence Day parade as marshal of the Eighth Division, representing Sacramento's Black community in the civic procession.[42]

Despite the limited size and political power of Black Sacramento in the early twentieth century, this community drew upon the strengths of its religious and social institutions and the talents of its leaders to organize and advocate for their community's survival in an era of institutional racism. When the forces of law and order were also agents of racial exclusion, leaders like Reverend Harvey and Captain Fletcher represented agents of a higher justice battling the wickedness of racism, with the West End Club as allies sharing common ground.

THE EUREKA CLUB CHANGES HANDS

At their clubhouse above the Nippon Theatre, Grant Cross and William Snow operated the Eureka Club, becoming an established part of Sacramento's business community despite subsequent raids by police for gambling violations, the presence of alcohol and occasional white visitors. Grant Cross joined Sacramento's chamber of commerce in October 1920, and Snow hired a young assistant, Charles Napoleon Derrick, born in 1889 in Arizona Territory, to manage the club. They remained active in local athletics, including a citywide relay race around Capitol Park in 1920, boxing promotion and baseball teams, all featuring local Black athletes.

On September 21, 1921, William Snow died of pneumonia. His estate included a Cadillac and approximately $3,000 in cash, jewelry and

property—a total estate of $7,700. Without a will, this was distributed to his mother and brother, who also lived in Sacramento. Grant Cross made initial efforts to open a pool hall at 1223 Fourth Street but was denied by the city council. Charles Derrick took over management of the Eureka Club in 1923, which was renamed the "Eureka Social & Athletic Club" in city directories after 1925. Derrick also continued a tradition established by Cross and Snow; following the example of their payment of bail for a group of women in 1911, Derrick paid the bail for a group of African American men and women arrested in June 1922 for vagrancy, per the *Union*, because "they were undesirables who had been inhabitating [*sic*] the western section of the city, maintaining themselves in a fashionable style without visible means of support." Their arrest followed an attack on a white tourist from Oregon, and charges were dismissed when no evidence was produced of their involvement.[43]

In 1922, when an African American baseball team, the Los Angeles Giants, sought accommodation in Sacramento for an exhibition game, a local newspaper editor referred their team manager to Grant Cross, noting that he was the man who "made Carrie Nation famous," referring to Skewball's association with local sports, Black activism and repeated violation of liquor laws.[44] In the same year, Cross moved from the West End to a house at 909 Twenty-Second Street near Boulevard Park. In 1923, Cross and a group of friends served as extras in the filming of *Cameo Kirby*, a riverboat movie principally shot in Sacramento. A *Sacramento Bee* article includes a photo of Cross, wearing his characteristic top hat at a sharp angle, and describes his preferred outfit, including a colorful flowered vest and "an ancient pair of trousers." The newspaper account clearly recognized that Cross was a well-known figure to thousands of Sacramentans and better known as "Skewball" than by his given name.[45]

Details of the last days of Grant Cross remain elusive. He was admitted to Stockton State Hospital on January 22, 1924, for "alcoholic psychosis, acute hallucinations, arteriosclerosis, syphilis." Cross died on October 20, 1930, with his cause of death listed as "General Paralysis of the Insane." No Sacramento newspaper appears to have reported on his hospitalization or his death; hospital admission records suggest that he may have returned to San Joaquin County prior to his institutionalization. Grant Cross and William Snow came to Sacramento as outsiders, and their efforts inspired Black Sacramento and drew the ire of white authorities. Their efforts were little known, but their work set into motion other events that outlived both men.[46]

Serra Hall became an important community center for Sacramento's African American and Slavonian communities but was condemned by reformers for tolerance of gambling and interracial dancing. Serra Hall burned on September 20, 1919. *Center for Sacramento History.*

THE LOST MUSIC OF THE WEST END

The music of the "Negro dances" at Serra Hall and the Churchill was persuasive enough to draw young white women (and men) into the forbidden West End, Douglass and Eureka Clubs. Reporters sometimes described it in comparison to popular music such as the tango, foxtrot and hesitation, but these reporters may not have had the musical language to describe Black music in this era, the dawn of jazz. The musical influences present in northern California in the 1910s were different than those of New Orleans, the birthplace of jazz, but the West Coast had its own Black musical traditions dating back to the gold rush. In 1850, Bayard Taylor visited Sacramento, remarking that there was more music there than in San Francisco, and commented on Black musicians of the era:

These songs are universally popular, and the crowd of listeners is often so great as to embarrass the player at the monte tables and injure the business of the gamblers. I confess to a strong liking for the Ethiopian airs, and used to spend half an hour every night in listening to them....The spirit of the music was always encouraging; even its most doleful passages had a grotesque touch of cheerfulness—a mingling of sincere pathos and whimsical consolation, which somehow took hold of all moods in which it might be heard, raising them to the same notch of careless good-humor. The Ethiopian melodies well deserve to be called, as they are in fact, the national airs of America. Their quaint, mock-sentimental gaiety and irreverent familiarity with serious subjects—and their spirit of antagonism and perseverance—are true expressions of the more popular sides of the national character.[47]

The Black music of the gold rush evolved in places like San Francisco's Barbary Coast, Sacramento's West End and in Stockton, where the first dance craze based on Black dance styles, the cakewalk, appears earliest in the historical record. Later dances, like the turkey trot, emerged from San Francisco and were passed along to the nation, arriving early in Sacramento. The word "jazz" was first used in print to describe the musical form emerging from New Orleans in San Francisco on March 6, 1913. The first Black musicians to describe themselves as a jazz band were also San Francisco performers—Bert Kelly's Jazz Band and Sid LeProtti's "So Different Jazz Band." Touring New Orleans musicians visited the West Coast, bringing their new musical style with them, and California musicians encountered them on the road. How many of these musicians stopped in Sacramento or passed through on their way to San Francisco or Los Angeles? Due to men like Cross and Snow, there were clubs, musicians and an audience in Sacramento.[48]

There are no known recordings of the music played at the West End Club's venues, and the names of most of the performers are not known. Similarly, the influence of Cross, Snow and their contemporaries on Sacramento are difficult to determine except by inference. Compared to T. Allen Harvey or Captain Fletcher, Grant and Snow's immoderate lifestyles and direct methods drew the ire of white authorities, but they also inspired those around them, including the entrepreneurs of the emerging Jazz Age and those who challenged the limitations of Prohibition. The greatest contribution of the West End Club may have been the very name, the West End, which was established almost twenty years before King Oliver wrote "West End Blues,"

referring to a neighborhood near St. Louis, not Sacramento. The West End replaced "the tenderloin" and "the lower part of town," names that were rarely capitalized as neighborhood monikers. But with its capitalization, the West End became a place, even if it was a place bitterly spoken of by social reformers. To them, this was the music of the tavern, the wicked dance hall and the brothel. To the residents of "the lower end of town," the music of the West End lifted their aspirations higher than the capitol dome that marked its eastern boundary.

QUEEN OF THE SACRAMENTO TENDERLOIN

rom the 1880s until about 1920, Sacramento had a district where prostitution was tolerated by the authorities, called the tenderloin. Sometimes called the *demi-monde* ("half-world"), these districts usually existed in a gray area between legality and illegality. Similar districts in other cities included San Francisco's Barbary Coast, Storyville in New Orleans, or Chicago's Levee. Chicago was also the origin of social reform societies intended to eliminate prostitution, which was called "the social evil" in polite society and "white slavery" in public presentations. The conditions of nonwhite prostitutes were of less concern to Progressive activists whether they were located in Chicago or Sacramento. Despite the presence of African American, Chinese, Japanese and Latino brothels in Sacramento, other than concern from a eugenic perspective about interracial sex, the Progressive emphasis was specific to women of European descent who were involved in prostitution. Like San Francisco's Tenderloin, which superseded the Barbary Coast as a vice district, the name may have been derived from New York's original Tenderloin district, brought to California by the large number of New Yorkers who settled in Sacramento and San Francisco during the gold rush.

Sacramento's tenderloin ran along L Street and Second Street, through the West End, sharing the same geography as Sacramento's Japanese, Chinese and African American neighborhoods. Facilities for prostitution operated openly, often including listings in the city directory. These included brothels, dance halls, cribs and parlor houses. Brothels, often referred to as "resorts"

This view down L Street facing west from Fourth Street shows the Nippon Theatre, front gate to the Cherry Club and other West End businesses near the waterfront docks. *Center for Sacramento History.*

or "sporting houses," were general-purpose institutions for prostitution, including long-standing local institutions like Fanny Brown's "Palace" at 909 Second Street, opened in 1878. Dance halls combined prostitution with live music, entertainment and dancing. The Art Dance Hall at 223 L Street was a small storefront leading into a larger hall, lined with curtained booths. The Casino at 119 J Street, another enduring institution, first opened in 1879 and also featured these booths, described as "boxes" in fire-insurance maps. Instead of renting a room or accompanying a woman to a crib, customers could simply close the curtain of a booth for a semi-private encounter. The Art and Casino were also notorious venues for ragging and other popular but semi-obscene dance styles targeted by the 1912 Bliss Ordinance. Cribs were typically upstairs rooms in rooming houses or were located above businesses and rented by prostitutes for off-site liaisons; these were often indicated by "½" in the street address, used to identify upstairs apartments. Streetwalking prostitutes typically used a crib, but part of the purpose of a formal tenderloin district was to discourage streetwalking activity.[49]

The final type of facility, the parlor house, was an upper-class destination distinct from the dance hall or brothel, with elaborate décor and wealthy clientele. The most sensational story of the Sacramento tenderloin was the tale of Cherry de Saint Maurice, a flamboyant and successful madam, and her Cherry Club, Sacramento's best-known parlor house. Cherry's death

highlighted the dangers of the *demi-monde* and became the justification for civic reform that ended legal tolerance of prostitution in Sacramento.[50]

Brothels and parlor houses used music to set the mood for customers. Ragtime, the product of nineteenth-century musical geniuses like Scott Joplin, was the popular music in Victorian tenderloin districts. Like other American musical forms developed by Black musicians, ragtime was warmly embraced by young people and vilified by parents and authorities. The *Sacramento Union* "Musical Items" column of February 4, 1906, had the following to say about ragtime:

> *Mrs. M.E. Pratt, Matron of the Detention Home of Los Angeles, says of ragtime: "To my mind, the ragtime music is demoralizing, and the present popularity of this style seems to have its decided effect—not a good one—on children. Music has a much greater power to mold the mind than many people give it credit..." Mrs. Pratt is right. The institutions that foster this class of music are cheap vaudeville theaters—destroyers alike of the moral, esthetic and artistic senses.*[51]

In the early twentieth century, ragtime was filtered through the talents of another generation of African American musical innovators emerging from New Orleans' Black neighborhoods and expressed in the brothels of Storyville. Their music spread to the rest of the nation via these New Orleans musicians and those they inspired, becoming jazz. Playing music in brothels offered economic opportunities to performers of ragtime and early jazz, and popular music played an important role in the business of prostitution. Dora Russell, operator of a Second Street brothel, considered pianos so essential to her business that when a July 1912 fire destroyed her brothel, including several rented pianos, she refused to pay the rental agency for the loss of the pianos because they were "used to assist in an immoral business."[52] The music of the brothels was uninhibited and sensual, its energetic beat keeping time for dances and sexual encounters. The fast, frenetic pace of ragtime may have even encouraged brothel customers to finish their business quickly.

CHERRY DE SAINT MAURICE

Cherry de Saint Maurice, Sacramento madam and entrepreneur, was well known for her business acumen, beauty, indomitable spirit and wealth; she was frequently called "the Queen of the Sacramento Tenderloin."

She demanded respect and equality as a businesswoman in an era of gender inequality, but her profession brought her into conflict with Progressive reformers. Her brutal murder, and the veiled and contradictory stories of her life, made her a mythical figure in Sacramento long after her death.

Many voyagers to California came to remake their lives, abandoning their past on the trip westward. Cherry de Saint Maurice was so successful in erasing her past that her real name is still unknown. Official reports estimated her age at thirty-five or thirty-seven when she died, but one account claimed she was twenty-nine. She may have grown up in the Midwest, either near Madison, Wisconsin, or in a small town in Illinois. According to Cherry, she was married

Cherry de Saint Maurice, queen of the Tenderloin. *Sacramento Public Library.*

at sixteen and had a son in Chicago and was renounced by her mother, a society matron, and her former associates in the Midwest thought she was dead. Other reports claimed her child in Chicago was a daughter, and that she never married. She owned a large doll that she cradled like a living child, suggesting that she abandoned a child whose absence she mourned deeply. Even accounts of her ancestry vary; newspaper reports described her as German or Irish. On her 1910 census form, Cherry claimed she was born at sea, that her father was French and her mother from Kentucky, and that she was married and twenty-two years old (she was probably closer to thirty). She was known for exquisite style, wearing the latest fashions and expensive jewelry. Cherry came to Sacramento in 1903 as a chorus girl in a traveling production of the musical comedy *Floradora* and left the company to work at Fanny Brown's Palace brothel on Second Street.[53]

In November 1907, Cherry purchased an elegant two-story brick home at 327 L Street equipped with ten bedrooms and a full basement, just a few steps from the enormous Weinstock & Lubin department store at Fourth and K Streets, across L Street from the Nippon Theatre, future home of the Eureka Club. She named her parlor house the Cherry Club and decorated it in sybaritic splendor, with artwork, cut glass, silk draperies, paintings of nudes and silver jewel cases. She hired a talented young pianist, Sadie Harris, to play in her parlor. The club even had telephone service and was listed in the city directory as Main 543.

This phone number also pointed toward a mysterious clue to her past. In April and May 1907, the *Sacramento Union* carried a classified ad offering a generous reward for the return of a heart-shaped diamond locket with a chain with the words "To Cherrie from Will" engraved on the back and a photo of a child inside, lost near 327 L Street, the address of the Cherry Club. The advertisement asked the potential finder to call Main 543, the Cherry Club's phone number, if the locket was found.[54]

The Cherry Club was an immediate success; it became a rendezvous for prominent Sacramento citizens and was well known throughout California as an elegant, fastidious resort. Success gave Cherry a reputation as the wealthiest woman of the Sacramento tenderloin. The business of prostitution paid the bills, but Cherry's own intellectual prowess made the Cherry Club something greater—a salon where she discussed the life of the underworld with ministers, priests and elected officials. She was described as an astute, educated and well-read woman, and her library was filled with books on economics and contemporary social issues along with the classics, and she could debate and defend her positions with authority and vigor. With the Cherry Club located only eight blocks from the State Capitol, Cherry appeared several times before Governor Hiram Johnson to protest his signing of the Grant-Bohnett Bill, a state law intended to ban red-light districts and legal prostitution in California. Her defense of legal brothels was based on the trade's dangers, as an outright ban would drive the business underground, exposing prostitutes to even greater peril. Because many legislators and other public officials were also her customers, she held a dim view of politicians who moralized in the capitol by day and patronized the tenderloin resorts by night. In her own words, as quoted in the *Sacramento Star*: "I am going to stay with the game long enough to beat the people who are trying to close up houses such as mine throughout the state. I am going to fight them to a finish, the hypocrites!"[55]

Progressive reformers in other cities fighting the "social evil" shut down their red-light districts. The Chicago Levee closed in 1911–12, and the Barbary Coast and Storyville shuttered in 1917. Reformers in Sacramento, including Commissioners Luella Johnston and Charles Bliss, saw the elimination of the "social evil" in Sacramento as a method of civic promotion; they assumed that the migrants flocking to California cities like Los Angeles bypassed Sacramento based on the city's perceived status as a center of vice and sin.[56]

While Cherry advocated for the right to pursue her profession, she also recognized its dangers, brooded over the fact that many women in her

In 1907, Cherry de Saint Maurice purchased this stately residence at 327 L Street to serve as the Cherry Club, an exclusive parlor house. She maintained a residence on the first floor. *Center for Sacramento History.*

profession died by violence and feared that she would be murdered. Women working in brothels were exposed to multiple dangers and had little control over their own lives; they were often referred to as "inmates" in newspaper accounts. In February 1909, twenty-four-year-old Cherry Club employee Sadie Harris killed herself by drinking carbolic acid. Harris was a skilled musician who came to Sacramento as a pianist, apparently escaping her marriage to a much older man in Fairfield. Originally the Cherry Club's piano player, she later transitioned to prostitution. The reasons for her suicide were never clear, but a postcard discovered in her room suggested that her family or friends in Fairfield had discovered her true profession. She had told them she was working in a Sacramento hat shop, and the shame of the revelation could have driven her to suicide. Coincidentally, nearly twenty years earlier, 327 L Street had previously been utilized as a brothel, and Emma Strasheimer, an employee there, also committed suicide via carbolic acid on November 9, 1889, after an argument with her lover, Harry Morris, a San Francisco piano player.[57]

In 1909, Cherry became involved with John Francisco, also known as Rufus M. Francisco, a manager at the Nonpareil department store, in a stormy relationship that combined business with their personal lives. On February 20, 1908, Francisco was arrested after assaulting Cherry, smashing furniture and windows in the Cherry Club and then attempting

to escape by running up K Street. Francisco was fined fifty dollars, but Cherry refused to press charges for the assault, stating that she still loved him despite his violent actions. Francisco left the department store business in 1908 to operate Oak Hall, a bar and resort on Riverside Road just north of Sacramento's present-day Pocket neighborhood, next to a turn in the Sacramento River still known as Oak Hall Bend. He renamed the bar the Francisco Inn. Francisco may have encountered financial difficulties after being severely burned in August 1909 in an acetylene explosion, as he announced the sale of the business in October of that year. Cherry purchased the bar from Francisco and the surrounding thirty-four acres of land from Manuel Silveira in 1910. She kept the Oak Hall name and hired Francisco as manager. In early 1911, Francisco accused Cherry of drawing fraudulent checks on Oak Hall's business account, taking advantage of his status as business partner. Cherry fought this accusation, claiming that she was the owner and Francisco was an employee, and she had the right to withdraw funds from the account. Francisco left Sacramento not long afterward with the fraud case still pending.[58]

The year 1911 was trouble-filled in Cherry's life. In addition to the fraud charge, burglars twice attempted to break in and steal her jewelry. In August, E.F. "Slim" Johnson was sentenced to five years in prison after he was caught stealing jewelry from Cherry's bedroom. In October, four police officers engaged in a gun battle with Asaichi Iwasaji, a former cook at the Cherry Club who broke into the club's basement to steal Cherry's jewelry. Iwasaji was apprehended and imprisoned.[59]

Advertisement for Oak Hall, a roadside resort operated by J.M. Francisco and later sold to Cherry de Saint Maurice. *Sacramento Public Library.*

On July 18, 1911, Cherry took a trip to the Tahoe Vista Hotel in her cream-colored Packard touring car, driven by her chauffeur James Smith. Her blonde curls, low-cut lace dress and high-heeled patent leather shoes with rhinestone buckles made an impression on the residents of the remote mountain resort. She made the drive to invest in the newly announced Tahoe Vista subdivision, purchasing a lot for a new summer home on the northwest shore of Lake Tahoe. However, while the hotel and casino established for the Tahoe Vista community were economically successful, the real estate venture did poorly. Other potential purchasers learned Cherry de Saint Maurice's profession and became hesitant to build family homes adjacent to one of California's best-known madams.

More trouble arrived in October 1911, when fifteen-year-old Warde Meister, son of a prominent Sacramento family, went on a joyride to Oak Hall and four other clubs in Sacramento's suburbs. Meister was already considered a juvenile delinquent by the Sacramento courts, but his well-regarded family name resulted in probation instead of a jail sentence. Warde violated his parole, taking his parents' car and two teenage friends, Ida McClure and Josie Baginstock, on a wild ride that ranged from Oak Hall all the way to a Folsom roadhouse, reportedly drinking several beers at each location. On October 19, owners of all five clubs, including Cherry, were arrested by the Sacramento County sheriff for selling liquor to minors.

The other four resort owners pled guilty to the charge, paying a $150 fine, but Cherry chose to fight. Her attorney accused the court of negligence, failing to keep juvenile Warde Meister under control, and stated that Cherry, the owner of the resort, should not be held responsible for her employee's actions in serving to minors. The local superior court judge found Cherry guilty, recommending a jail sentence of several months. Cherry appealed the charge to the California Supreme Court based on her express instructions to employees regarding serving minors and whether it was possible to contribute to the delinquency of a teenager who was already clearly a juvenile delinquent. The hearing was scheduled for the summer of 1913, but tragedy intervened.[60]

On July 8, 1913, Cherry failed to respond to repeated knocks on the door to her private chambers. Workmen who arrived to install new carpet received no response in person or by telephone, and a messenger from a local bank also got no response. Cherry was known to sleep late and was careful about her privacy, so her failure to wake was not considered unusual. When four of Cherry's employees returned to the club that afternoon from their daytime errands and theater visits, the housekeeper, Sadie Johnson,

informed them that Cherry could not be roused. At about 5:30 p.m., Cherry Club employee Cleo Sterling volunteered to peek into Cherry's bedroom window from outside the house. She fell back and screamed at the sight of Cherry's lying face down on the floor, nude and obviously dead.

Police and the coroner arrived within minutes, drawing a crowd of several hundred people. Police inspectors and coroner W.F. Gormley investigated the room, discovering that money and jewelry were missing. Gormley concluded that Cherry was strangled from behind, breaking her neck, evidence of the culprit being someone with enormous strength. Newspaper accounts even compared the strangulation to those depicted in Edgar Allen Poe's "The Murders in the Rue Morgue." Gormley also found bruises and scratches on her forearms, evidence that she had fought the burglar. Her beloved doll was also found face down next to her body. The robber had gone through a few drawers, but not thoroughly enough to find all of Cherry's jewelry, suggesting a hurried exit. The only immediate clues were a piece of tape found underneath her body and a few fingerprints, which were recorded by Officer Max Fisher of the city's police identification bureau. The house porter, Eddie Aoki, was also questioned.[61]

The *Sacramento Bee, Union* and *Star* prominently featured the story of Cherry's murder for days, and the story was carried in many California papers and throughout the nation. Some suspected revenge by a Cherry

News of Cherry de Saint Maurice's murder drew a crowd outside the Cherry Club; note the tower of the Weinstock-Lubin department store at the upper right, indicating the proximity between the "tenderloin" and Sacramento's largest department store. *Sacramento Public Library.*

Club patron in response to a blackmail threat. Others suspected ex-partner J.M. Francisco, who had returned to the Cherry Club a few days before the murder. Eddie Aoki was suspected because of the earlier attempt to rob the club by Assaichi Iwasaji, based on the assumption that they were both Japanese, and a journalist's claim that the strangulation suggested "Jiu-Jitsu manipulations." Cleo Sterling, who had peeked into Cherry's window, claimed Cherry received two male visitors earlier that day, traveling salesmen whose identities she did not know.

After only two days, Cleo Sterling's account of the events around the time of the murder began to fall apart. Aoki informed police that he saw Sterling leave Cherry's quarters with two men, Sam Raber and Jack Drumgoole. Raber was a handsome, dark-haired and brown-eyed Sacramento café entertainer whose repertoire included female impersonation. His career in Sacramento had hit a dead end; he was fired from a job at the Oriental Café at Third and K Streets because he was too insistent for tips. He was reportedly a "pimp and opium fiend," fond of wearing a ten-dollar gold piece with a diamond chip in the eagle's eye as a pendant. Drumgoole was a prizefighter from Chicago; he was not enormous at five feet, ten inches, and 180 pounds, but he was known for his strength. Years of fights left him with a broken nose and a noticeable facial scar; he was considered a "third-class" fighter. Raber met Drumgoole in Reno and brought him to Sacramento to arrange cash fights for him, although Drumgoole had not boxed professionally in two years. A crucial piece of evidence was found in Raber and Drumgoole's residence at the American Cash Apartments on Eighth Street. The tape found under Cherry's body was also found in Drumgoole's belongings—it was the same sort of tape used by boxers to tape their fists before a match. Both men left Sacramento in a hurry on the day of the murder.[62]

A statewide manhunt was announced, but Governor Hiram Johnson refused to post a reward for their apprehension, perhaps relieved that he would no longer be subjected to angry visits from Cherry. The police announcement mentioned that Sam Raber's skill at female impersonation meant he might have left Sacramento disguised as a woman, and that he was an opiate addict. Police held Cleo Sterling for questioning as other witnesses revealed that she was Sam Raber's lover and lived with Raber and Drumgoole at their Eighth Street apartment. She caused a stir in court, calling the other witnesses liars, before being returned to jail.

On July 10, a boxer thought to be Drumgoole was arrested in Colfax, suggesting that the pair had headed in opposite directions, but the boxer arrested in Colfax was A.C. Johnson, another prizefighter of similar hair

Cleo Sterling, employee of the Cherry Club, was involved in a relationship with Sam Raber and devised the plan to rob her employer. *Center for Sacramento History.*

color and build. Two days later, Cherry's funeral was held at Gormley's Funeral Parlor at 720 H Street. Her quick burial may have been due to a flood of hundreds of applicants at the county morgue who wished to view Cherry's dead body. Dr. S. Fraser Langford preached a sermon warning of the dangers of prostitution: "The doors are practically barred to the woman who seeks to escape from a degrading life of streetwalking. The avenues of commercial and social life are closed to her." He suggested turning the Cherry Club into a rescue home for women who wanted to leave the life of prostitution. Meanwhile, police bulletins about Drumgoole and Raber circulated the state.[63]

On July 15, Katie Oliver of Broderick announced that she believed she was Cherry's daughter, citing their physical resemblance, and that her mother, Cheryal Doone, had signed her name "Cherry." She had not seen her mother in fourteen years, as she had abandoned the family when Katie was five years old. Despite her claim, Oliver denied that she was interested in Cherry's estate, estimated at about $50,000 in property and jewelry. Two pictures of children were found in Cherry's personal effects, and neither of them bore a resemblance to Katie Oliver. Cherry's

Sam Raber, the nightclub musician accused of murdering Cherry de Saint Maurice. *Center for Sacramento History.*

property included the Cherry Club, the land and the buildings at Oak Hall, fifty acres on the Haggin Grant (which rapidly became the suburb of North Sacramento) and properties in Lake Tahoe in addition to jewels and artwork.

A few days later, another claimant emerged, the famous actress Anna Held, lover of Ziegfeld Follies impresario Florenz Ziegfeld. According to a statement by Held's attorney, "In 1911 when Miss Held played in Sacramento, Cherry called on her in her private car and said, 'You are my only heir…I shall leave everything I have to you.' She told Miss Held that her mother was a sister of Miss Held's father." She briefly attempted to claim Cherry's estate, but when it became apparent that Cherry's debts on still-mortgaged properties exceeded their resale value, Anna Held dropped the claim.[64]

Stories related to Cherry's murder continued for weeks, including a theory that her beloved doll might contain a fortune in jewels. A woman on Twentieth Street told a reporter that she dreamt Cherry's last will and testament was hidden in the doll, but investigators found neither jewels nor a will. A search of Cherry's safety deposit box revealed diamond rings, jewelry

Jack Drumgoole, professional boxer and Sam Raber's roommate, whose powerful hands broke Cherry de Saint Maurice's neck. *Center for Sacramento History.*

and insurance policies. On July 25, burglars ransacked the Cherry Club while a night watchman assigned to guard the building was at lunch.

On July 27, Jack Drumgoole and Sam Raber were arrested in a San Diego pawn shop. After two weeks hiding in the Sibert Hotel in San Diego, Raber, who had sewn Cherry's jewelry into the lining of his coat, attempted to sell a pendant with a tiger's head and a diamond in its mouth, apparently not noticing that "Cherry" was engraved on the back. The operator of the pawn shop reported this to the police, who arrested both men. A day later, Raber confessed that he and Drumgoole had robbed Cherry but stated that he did not murder her. They planned to knock her unconscious and then steal the jewelry and only learned the next day that she died. On the night of the murder, they borrowed corks from a nearby bar to disguise their faces with burnt cork, hoping to be mistaken for Black men. Neither admitted to the murder, but Raber admitted that he tied her up with boxing tape while Drumgoole held her still. Cherry begged them to spare her life, crying, "Take all I've got, boys, but don't kill me! God bless you." Raber also wrote a nineteen-page poem about the crime while awaiting arraignment.

As details of the crime emerged, Cleo Sterling was identified as the planner and instigator of the robbery. She previously conspired with Drumgoole and Raber to rob Dr. H.E. Wright. The Wrights briefly fostered Sterling in their M Street home, so she knew where their valuables were kept. Jack and Sam secretly gained access to the Wrights' keys and made wax impressions, surveyed the house and prepared to break in, but the key they made did not work, so they gave up and returned without the jewels. Sterling berated them mercilessly, accusing them of cold feet, and then began planning to rob her employer. She suggested that they disguise themselves as Black men using burnt cork and helped Raber apply a false moustache and goatee. After Sterling let them into the Cherry Club early on the morning of July 8, they knocked on Cherry's door, claiming they were messengers. Cherry, apparently having just emerged from the bathtub, answered the door nude. The two men seized and overpowered her. While Raber went after the jewels, Drumgoole strangled Cherry, apparently planning to do so only until she passed out, but Cherry desperately fought to escape Drumgoole's grip. The fighter's hands crushed her throat, killing her. Raber assumed she was unconscious, and the two left with the jewels. Raber called Cleo Sterling later that day to inquire about how seriously Cherry was injured, but Sterling reported that Cherry was dead. The two quickly left for Vallejo, shipping the jewelry to Salt Lake City, and later had the package forwarded to them in San Diego.[65]

Raber, Drumgoole and Sterling were each charged with the murder of Cherry de Saint Maurice. As the trial date approached, Raber claimed that Drumgoole had killed Cherry, in part out of concern for Cleo Sterling after learning she was also charged with the crime. His cooperation did little, as there was already copious evidence against him. Drumgoole insisted he knew nothing about the murder at all, but police accounts suggest he was a very bad liar.

IN THE INTERIM, THE pending fraud suit by Francisco and the appeal of the Warde Meister case were both heard and were dismissed due to Cherry's death. On September 11, the furnishings of the Cherry Club were sold at auction at W.A. Mackinder's storefront at 618 J Street. Auction items included paintings (including a reproduction of *September Morn* by Paul Chabas), a phonograph, manual and player pianos, furniture, champagne and Cherry's beloved doll. The auction drew a huge crowd, including eager bidders and the merely curious. The auction raised nearly $5,000. No mention was made of the purchase price of the doll. With no clear

A print of *September Morn* by Paul Chabas was one of many of Cherry's possessions sold at auction after her death, including player pianos, furniture, jewelry and her life-size doll.

heirs to claim the funds, the money and Cherry's property—including land in North Sacramento, near Lake Tahoe, Oak Hall and the Cherry Club itself—went to Sacramento County.

In October 1913, all three trials concluded. Jury instructions included the stipulation that "If two persons actually engaged in the robbery of another person, by agreement, and during the commission of the robbery the victim is killed by either of them while in the actual commission of the robbery, the other being present, aiding and abetting in its commission, it makes no difference who actually did the killing. Each is responsible for the death and under the statue each is guilty of murder in the first degree." The fingerprints found at the scene matched those of Raber and Drumgoole; this was the first time this new forensic technology was used in Sacramento. On this basis, and due to the testimony of multiple eyewitnesses, Raber and Drumgoole were both found guilty of murder. Cleo Sterling, who had planned the robbery but was not present when Cherry was killed, was acquitted. Jack Drumgoole was sentenced to life in prison, and Sam Raber was sentenced to death. Sterling stayed in contact with Raber after his sentencing. She left

Sacramento and traveled to Oakland, Portola and Reno, sending him letters and money. Despite an affidavit signed by Jack Drumgoole admitting that he killed Cherry De Saint Maurice, Raber was hanged on January 14, 1915. Raber's funeral was held in Gormley's Funeral Parlor, the same location where Cherry's memorial service was held, and he was buried in St. Joseph's Cemetery. Cherry's body was buried in the Odd Fellows Cemetery on Riverside Boulevard, up the road from her Oak Hall resort. Drumgoole died of tuberculosis in San Quentin in 1920. The former Cherry Club, renamed the Lion Hotel, was destroyed in a fire on June 21, 1938, and Oak Hall was demolished in 1949. Cherry de Saint Maurice remained a well-known figure in Sacramento many years after her death, even if later accounts sometimes sanitized her profession as "entertainer" instead of "madam."

4

FROM PROSTITUTION
TO PROHIBITION

*I*n the wake of Cherry de Saint Maurice's life and death, the Grant-Bohnett Bill (the Red Light Abatement Law) became law in 1914. In October 1913, Sacramento's city commissioners voted to close all of the resorts of the Sacramento tenderloin, in part due to the publicity and notoriety of the Cherry Club. The Bliss Ordinance was updated to close saloons between 1:00 a.m. and 6:00 a.m. and prohibit the sale of liquor to anyone under twenty-one. The new ordinance also limited the height of booths in saloons to four feet, preventing them being used for sexual encounters. In the following months, a few of the more notorious resorts closed, including Frenchy Lapique's resort at 1021 Second Street and Fanny Brown's Palace, but others continued operation or moved to new locations.[66]

True to Cherry's statements about "red light abatement," prostitution did not vanish with the change in policy; it merely hid farther from the law, and madams were often replaced by male pimps with fewer scruples about legality and safety. Some of these men, including Italian immigrant Joe Fuski, seemed to validate vice crusaders' "white slavery" narrative, which often claimed that the men most responsible for drawing young women into prostitution were generally Southern or Eastern European immigrants. In this way, the antiprostitution campaign was linked to efforts to curtail immigration.

New legal tools intended to limit prostitution, including the Mann Act, were often used to enforce racial norms and eugenic ambitions. As the

United States entered World War I, Progressive efforts to limit prostitution changed focus from the salvation of women from abduction and "white slavery" to medical isolation of sexually promiscuous women in the name of social hygiene and preventing venereal disease. Law enforcement methods developed to fight prostitution were also utilized to enforce alcohol prohibition, the last great Progressive cause, personified in Sacramento by Special Agent Daisy Simpson.

KITTY NISETICH: MURDER OR SUICIDE?

Immigrant families arriving in Sacramento often settled in the West End, meaning that the children of these families frequently grew up in the shadow of the tenderloin, and their lives intersected with its dangers. Immigrants Lawrence and Katherine Nisetich arrived in the United States in 1897 from Mirca, Croatia, with their children, Frank (born in 1886), Kitty (born in 1893) and Tony (born in 1896). Lawrence died shortly after their arrival in San Jose, and Katherine brought her children to Sacramento around 1903, where Frank found work as a butcher (giving him his lifelong nickname, "Butch") and Tony and Kitty enrolled in school. In Sacramento, they joined a small community of Croatian immigrants, generally known in Sacramento as "Slavonians." Tragedy struck the family on March 20, 1907, when Tony drowned in the Sacramento River at age ten; despite the posting of a reward, his body was never found. In 1908, Katherine married Pellegrino Gabrielli, an Italian winemaker who also owned the Gabrielli Hotel at 118 L Street.[67]

KATHERINE NISETICH, beautiful young Sacramento woman, whose body was found in the Sacramento River yesterday and identified last night, and over whose death there is a deep mystery.

Katherine "Kitty" Nisetich dreamed of a career on the stage, but it was cut short by scars from surgery on her throat, which she concealed with a black choker. When she was found drowned in the Sacramento River, investigators debated whether she was murdered or committed suicide. *Sacramento Public Library.*

Young Frank grew up in the West End and became involved in its underworld; he was part of a group (described as "nine Greeks and Americans") arrested in Serra Hall in

February 1915 for gambling. Kitty dreamed of a career on the stage and was well-known for her beauty. She suffered respiratory problems, and surgery to address these issues left her throat scarred; in photographs, she wore a black choker around her neck, possibly to disguise the scar. In September 1915, tragedy again struck the Nisetich family. Kitty disappeared after telling her family she planned to visit the Panama-Pacific Exposition in San Francisco. On September 24, Kitty's body was found floating in the Sacramento River near X Street, dressed only in a chemise and underskirt, near the site where Tony drowned eight years earlier. Her body was weighted down with a three-foot piece of steel rail attached to her waist by a steel cable.

Police initially investigated Kitty's death as a murder, but other evidence pointed to suicide. She was in love with J.C. Monohan, a railroad fireman, but her family wanted her to marry Anthony Chargin, a local liquor dealer; Kitty reportedly threatened to kill herself if she was forced to marry him. According to Frank and her half-sister Edith Gabrielli, Kitty had threatened suicide before, including attempts via poison and an attempt to cut her own throat. Two weeks prior to her death, her other half-sister Elizabeth walked with Kitty near the spot where Tony was drowned along the Sacramento River near X Street. Indicating the river, Kitty said, "I am going to jump in there and they will never find me." Just before leaving, her neighbor, Mrs. Matroni, asked when Kitty would return. She replied, "I don't think I will ever come back."[68]

The coroner initially concluded that her death was a suicide, supported by stories from friends and relatives of her melancholy brought on in part by frustrated ambitions for an acting career. A grand jury was convened to investigate unanswered questions that pointed to possible foul play, including what had happened to the rest of Kitty's clothing. An anonymous tip to the Sacramento district attorney's office alleged that Kitty was murdered and that a ring given to her by Anthony Chargin was stolen before Kitty's death, with the money from the ring's sale divided between her mother, her half-sister Edith and the anonymous caller. This caller also alleged that Kitty's sister and mother had found her in a "Greek house of ill repute" and could not convince her to leave.

Newspaper reports regarding the grand jury differed; reporting in the *Union* leaned toward suicide, while the *Bee* claimed the evidence pointed toward murder. The grand jury concluded that suicide was unlikely because Kitty, of delicate stature (she weighed only 112 pounds) and with known health problems, did not seem physically capable of handling the sixty-pound rail and heavy steel cable that weighed down her body. Anthony Chargin

According to witness testimony, Kitty Nisetich had a relationship with Ed Mehner, the bridge tender of Northern Electric's M Street bridge, shown here while open around 1915. *Center for Sacramento History.*

also told the jury that Kitty claimed an unidentified woman had threatened her life; further testimony revealed that this woman was the wife of Edwin D. Mehner, tender of Northern Electric's railroad bridge at M Street. Edith Gabrielli testified that she had seen Kitty being hugged and kissed by a man in the bridge-tender's tower, raising the question of a possible love affair with Mehner. Edwin Mehner testified that Kitty discussed a plan to commit suicide by jumping into the river with a weight attached to her body. He thought she was joking, but Kitty mentioned that she previously tried to kill herself with sleeping powders and preferred to vanish in the river so nobody would find her body.

Subsequent testimony by Chargin revealed that another woman had threatened Kitty, Mrs. J. Petrovich, after Chargin had knocked down her husband for insulting Kitty. According to Chargin, Mrs. Petrovich swore revenge on Kitty for the assault, but a police inquiry concluded that the threat was not serious. After extensive testimony and often contradictory evidence, the grand jury finally concluded that there was not sufficient direct

evidence of murder to continue and left the matter officially unresolved. Frank remained convinced that his sister was murdered.[69]

In the wake of Kitty's death, Frank's gambling continued; his next arrest occurred at Jake Zemansky's club at Third and K Streets in December 1916 during a mass raid involving more than twenty people. Zemansky protested the arrest to the press. "Why pick on us?" he asked, "I fail to see why they should pick on me when Chinatown and these other places are allowed to run." Ironically, the *Union* reported the arrest of Chinese drug distributor Wah Kim Gee on the same day half a block from Zemansky's club. The story of Kitty Nisetich is an example of the interconnected and often contradictory nature of the West End; rumors of Kitty's involvement with prostitution provided fuel to reformers' beliefs that young women in desperate situations were frequently led into the life of the *demi-monde* by unscrupulous and dangerous men.

THE DIGGS-CAMINETTI MANN ACT CASE

In 1909, Congressman James R. Mann of Illinois introduced a bill titled the White Slave Traffic Act, or the Mann Act. The bill was principally authored by Chicago Progressive organizer and attorney Edwin Sims. In Chicago, home of the infamous Levee district and much national Progressive organizing intended to limit prostitution, Sims coordinated Secret Service agents and federal marshals in a raid on the Chicago Levee in 1908, enforcing the Immigration Act of 1907, which forbade importing women into the United States for the purposes of prostitution and mandated deportation of women arrested for prostitution within three years of immigration. Sims's crusade against prostitution combined Progressive hostility to immorality with racial nativism; he once declared, "I am determined to break up this traffic in foreign women....It is my sworn duty, and it should be done to protect the people of the country from contamination." To Sims, this "contamination" referred equally to sexually transmitted diseases and many European immigrants.

The Mann Act applied the Immigration Act's regulation to travel between states by triggering a federal response via the Interstate Commerce Clause. A new branch of the Department of Justice, the Bureau of Investigation (later known as the FBI), investigated violations of this act. The act stated that anyone found guilty of transporting a female across

Jack Johnson defeated James Jeffries, the "Great White Hope," on July 4, 1910. This Reno match was covered via radio and telegraph updates throughout the nation, including in Sacramento. Johnson became the scapegoat in the nation's first major Mann Act prosecution. *Center for Sacramento History.*

state lines for the "purpose of prostitution or debauchery, or for any other immoral purpose" be fined up to $5,000 and sentenced to up to five years in prison. While the text of the law did not specify that the women must be white, its formal name, the White Slave Traffic Act, implied the racial characteristic of the law.

The first application of the Mann Act in criminal prosecution was used against African American boxing champion Jack Johnson in 1912. Johnson was initially accused of kidnapping Lucille Cameron of Milwaukee; Cameron's mother was upset that her daughter was dating Johnson, but the investigation fell apart when investigators discovered that Cameron came to Chicago three months before she met Johnson, and in December 1912, Johnson and Cameron were married. Investigators later located Belle Schreiber, a former companion of Jack Johnson. Her testimony, including statements about an October 1910 trip from Pittsburgh to Chicago "for the purpose of prostitution and debauchery," became the basis of a Mann Act case against Johnson, who was arrested on November 7, 1912. The following May, an all-white jury found Johnson guilty. He was sentenced to one year and one day in federal prison. Johnson responded by leaving the United States; he did not return until 1920, when he surrendered himself to police

and served his sentence. This sentencing and exile also sabotaged Johnson's boxing career and cost him his championship title. Prosecution of Johnson seemed motivated by his marriage to a white woman, especially considering that his relationship with Belle Schreiber began before the Mann Act became law, making his prosecution *ex post facto*.[70]

The second prosecution under the Mann Act brought national attention to Sacramento. In March 1913, two young Sacramento debutantes, Marsha Warrington and Lola Norris, were reported missing. Warrington was twenty years old and Norris was nineteen, both from prominent Sacramento families. The suspects in their abduction were two married men, architect Maury Diggs, age twenty-six, and his friend, clerk Farley Drew Caminetti (commonly known as "Drew"), age twenty-seven. Both men also came from prominent families; Drew's father was Anthony Caminetti, former member of Congress and recently appointed U.S. Commissioner General of Immigration. Maury Diggs's father, I.P. Diggs, was a successful contractor based in Berkeley, and his uncle, Marshall Diggs, was a former California state senator and partner in the Thomson-Diggs Company, a major California hardware distributor. In 1911, Maury Diggs had designed the Thomson-Diggs Hardware warehouse at Third and R Streets, along with his business partner Clarence Cuff, before taking a position as California State Architect.

Despite the fact that he was married and had a child and a respectable career, Maury Diggs had a reputation in Sacramento as a wild man, and he had an arrest for forgery on his record. Warrants were issued for both men after witnesses reported that Diggs made bank withdrawals and Drew resigned from his job, and an eyewitness account reported that both men and both women were seen at the Saddle Rock restaurant (owned by City Commissioner Ed Carraghar) at 11:00 p.m. the night before their disappearance. On March 14, all four were located in Reno, Nevada, in a bungalow on Cheney Street. Diggs attempted to conceal their identity, claiming his name was Enright when two police officers arrived at the bungalow's door. The officers replied, "Your name may be Enright, but you are in wrong." In response to this terrible pun, Diggs broke down and admitted his identity, and the police took all four into custody.[71]

During the summer of 1913, a San Francisco federal grand jury prepared to try Maury Diggs and Drew Caminetti under the Mann Act. Their politically powerful families made efforts to influence federal officials to drop the case; on June 21, John McNab, U.S. District Attorney of Northern

Lola Norris, sketched in court by Artist Packer of The Call's staff, and photo of bungalow in Reno, Nev., in which Diggs-Caminetti party was arrested

Lola Norris, as sketched for the *Sacramento Union*, and the bungalow in Reno where Drew Caminetti and Maury Diggs brought her and Marsha Warrington, triggering a Mann Act prosecution after they crossed state lines. *Sacramento Public Library.*

California, resigned his position after Attorney General James Clark McReynolds ordered him to drop the case. According to reports in the *San Francisco Call*, McReynolds was pressured to delay the trial until Anthony Caminetti himself could personally defend his son, and McNab reported that friends of the defendant had boasted that the case was fixed. The political pressure of McNab's resignation forced the issue of prosecution, which proceeded in August 1913.[72]

Marsha Warrington, who had made efforts to shield Diggs from suspicion during police questioning, gave minimal responses in court, but Lola Norris provided more complete and direct answers. Norris testified that she met Drew in the summer of 1912 and Diggs the following October. The four took several trips to San Francisco and San Jose during the course of their relationship, and Diggs and Drew had convinced the two women that the trip to Reno was necessary because they had been found out, and their wives had threatened to name both women as accessories in an abandonment suit. Diggs's defense attorney challenged whether the prosecution was a violation of the Mann Act, because the women were not brought across state lines for purposes of prostitution. McNab's resignation and the sensationalism of a Mann Act prosecution resulted in national attention to the trial; all parties involved were now on a national stage and documented in newspapers, films and photographs. On September 17, 1913, Diggs was sentenced to two years in prison and ordered to pay a $2,000 fine; Drew was sentenced to eighteen months and fined $1,500. Both men appealed the case all the way to the U.S. Supreme Court, which initially denied the petition, but in the end the case was heard and upheld. The Diggs-Caminetti Case created precedent that the Mann Act need not be used solely in cases involving prostitution. After conviction, Drew worked on his family's Amador County ranch until his death in 1945. Diggs and his wife divorced, but he remarried (to Marsha Warrington) and moved to Oakland. His reputation as an architect in Sacramento was ruined, but he continued designing buildings in the Bay Area, including Oakland's Fox Theater and the Bechtel Building. The Diggs family initially lived in the Bechtel Building, but Maury still had a trace of his old wild streak; he lost their Bechtel apartment in a card game and had to move to a smaller home on Lakeshore Avenue.[73]

RED LIGHT ABATEMENT AFTER THE CHERRY CLUB

In Sacramento, the state Red Light Abatement law proved more effective than the Mann Act, even if new brothels opened as soon as old ones closed. By the spring of 1914, less than a year after Cherry's death, the Cherry Club was reopened as an African American–operated bar and lodging house. In November 1915, another local madam, Carmen Grey, was evicted from her previous establishment by her landlord, grocer A. Schaden, because the red-light law made him liable for a brothel operated on his property. Police realized that Grey relocated to the Cherry Club when neighbors reported that her talking parrot, a well-known pet, was spotted outside. The Cherry Club, which had been sold to Frank Shields at the county auction, was later sold to Dr. T. Wah Hing, a Chinese physician, who leased the property to Carmen Grey, who reopened the building as a brothel. District Attorney Hugh Bradford filed notices to Grey, Dr. Hing and the Sacramento Bank, carrier of the loan for the Cherry Club property, in December 1915, but the wheels of justice turned slowly in this case.

On March 15, 1916, the city commission held a large public hearing about gambling and prostitution based on claims that Commissioner Gustavaus Simmons, whose responsibilities included the police department, was allowing prostitution to run rampant and selectively enforcing gambling laws. Initially scheduled for a hearing in city hall, the meeting was relocated to the Clunie Theatre due to concerns by the city's vice committee about enormous crowds; the two-thousand-seat theater was filled to capacity. Police chief Ira Conran reported on efforts undertaken to limit prostitution, including sixteen brothels closed since he took office, increased prosecution of streetwalkers and a dramatic increase in fines for gambling—from $535 in the six months prior to his administration to $2,435 in the following six months. When asked if gambling continued in Sacramento, he replied, "I don't know it of my own personal knowledge, but if I was a betting man, I would bet there was."

A.B. Casey, a private detective hired by the vice committee, described many brothels, cribs and parlor houses where potential customers could select a woman from the house's upstairs windows or in the main parlor, including dozens of active brothels and repeated solicitation by streetwalkers. He witnessed one policeman tell a streetwalking prostitute to "get off the streets or she would get him in trouble," implying that her presence outside a brothel might draw attention to his lack of enforcement. She replied, "Go soak your head!"

Chief Conran also stated that he was aware that Carmen Grey now operated the former Cherry Club but claimed the property was simply a rooming house, stating, "No complaint has been made to me about the house, and it is run orderly so far as I know." Conran accused the vice committee of "making a mountain out of a molehill," defending his own efforts at red-light abatement. No clear conclusion was reached, but the *Union* reported that "the Clunie theater last night saw one of the best shows that was ever staged in the building, and the crowd was the largest that ever jammed into the structure."

In January 1918, Judge Charles Busick finally ordered the former Cherry Club property closed for a period of one year. By this time, citywide efforts had pushed prostitution farther underground, driven in part by concerns from U.S. Army requirements that cities near army bases limit the spread of venereal disease. Cities that failed to address military concerns risked being declared "off limits" to military personnel. Wartime efforts so sufficiently suppressed prostitution that no brothels reopened in the Cherry Club site after Carmen Grey's eviction; it became the Lion Hotel, a Japanese boardinghouse.[74]

Originally painted around 1900 for a brothel in Winters, California, this painting, known as *Stella*, was purchased by a West Sacramento bar owner in 1915 and was located there during Prohibition, when the bar became a speakeasy. *Kevin Winter collection.*

By late 1918, state officials expressed the opinion that Conran's and Simmons's efforts at driving prostitution from the city were almost too effective. Dr. W.H. Kellogg, of the State Board of Health, reported that:

> *The driving away of these women by Commissioner Simmons and Chief of Police Conran is contrary to the wishes of this board.…The program to which this department pledged its support did not call for a general exodus of women of the underworld, but rather it was desired that knowledge of their whereabouts be secured, that examination might be made of such women, and those having venereal disease segregated and sent to the hospital for treatment. The State Board is co-operating with the War Department in combatting this disease and preventing its spread. We lose sight of the moral issue involved for the time being. The Social Welfare Committee looks after that.…What can we accomplish in the way of protecting the soldier and civilian if the scarlet women are driven from one community to another? Our work is state-wide in its nature, and such a scattered process would daily serve to spread the disease.*

Efforts by military authorities to contain prostitution as a means of disease control reflected a shift from the "moral panic" approach of Progressive antivice activists to the seemingly more "scientific" approach of eugenics. The story of Joe Fuski seemed to validate both "white slavery" fears and the racial theories of eugenicists.

KING OF THE TENDERLOIN, JOE FUSKI

The death of Cherry de Saint Maurice and the end of official tolerance of prostitution in Sacramento created opportunities for dangerous men, just as Cherry predicted. Joe Fuski, an Italian immigrant born around 1885, was a well-known character in the tenderloin. He worked as a building contractor but had a life in the underworld as a con artist. In November 1914, he was arrested for fighting in a downtown dance hall with John Farrell. Both were taken to the police station and arraigned for twenty-five dollars bail each. Fuski immediately pulled a large roll of bills from his pocket and paid his bail. Fuski turned to Farrell and asked, "How about you?" Farrell indicated he had no money, so Fuski handed over another twenty-five dollars to pay his former combatant's bail. The two left the courthouse on far friendlier terms.[75]

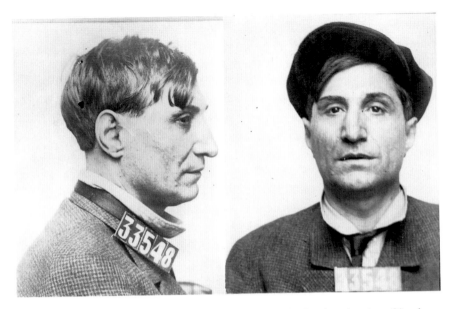

Joe Fuski, an Italian immigrant, filled the power vacuum left after the toleration of legal prostitution ended in Sacramento. Fuski's case became fodder for eugenics advocates calling for strictly limited immigration from Italy and many other countries. *California State Archives.*

Between 1916 and 1918, Fuski established several brothels and cribs in Sacramento, in the old tenderloin and in a road house on Lower Stockton Road, just as the city of Sacramento was enforcing the Red Light Abatement Law. Fuski quickly acquired the title "King of the Tenderloin" due to his brothels and the political influence he was able to wield among voters in the waterfront neighborhood. In a Sacramento courtroom, Jean Lapique, a Southern Pacific employee attacked by Fuski at Second and L Streets in 1918, described Fuski as "the most notorious character in this part of the country and well known operator of houses of prostitution"; Fuski was acquitted because Lapique reportedly started the fight. Lapique, also known as "Frenchy" Lapique, was the operator of a brothel at 1021 Second Street that closed in the wake of the Cherry de Saint Maurice murder; he accused the City of Sacramento of selective enforcement of the Red Light Abatement Law.[76]

On September 6, 1918, police raided seven brothels in the alley between Second, Third, L and M Streets. Twenty-one women were arrested in accordance with War Department efforts to limit prostitution via medical quarantine. The women arrested reported that they were assured protection from city police by Joe Fuski, but the raid was conducted by Sacramento

County sheriff's deputies in conjunction with state and federal authorities. Wartime scrutiny meant bribes to local officials were less likely to protect brothels and their workers.[77]

In December 1919, Sacramento deputy district attorney Clifford A. Russell brought indictments against Joe Fuski and Steve Svetnich, an employee of the Rosemount Grill, based on the testimony of Esther Greeley, a sixteen-year-old from San Francisco who had come to Sacramento and arrived at the Art Dance Hall, where she was solicited to work as a prostitute by Fuski's procurer Joe Costello. Greeley's testimony provided sufficient basis for warrants against Fuski, Svetnich and Costello. District Attorney Russell was confident that this case was strong enough to defeat the new King of the Tenderloin, and indictments were filed on December 10, 1919. After the men were arrested on the day of their indictment, Fuski was able to post bail, although at a steeper cost than what he paid after his 1914 fistfight—$10,000 for himself and $5,000 for Svetnich.[78]

At the trial, held on January 12, 1920, Joe Costello testified against Fuski in an account dramatic enough that Fuski responded with "words not fit to print." Esther Greeley, who worked under the alias Peggy O'Neill, told "the story of her downfall and how she had been inveigled into living a life of shame in houses on K Street leased and operated by Fuski." She also detailed how financial transactions between Fuski and the operators of each resort worked and how she read the financial transcripts to Fuski, who was illiterate but could count.[79]

Despite the testimony of Greeley and Costello, Fuski was acquitted thanks to two jurors, George DeMartini and Angelo Marino, who refused to convict. The *Sacramento Union* reported the names of these jurors, alleging that their shared Italian heritage must have been the reason for their insistence on acquittal. District Attorney Russell was aware that DeMartini was a gambler well known in nightlife circles, and allowing him to remain on the jury was a risk, but he had already exhausted four of his five peremptory challenges and knew that other potential jurors might not be able to be counted on for a conviction.[80]

Shortly after the trial, a grand jury was convened to investigate the circumstances of the Fuski trial and ascertain if bribery was involved in the decisions of jurors DeMartini and Marino. The grand jury quickly discovered that DeMartini and Marino both knew Fuski, despite having claimed they were not personally acquainted with him, and both men were prosecuted. A second trial was scheduled and subject to multiple delays, including one delay for Fuski's bladder surgery and an attempted

change of venue when Martin Welsh, Fuski's attorney, claimed Fuski could not receive a fair trial in Sacramento County due to publicity surrounding the case. During the second trial, two jurors reported that former city dogcatcher John Martin, a friend of Fuski, approached them and asked them to hold out against conviction. At the second trial, the jury returned after only five minutes, and Fuski was found guilty on February 26, 1920.[81]

Joe Fuski entered San Quentin State Prison on March 8, 1920, and was discharged on August 8, 1922. In the aftermath of the Fuski trial, the district attorney's office declared "open season" on other alleged resorts and brothels in Sacramento, setting dates for the closing of a dozen properties, with most of them located in the former tenderloin. Commissioner Charles Bliss used the Fuski case as part of a larger campaign to advocate for another new city charter, known as a "council/manager" system, with at-large councilmembers and a professional city manager instead of elected commissioners. By associating the continued toleration of vice with political bosses like Ed Carraghar and connecting them in the public mind with figures like Fuski, Sacramento's Progressive leaders hoped to sway the voting public to support charter reform. Brothel closures and convicted procurers provided evidence of a social problem and demonstrated the effectiveness of Progressive solutions.[82]

During Fuski's term in San Quentin, State Senator Edwin E. Grant, author of the Red Light Abatement Law, became involved in Fuski's case. Using his political influence, Grant was able to ensure that Fuski was deported to Italy shortly after his discharge from San Quentin. Grant, an advocate of eugenics, used Fuski as an argument for stricter immigration laws from nations outside of northern Europe. In an essay titled "Scum From the Melting Pot," Grant argued that "Continental standards regarding womankind generally differ considerably from those America has inherited from Britain. Violators of such laws are largely Mediterraneans....A systematic deportation not only eugenically cleanses America of a vicious element but the moral effect upon their native countries makes deportation of offenders, in an international sense, doubly worthwhile." Grant's racist language also reflects the negative stereotypes of Italian immigrants, often perceived as dangerous anarchists or sinister criminals like Joe Fuski, that were prevalent during the 1920s.[83]

OFFICER DAISY SIMPSON, UNDERCOVER AGENT

The Red Light Abatement Law became an effective tool to close houses of prostitution, although it required patience in its application. The Art Dance Hall at 223 L Street had a longstanding reputation as a center of vice and a recruiting site for brothels long before Esther Greeley's testimony in the Fuski trial. In March 1918, court proceedings began against the Art and its owner Charles Gibney, stating that "said premises were and now are used for purposes of lewdness, assignation, and prostitution," beginning the first effective use of the Red Light Abatement Law to close a dance hall in California. The case was appealed, and the hall did not close until December 1919, but Joe Fuski's arrest and Greeley's testimony were enough to permanently close the Art.[84]

To prosecute, investigators required proof that a building was used for prostitution. This evidence was obtained by special investigators like Daisy Simpson. Born in Dayton, Washington, in 1890, Simpson had a wild youth in San Francisco and Los Angeles, struggling with alcoholism and opiate addiction that culminated in hospitalization and a suicide attempt in 1917. This experience was enough to change the course of her life, and she decided to use her intimate knowledge of the underworld to serve the cause of justice. In late 1917, after recovering from addiction and a self-inflicted gunshot wound, she joined the State Law Enforcement and Protective League and became an investigator. Based in San Francisco, she started her career investigating Sacramento brothels in January 1918. To secure evidence, she posed as a sex worker seeking employment under the name Daisy Sinkins, then filed complaints against brothel proprietors. One of her first successes was the closure of the Casino Dance Hall, which had been in operation since 1879. Almost immediately, her past caught up with her when defense attorneys revealed elements of her sordid history to discredit her testimony. Judge Peter Shields was unconvinced by the defense attorney, and subsequent judges also utilized her testimony based on her expertise with the underworld. Other Sacramento resorts closed with the help of Simpson's testimony included the Apex Hotel, Marble Hall, Yosemite Rooms, Arcego House and many known solely by address. As her reputation grew, she frequently used disguises and costumes to avoid detection. Despite the obvious hazards of this occupation, Simpson was resourceful, fearless and unrelenting in her task.

From 1918 to 1920, Agent Simpson focused her efforts on fighting prostitution, but when the Volstead Act and statewide alcohol prohibition

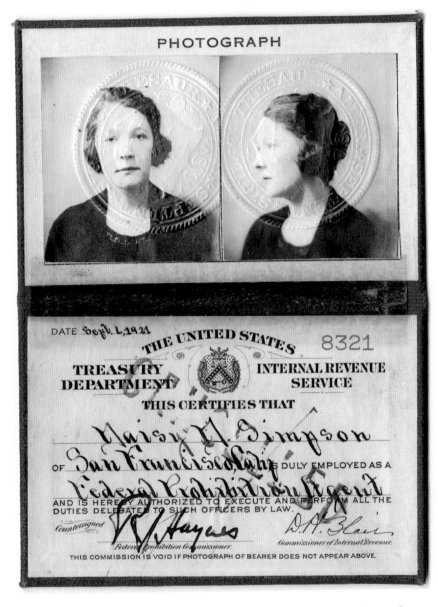

Federal identification card of Daisy Simpson, special agent who infiltrated houses of prostitution in Sacramento before transitioning to enforcement of alcohol prohibition. *National Archives.*

laws went into effect, her skills were just as useful for sniffing out speakeasies. This undertaking was often riskier than investigating brothels. On October 6, 1921, Agent Simpson entered a restaurant at 517 K Street owned by John Stratis, who was suspected of serving alcohol, and ordered a drink; when the drink was delivered, Simpson called to her partner, Agent G.H. Crawford, to arrest the waiter. A cook, Mike Kurmnolis, heard the disturbance and entered the dining room with a revolver, ordering Crawford to release the waiter; Crawford managed to wrench the pistol away from Kurmnolis and apprehended both men.[85]

After 1921, Simpson was reassigned to San Francisco. She continued her career and was involved in multiple hair-raising escapes and gunfights until 1926, when she relapsed into opiate abuse and, after being arrested for narcotics possession, attempted suicide a second time. Daisy Simpson retired from law enforcement and managed a motor lodge outside Sausalito until her death in November 1940.[86]

THE BOOTLEGGING BOXER

*I*n the 1920s, the careers of many Sacramento restaurant owners came into contact with Prohibition. George Dunlap was trained in Southern Pacific's dining-car department, but his career changed after his arrest for smuggling liquor into Oregon, leading to him establishing his own restaurants. Ancil Hoffman's business enterprises found success where the West End entrepreneurs of the preceding two chapters encountered resistance, allowing him to transition from restaurants and entertainment to boxing management and, later, local politics. Restaurant and theater owner Yusuke Nishio crossed boundaries as necessary for economic success, leasing space in his theater to African American social clubs, offering Chinese food in his Japanese restaurant to satisfy American palates and serving bootleg sake during Prohibition. Japantown also had its own speakeasies, which were sometimes associated with a mysterious organization called the Tokyo Club. As Sacramento's Nisei generation matured, some fell in love with jazz and found their own musical voice—which often meant leaving the United States behind.

SCREEN NEWS

The 1920s were a boom period in Sacramento. The exuberant economy of the era led to dramatic growth and prosperity. The city's skyline sprouted

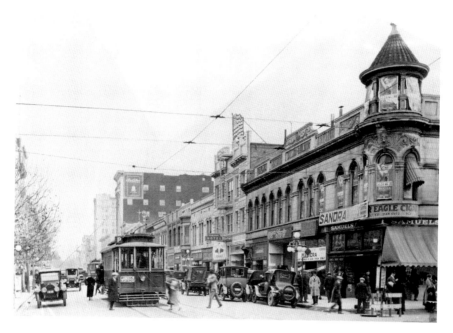

The Schlitz Café, one of Ancil Hoffman's bars, was located at 708 K Street in the middle of this block. Hoffman managed boxer George Lee from an upstairs office. *Center for Sacramento History.*

its first skyscrapers, including the California Fruit Building, the Cal-West Insurance Building and the Elks Building. Streetcar suburbs sprawled in all directions, following new attractions like Del Paso Park, William Land Park, the California State Fairgrounds and Joyland. Alcohol prohibition shut down Sacramento's wineries and breweries, at least officially, except for production of "sacramental" and "medicinal" alcohol and "near beer." These exceptions resulted in dramatic increases in wine consumption for spiritual purposes, enormous numbers of prescriptions for those suffering from excessive sobriety and several varieties of "near beer" that were nearer to beer than the law allowed.

During this heady era, Sacramentans had another reason to be optimistic, as Hollywood came to Sacramento for a decade. Riverboat movies were a fad of the 1920s that drew movie producers to Sacramento as they hoped to simulate the Mississippi River in a location closer to Hollywood and with a more agreeable climate and notoriously lax enforcement of Prohibition. Sacramento's chamber of commerce was eager to capitalize on the moviemaking boom, promoting Sacramento via local initiatives,

national campaigns and *Screen News*, a magazine intended to promote filmmaking in Sacramento. The Sacramento Chamber of Commerce pursued film production companies, convincing them to open in or relocate to Sacramento.

Screen News, which was distributed at Sacramento movie theaters, combined movie listings, gossip and photos of Hollywood stars with articles about the suitability of Sacramento as a site for filmmaking and movie production. In print from 1922 until 1927, *Screen News* advertised local restaurants, hotels, music schools and clothing shops, along with construction and supply companies of all sorts that might be useful for filmmakers seeking sets, props, actors, musicians and so on.

Screen News also ran advertisements for Buffalo Beer despite its publication during Prohibition. Some breweries survived Prohibition by manufacturing soft drinks or low-alcohol "near beer," but the *Screen News* advertisement is specifically for bock, a strong beer with a high alcohol content, which was difficult to brew as a low-alcohol "near beer." Other advertising in *Screen News*, aside from semi-legal beer ads, included show times for motion pictures, burlesque and vaudeville theaters.

Many issues of *Screen News* featured a column called "A Message to the Housewives of Sacramento" by contributing editor John Henshall—a title that suggested household hints or family advice. The column's real subject matter consisted of racially charged warnings about the growing presence of Japanese in the United States. Claims about their rising population numbers and high birth rate, the impossibility of their assimilation into American life, the poor health of their people and their potential to steal jobs by undercutting labor prices were common subjects for each column. The proposed solution was exclusion and expulsion. Advertisements on the page with the "Housewives" column were primarily meat markets owned by non-Japanese, with ad copy such as, "The Only American White Meat Market West of Seventh Street" and "Mr. Dealer: You don't have to buy your fish from Orientals!" The reasons for disguising these poisonous diatribes as advice for housewives, or for their inclusion in a cinema publication, are not known.[87]

GEORGE DUNLAP: A RESTAURATEUR TRIES THE WHISKEY TRADE

George Thomas Dunlap was a lifelong Sacramentan whose culinary skills took him many places, including on a short trip outside the law. Born in 1884, he was the son of Isaiah Dunlap, a lieutenant of the Sacramento Zouaves. George grew up at 1525 Fourth Street, and during his childhood, he transferred from a predominantly white neighborhood school to the Colored School on Ninth Street. According to Dunlap, "I chose the colored school because I wanted to be loyal to my race."

George Thomas Dunlap left school after the fourth grade to help take care of his family. He developed culinary skills early in life, once saying, "There were six in my family, and I was the one who stayed home and did all the cooking." He found jobs hauling fertilizer to Chinese vegetable farms south of Sacramento and as a vegetable dealer at a wholesale market on Fifth Street. As a young adult, he began work for Southern Pacific Railroad

George Dunlap operated several restaurants in downtown Sacramento, including one in the ground floor of the Capitol Hotel on the southwestern corner of Seventh and J Streets. *Author's collection.*

as a "red cap" porter and started payments on a house lot in Oak Park. In 1907, at age twenty-three, he brought his new bride, Anna Louise Butler, to their new home on Fourth Avenue. His daughters, Audrey and Doris, were born in 1908 and 1912, respectively, and two of Anna Dunlap's nieces came from Oakland to live with the Dunlaps during World War I.

After rapidly rising through the ranks, Dunlap became headwaiter and then chef on Southern Pacific's fleet of private cars, serving as the private chef for the Sacramento Division superintendent. Providing service to the private cars, which were used to carry railroad executives and elite visitors, including elected officials, required the highest level of culinary skill but may not have been regular enough to require Dunlap's full-time attention. In 1917, following the advice of Southern Pacific supervisor J.T. Brennan, Dunlap opened his first restaurant at 621 J Street and a summertime concession stand at the California State Fairgrounds but continued working for Southern Pacific. According to Dunlap, his restaurant received interracial trade, although some white customers were uncomfortable dining in African American–owned restaurants—to the point where many restaurants were segregated, and others even advertised their exclusive employment of white kitchen staff.[88]

Dunlap's employment with Southern Pacific ended shortly after an incident in February 1919 when he and his brother Walter, also a Southern Pacific employee, were accused of smuggling whiskey into Oregon. Prohibition had not yet gone into effect throughout the United States, but Oregon was already a dry state. Also charged were J.B. and Michael Mazzucchi (owners of a liquor store at 1110 Second Street), J.A. Nichols, J.W. Botts and Emil Becarri. According to federal agent J.W. Towns, whiskey purchased from Mazzucchi's store was delivered to the Dunlap brothers, who smuggled it aboard a private car for delivery to Botts and Becarri in Cottage Grove, Oregon. In addition, a witness reported that the Dunlaps had previously transported whiskey concealed in bales of hay. However, the case was dismissed because the indictment read that the whiskey was transported into Washington when it should have read Oregon. Despite a newspaper report that the indictment would be refiled, the charges were apparently dismissed. However, Dunlap left Southern Pacific's service a few months later in July 1919. Whether his employer's suspicions regarding the smuggling incident or the increased demands of his restaurants were the cause of his departure is unknown.[89]

George Dunlap closed his J Street restaurant in 1921 to operate the dining room of the Capitol Hotel at Seventh and K Streets. This enterprise

failed after only one year, but Dunlap had other resources. Utilizing his Southern Pacific experience, George secured a contract to operate dining cars on Sacramento Northern Railroad, the electric interurban that ran from Chico to Oakland via Sacramento, and a diner onboard the *Ramon*, the ferry used to carry Sacramento Northern's trains across Suisun Bay. This contract lasted until Western Pacific acquired Sacramento Northern, and the company replaced Dunlap with Western Pacific dining car staff.[90]

In 1930, Dunlap opened the restaurant that, along with his California State Fair concession stand, became his mainstay: Dunlap's Dining Room, located in his Oak Park home. Dunlap knew that he had to attract a white customer base even if it meant potentially alienating local Black customers, whose access to Dunlap's was limited in order to avoid deterring white customers. This survival strategy was critical for economic success in Sacramento due to the limited size of the African American community. The combination worked, and Dunlap's became a Sacramento culinary institution for decades. As an African American businessman, he initially had difficulty establishing a white clientele in downtown Sacramento. After abandoning his short-lived experience as a bootlegger, George Dunlap became a respected restaurant owner, welcoming Sacramento diners to his family's living room.

ANCIL HOFFMAN, THE BOOTLEGGING BOXER

Born in Kellerville, Illinois, in 1884, Ancil Hoffman became one of Sacramento's most recognizable civic and business figures. His father, Albert Hoffman, moved their family to Oklahoma, where Ancil's mother died, and then to Sacramento in 1890. Albert Hoffman opened a saloon at Seventh and E Streets, and Ancil attended elementary school at Union Primary School two blocks away on G Street, along the eastern edge of China Slough. Ancil quickly became fascinated with Sacramento's city life, including Chinatown (alongside the old slough) and the old city jail at the foot of I Street. He sold copies of the *Sacramento Bee* on K Street and even befriended the newspaper's publisher, Charles K. McClatchy.

In a 1941 interview with the *Sacramento Bee*, Hoffman claimed that he participated, with a team of local boys, in a baseball game against the Boston Bloomer Girls, an all-female baseball team, at an exhibition game held on October 31, 1897, at Snowflake Park (at Twenty-Ninth and R Streets). At

this game, Ancil met one of the Bloomer Girls, Nellie Bly.[91]

As a teenager, Ancil returned to Oklahoma with his father to operate a trading post. By the start of the twentieth century, Ancil had an adventurous spirit and athletic skill despite his small physical size. When the Boston Bloomer Girls, the women's baseball team he met in Sacramento, came to Oklahoma in 1905, he was reunited with his friend Nellie Bly and secured a job as the team's equipment manager. While he was traveling with the Bloomer Girls, the third-base player fell ill, so Hoffman donned bloomers and a red wig and played in her absence for several games. The uniform, wig, some judicious padding and Ancil's small stature (five-foot-one and 105 pounds) successfully disguised his gender. After his travels with the team, he returned to Oklahoma but was dissatisfied by frontier life. He asked his father whether he should move—Kansas City or Sacramento—and his father advised a return to Sacramento. Ancil hopped a freight train headed west.[92]

Ancil Hoffman in a boxing pose, circa 1910. Standing five feet and one inch tall and weighing 110 pounds, Hoffman had a reputation for throwing a fearful punch. He transitioned from boxing to business with great success. *Center for Sacramento History.*

Upon his return to Sacramento, Ancil worked for his uncle, Henry Hoffman, at Henry's Sixteenth and M Street grocery store. Along with a friend named Sheehan, young Ancil made money by rolling a wheelbarrow to the Southern Pacific shops, filling it with discarded ice from refrigerator cars, and selling the ice to local saloons. Once these saloons learned where Ancil obtained his ice, they turned to more reputable local ice companies, but it gave Ancil his first experience with entrepreneurship.

Ancil met the members of the Sacramento Athletic Club at Sixth and M Streets (relocated in 1909 to the Meister Building on Ninth Street between I and J Streets) and became interested in boxing, trading in his baseball cap (and bloomers) for boxing gloves. Despite his small size and short stature, Ancil threw a terrific punch and had a great fighting spirit. He had some success in boxing, including the knockout of a local boxer known as "Two-By-Four," but it was not a lucrative career, as boxers were paid by taking up a collection from those in attendance at the match. According to Hoffman,

his boxing career ended after landing a knockout punch so severe that local officials were afraid Ancil had killed his opponent. The officials revoked his boxing license, leading Ancil to claim he was the only boxer ever banned from the sport for hitting too hard.[93]

In 1906, Ancil opened his first bar, the Ancil Hoffman Saloon, at 1801 M Street. In 1910, he opened a second saloon, the Schlitz Cafe at 708 K Street, featuring live entertainment, and drawing some of the top acts of the ragtime era, including Al Jolson, who was just starting his career. In 1912, he leased the northwest corner of Tenth and K Streets to open a new café, intending it to be the showplace of Sacramento. The Ancil Café opened on December 4, 1912, with a bar finished in Circassian walnut, inlaid with mother of pearl and ebony, a dramatic fireplace and leather-upholstered booths. The Ancil also received an all-night saloon license, permitting liquor sales around the clock.

Ancil's nightclub and restaurant at 514 K Street was originally called the Hof Brau, but the name proved unpopular after the start of World War I, so he held a contest to rename the restaurant. The winning name was "All-American." The preferred brand at Ancil's bars was Schlitz, which was shipped by the carload from Milwaukee. When Schlitz was not available, Ancil substituted with Buffalo and Gilt Edge beer supplied by his friend Frank Ruhstaller. His decision to rename the Hof Brau "All-American" to avoid prejudice against Germans during the war represents a form of enculturation common in the early twentieth century and is representative of Progressive social practice. Adaptation from European tradition to the American way of life—the "melting pot" of American culture—often meant discarding past cultural connections. In this sense, becoming "American" was synonymous with becoming white. The opportunity to become white was available to a limited subset of immigrants, primarily those from Northern and Western Europe, and in special situations, such as women entering the West End Club. Ancil's whiteness also provided him with an opportunity to draw those customers to his own club via entertainment previously limited to Black audiences by order of the city commissioners.

Ancil's travels during his youth exposed him to entertainment and ideas from around the country, and his proximity to the resorts of the tenderloin and the West End may have facilitated connections with local and touring musicians. As an ambitious entrepreneur, Ancil wanted the latest in contemporary music in his nightclubs. The first mention in the *Sacramento Union* of "jazz" in a nightclub setting are advertisements for the All-American Café in 1919. The music of the West End, which had

been a subject of earlier controversy and civic prohibition, became the all-American music of Sacramento's entertainment district. Where previous efforts to breach the color line with a new Black music form failed due to racial restrictions on public dances, Ancil succeeded. This was not Ancil's first experiment with live music, but his previous efforts had met with greater resistance.[94]

ANCIL'S FLOATING DANCE HALL

In response to the ragging controversy of 1912–13 and the temporary ban on the sale of alcohol at dance halls within city limits, Ancil Hoffman found a unique solution. By renting a two-deck riverboat, he created a floating loophole in the city's dancing laws. Hundreds of revelers, each paying a fifty-cent fare for admission, gathered at the Sacramento city wharf in May 1913 to board Ancil's floating palace. The lower deck featured a dance floor with an orchestra, where, according to the *Sacramento Union*, "the raggiest of modern music" was performed. The upper deck featured tables and chairs, an ice cream and sandwich stand and a bar. Riverboats departed at 8:00 p.m. for a four-hour trip upriver to Smith's Mound, returning to the Sacramento docks at midnight. Reportedly, the ice cream stand did little business, but the bar was very busy. With the riverboat technically located outside the city limits and on the border between Sacramento and Yolo County, dancing and drinking were combined on board despite a uniformed chaperone wearing a Sacramento sheriff's deputy badge. His duties were limited to occasional taps on the shoulder to limit too-enthusiastic dancers from engaging in "rough dancing," which was prohibited by a sign posted on the dance-floor level of the riverboat.

Ancil's riverboat had a short life, ending its excursions in June 1913, when authorities realized that the liquor was sold using a federal liquor license but without a county license. Because the craft departed from and arrived at the Sacramento docks, it was under Sacramento County's jurisdiction. Public outcry against the riverboat swayed county authorities to close the loophole that Hoffman's floating dance hall had sailed through during the spring of 1913, but as summer arrived, the loophole closed.[95]

THE CHEESE SANDWICH CONTROVERSY

In 1916, the Sacramento city commission, led by Commissioner Charles Bliss, launched an investigation regarding the liquor licenses in Sacramento restaurants. Holders of the Class "A" restaurant liquor license, the most common and least expensive license, were required to serve food in addition to alcohol; it was not permissible to order a drink without ordering food. The dangers of failing to provide food with drinks were outlined in a *Union* article titled "Barbary Coast Revived in Hof Brau," which connected Hoffman's saloons with the dangers of the tenderloin:

> *Bawdy women of the street mingle with foolish girls, some not yet out of their teens, in a long narrow room on K street under the Trow Hotel, where Ancil Hoffman, Sacramento saloon keeper, conducts the Hof Brau cafe, modeled after relics of the worst days of San Francisco's Barbary Coast. Spirituous liquors, as cheap as five cents a glass, make the conditions the more favorable for the professional prostitute and "landlady" to obtain influence over the young school and working girls of Sacramento, whose character, though weakened by parental carelessness, is not yet marked with actual vice. Hoffman has a class A restaurant liquor license. He is supposed to sell liquor only with meals, or by a loose interpretation of the law with only food of some kind. Instead- he openly and flagrantly makes his sales without as much as a cracker accompanying- the liquor. Beer is sold for five cents a glass, the same price that obtains in most Sacramento bar rooms. Waiters do not solicit the purchase of any eatables with the drinks.*[96]

Ancil Hoffman of the Hof Brau (prior to it being renamed the All-American Café), Andy Mikulich of the Peerless Café and George Lucich of the Rosemount Grill were called before the city commissioners to explain their actions. Hoffman claimed that most of the Hof Brau's patrons ordered food and had no intention to violate the law, but it was written in a confusing manner and easy to misinterpret. Andy Mikulich stated that other Class A holders were violating the ordinance, and he did the same based on their precedent. George Lucich denied that the rules had been violated in his restaurant. City commissioners reported that the Hof Brau posted placards stating that drinks would not be served without meals, but no efforts were made to uphold the placards' requirements.

The commissioners shifted the discussion to define what constituted a bona fide meal in a restaurant. After some discussion, the commissioners

decided that the bare minimum definition of a "meal" was a cheese sandwich: if the customer got two pieces of bread with a slice of cheese in between, that satisfied the requirement of the regulation. While Commissioners Bliss and Ed Carraghar called for the enforcement of the law as it existed, the other commissioners agreed that the regulation as it stood was too open-ended and required revision by the city commission.[97]

THE L STREET ARENA AND GEORGE WASHINGTON LEE

Ancil Hoffman retained his interest in boxing even after hanging up his gloves, becoming the boxing commissioner of the Sacramento Athletic Club in 1910 and serving as matchmaker for the club's boxing events. In 1916, the Sacramento Athletic Club lost its building on Ninth Street, and a theater was erected on its site. In response, Hoffman joined forces with

The L Street Arena, "the House of Action," was located behind storefronts on L Street between Second and Third Streets. This former warehouse had a seating capacity of more than three thousand people. *Center for Sacramento History.*

Fred Pearl of the Pastime Athletic Club and purchased a warehouse on L Street between Second and Third Streets. The 160-by-140-foot warehouse-turned-arena was on the alley, directly adjacent to the notorious Art Dance Hall, and located behind the Douglass Improvement Club's original 209 L Street location. By late 1916, the L Street Arena was in operation and hosting boxing matches. Hoffman's palace of pugilism had a capacity of 3,300 people—bigger than the largest theaters in Sacramento.[98]

Boxing was a sport that crossed the color line in American society. Jack Johnson's powerful fists smashed that line in 1908 when he became the first African American world heavyweight boxing champion. His "Fight of the Century" against James J. Jeffries, the "Great White Hope," on July 4, 1910, in Reno, Nevada, drew worldwide attention, and the defeat of Jeffries in that historic match triggered race riots in many American cities. In Sacramento, tensions were high, but according to contemporary news accounts, the fight did not trigger violence in Sacramento. At the local level, boxing advertisements for the Sacramento Athletic Club and the L Street Arena show many interracial matches.

Already an experienced matchmaker, Hoffman began managing boxers, using his 708 K Street restaurant building as a management office. His first boxer was George Washington Lee, born in 1900, a California native of Chinese and Mexican ancestry. Lee's family moved from San Francisco to Sacramento after the 1906 earthquake. Lee grew up in Sacramento and worked as a shipping clerk before picking up boxing gloves and fighting his first match against "Kid Blondie" at eighteen years old. Legendary boxer "Gentleman Jim" Corbett, former world heavyweight champion, wrote about Lee in 1920, praising Lee's potential as a young, up-and-coming fighter. Corbett described Lee's first gymnasium bouts as a sort of trial by fire:

> *Those first gymnasium battles in which George Washington Lee engaged were just about as tough as could be imagined. The white boys were out to knock all boxing thoughts out of the head of the Chinese youth—but they did not succeed. Lee fought back—and either held them even or whipped them. He was so successful that he decided to launch himself into a professional career.*

Lee's next obstacle was the resistance of fight promoters to accept a Chinese boxer in 1919 as anything other than a novelty act. As Lee's manager, Ancil Hoffman, an established promoter with his own arena,

George Washington Lee, born in San Francisco, became a professional boxer under the tutelage of Ancil Hoffman. He was known for his fighting spirit and became a popular "main event" boxer who toured internationally. *Author's collection.*

opened doors to the boxing world that otherwise might have remained closed. While many boxers of color were relegated to preliminary bouts at a boxing event, serving as an "opening act" for the headliner, Lee's boxing skill and Hoffman's business acumen turned Lee's matches into the "main event" and a popular audience draw in Sacramento and on the road.[99]

At Hoffman's recommendation, Lee wore traditional Chinese dress when entering the ring, and for promotional photos, he sometimes had a false Chinese pigtail taped to his head. This stereotypical Chinese costume was common practice in vaudeville, and Hoffman understood the value of showmanship. Hoffman's promotion of Lee's Chinese heritage made Lee uncomfortable, because he was proud of both his Mexican and Chinese ancestry. Even the nickname Hoffman devised for Lee, "Yellow Peril of the Prize Ring," both reinforced and lampooned Chinese stereotypes. These affectations helped promotion but did little to overcome the perception of Lee as a novelty. His transition to a main-event boxer came from his skill, speed and determination. While his fight record was not the greatest, his fighting spirit drew audience attention once he stepped into the ring sans Chinese robe and hat.

In 1921, Lee and Hoffman toured Asia and North America by steamship, with stops for boxing matches in the Philippines, Japan, China, Canada and Mexico, returning to Sacramento in early 1922. Because of his Chinese ancestry, Lee was forced to take extra precautions to return to the United States; the Chinese Exclusion Act required Lee to provide detailed proof of his American citizenship. To return to his home country, he provided a family biography, witness testimony and letters from Sacramento police chief Ira Conran and two other police officers testifying that they had known Lee since he was a child.[100]

In February 1924, Lee fought Filipino boxer Francisco Guilledo, better known as Pancho Villa, bantamweight champion of the world, at the L Street Arena. Lee had lost a match to Villa once before, during his steamship

tour, in Manila. The rematch in Sacramento was considered an exhibition match, but Lee again lost to Villa. The over-capacity crowd included a large number of Sacramento-area Filipino migrant workers who cheered Villa's victory and bought huge numbers of the match's commemorative programs. Lee continued his boxing career until 1927 and then retired from the ring, beginning a second career at the California state printing plant. He also followed Hoffman's example and managed prizefighters in the 1930s.[101]

Thanks to Hoffman's experience with entertainment venues, the L Street Arena was used for entertainment other than boxing. Because of its proximity to Japantown, the arena was sometimes used for Japanese sports. Some of the matches held at L Street featured jiujitsu and sumo wrestling and were sponsored by the Tokyo Club, a statewide network of Japanese-American gambling houses. In November 1921, the arena held a fundraising event for the Sacramento Fire Department Relief and Protective Association, reportedly the largest and most successful boxing benefit in the city's history. The participants, performers and contributors reached across racial lines; ticket sales were highest at the Red Front (a Portuguese bar), the Eureka Club and Harry Horimoto's cigar shop, which was located directly across L Street from the arena. In addition to boxing matches, the star attraction of the night was African American singer Ida Howard performing with Purcell's Jazz Orchestra. Howard also represented Oak Hall Café, Cherry de Saint Maurice's former roadhouse on Riverside Road, which was then under African American ownership. While Howard had performed in Sacramento before, the style of jazz she and the Purcell orchestra played were new to the boxing audience and very positively received. Howard was showered with tips from admirers in the audience during her performance and generously contributed the nineteen dollars and ten cents left on the stage to the relief fund, bringing the total to more than $1,300 (about $15,000 in 2019 dollars).[102]

HOFFMAN'S REAL ESTATE INVESTMENTS AND PROHIBITION

In 1915, Ancil received six avocado trees and planted them as ornamental shrubs until a friend noted that avocado trees produced a highly desirable

crop. Sale of the avocados from his yard proved so successful that he planted an orchard of two hundred avocado trees on a forty-acre ranch in Fair Oaks, where he already had an orange grove as the result of a 1913 real estate purchase. Sacramento was already sprouting new suburbs as a result of the breakup of the massive Rancho Del Paso in 1909 and the city's first suburban annexation in 1911. Hoffman saw the way that suburbs of Los Angeles and the San Francisco Bay Area were growing outward into their hinterlands—on property previously used for farmland—and realized that investments in agricultural land would eventually pay greater dividends as suburban tracts. His career as a farmer ended when a winter freeze killed his trees, but the land later became part of the suburban community of Fair Oaks.

> *When I bought a 40 acre ranch in Fair Oaks 60 years ago it was considered to be far out in the country. Houses were very scarce and it seemed like a long way out. But I always figured Sacramento would be a great city some day and owning property anywhere around the city was bound to pay off.*
> —*Ancil Hoffman, quoted in the* Sacramento Bee

More damaging than the loss of his orchard was the loss of his businesses with the coming of Prohibition. Two of his restaurants remained open, but his three bars and liquor distribution businesses disappeared overnight. Hoffman voluntarily returned his liquor licenses when the nation officially went dry but attempted to apply for a new license in April 1920 when rumors flew that the Supreme Court might overturn the Volstead Act. In 1919, he received multiple fines for selling alcohol in his restaurants. On March 1, 1920, *Union* columnist A.J. Waterhouse wrote a short poem following rumors that Hoffman would leave the United States for Cuba as a result of Prohibition:

CUBA'S WELCOME
It is reported that Ancil Hoffman may go to Cuba, and may there establish a saloon.
I Cuba might congratulate
If time were not so pressing,
But welcome, she, if we escape,
From Hoffman's style of blessing.[103]

On January 4, 1924, Ancil Hoffman was arrested along with one of his business partners, Fred Pearl, for violation of the Wright Act, California's alcohol prohibition law. Both men were accused of selling "intoxicating liquor" at the L Street Arena. A hearing for Pearl and Hoffman was scheduled on January 28, identifying them as "John Doe and Richard Roe," but neither man appeared in court, nor had they appeared at their arraignment four days earlier. The district attorney's response to this failure to appear in court was surprising; because the accused were not present, the court ordered that the indictment be dismissed on the grounds of insufficient evidence.[104]

Three days earlier, in response to Hoffman and Pearl's arraignment on January 24, the *Sacramento Union* had reported that District Attorney J.J. Henderson was asked to dismiss the charges by California state senator J.M. Inman, counsel for both men. Inman's evidence demonstrated that the soft-drink concession at the L Street Arena was not owned by Hoffman or Pearl but was in fact leased to R.A. Costello, who had claimed Hoffman and Pearl were the owners when the alcohol was discovered. Unlike the case of Cherry de Saint Maurice, in which the local court decided that as proprietor, Cherry was responsible for serving alcohol to minors, because Costello was a subcontractor, the property owners were not liable. (Inman was also the defense attorney for Sam Raber in the Cherry de Saint Maurice murder trial.) According to the *Sacramento Bee*, Costello was arrested for selling gin at the arena at the rate of twenty-five cents per drink. On the same day as Pearl and Hoffman's arraignment, *Bee* owner and editor Charles K. McClatchy's "Private Thinks" column included a cryptic passage referring to Prohibition:

Ours is the only government in history under which a citizen may appeal against the government itself, if that government tries to invade his civil liberty. The American is protected from tyranny by government through his ability to make appeal to the principles on which his government rests. Under the Eighteenth Amendment and the Volstead Act, individual rights have "gone glimmering," and there is no judicial protection thereof. On the contrary, any appeal in this matter is to the courts, based on the principles on which this government rests, would be futile.

For the Anti-Saloon League is the government.

And the rights of man are nil.[105]

McClatchy's stance against Prohibition was well known in Sacramento, leading some temperance advocates to criticize the *Bee* for encouraging violation of alcohol prohibition laws, but Hoffman's political power and influence, sufficient to enlist a California state senator as his defense attorney, cleared him of the alcohol sales charge. Hoffman also purchased the Nippon Theatre, home of the Eureka Club, on January 5, 1924, but maintained the building's tenants, implying a direct link between his own involvement with bootlegging and West End operators like Grant Cross.[106]

Hoffman became a full-time boxing promoter best known for his management of champion heavyweights Max Baer and Jacob "Buddy" Baer. In 1930, Al Jolson, who had performed at Hoffman's venues in Sacramento, invited Hoffman to Los Angeles to see Max Baer fight Ernie Owens. Hoffman was impressed with Baer's aggressive but theatrical style and offered to become his manager. The Baer brothers relocated to Sacramento and became the most legendary boxers of Hoffman's career.[107]

In a move that was perhaps an echo of Hoffman taping a pigtail to George

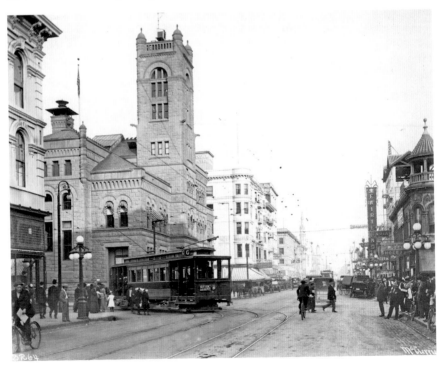

The stone post office at Seventh and K Streets was Sacramento's sole federal building; it served as an office for Prohibition agents in the 1920s. Despite their presence, there were reportedly multiple speakeasies within one block of the post office. *Center for Sacramento History.*

Lee, Hoffman added a Star of David to Max Baer's trunks when he fought German champion Max Schmelling, Hitler's favorite boxer, on June 8, 1933. Baer's grandfather was Jewish, but his family was Catholic, making the Star of David on his trunks a symbol of solidarity rather than faith. Hoffman's sense of theater—and both Hoffman and Baer's antipathy to racial intolerance—took precedent, and Baer's defeat of Schmelling in the ring that day symbolized resistance to racism. Hoffman retired from boxing management in 1942, having parlayed the funds generated from boxing matches into real estate in Orangevale, Fair Oaks and Citrus Heights. Those investments paid off handsomely in the late 1940s and early 1950s as suburban expansion leapt into eastern Sacramento County.[108]

In 1950, Hoffman was asked to take the place of Sacramento county supervisor Clarence A. Champlin, who died shortly after being elected. Hoffman accepted the position and won re-election three times. As a supervisor, he became interested in zoning and planning policy due to the county's explosive growth and was often at odds with the county's planning commission, which recommended against rezoning that would allow commercial development. In an interview with the *Sacramento Union*, Hoffman explained, "This can stop a lot of industry and business from coming to Sacramento, and you have to have industry to get tax support for the area." Hoffman began his second retirement in 1965, remaining active as a real estate developer, until his death on January 7, 1976. A Sacramento County park located on the American River in Carmichael was named in his honor prior to his death.[109]

We do not know how much inspiration Ancil Hoffman drew from the communities of color in the West End, but his actions reflected some of the attitudes of Sacramento's Black Progressives: an interest in civic reform and social progress, greater tolerance for the business of alcohol and dancing and a limited softening of racial boundaries in the name of economic opportunity.

YUSUKE NISHIO: A JAPANTOWN PURVEYOR OF FILM, FOOD AND BOOTLEG SAKE

Born in 1877 in Kanbara, Shizuoka Prefecture, Japan, Yusuke Nishio came to the United States in 1903. After first arriving in San Francisco, Yusuke and his wife, Nao (who came from Shimizu, Shizuoka, and followed Yusuke to the United States), moved to Sacramento a few months after the 1906

earthquake and fire in San Francisco. In 1907, he purchased a former secondhand store at 328 L Street, converting the ground floor to a movie theater named the Nippon and the upstairs area to a rooming house. The theater showed Japanese movies for the residents of Japantown and also showed American films as part of the Paramount motion picture chain.

On April 21, 1908, the Nippon caught fire. Early nitrate film stock was highly flammable, and the fire was pronounced to be the result of spontaneous combustion of the film. Fortunately, very few people were in the theater at the time, and there were no reported injuries. On the day of the fire, the Sacramento Board of Trustees mentioned the Nippon as part of a discussion about the safety of movie theaters. Despite concerns expressed by some trustees, Ed Carraghar vouched for the safety of the Nippon and supported a motion to give the theater more time to comply with the new safety codes. Only three months later, the Nippon reopened, fully repaired and modernized.[110]

As discussed in chapter four, the upstairs portion of the Nippon Theatre was rented to Grant Cross and William Snow in 1915. Prior to their tenure, and following the 1908 fire, the upstairs portion was divided into a rooming house for Japanese men and a billiard parlor, although some members of the public claimed it was a gambling parlor and house of prostitution. In testimony to the board of trustees, Police Chief William Ahern reported that no evidence of prostitution or gambling was present at the Nippon building despite repeated investigation by the department's Japanese translator. The Nippon Theatre was sometimes used for events other than films. On February 7, 1917, Professor G. Takahashi, middleweight champion of jiujitsu, bested Michael Athens, a Greek heavyweight champion of the style, during an event that also included an exhibition of kendo, a Japanese sword-fighting sport. Nishio had an interest in traditional Japanese athletics, and events of this sort helped maintain Japanese traditions in America.[111]

In 1921, Nishio sold the Nippon Theatre to Sentaro Mikawa, and in 1923, Nishio opened a restaurant, Wakano Ura, at 1224 Third Street, named after a beautiful scenic site in Japan. The menu at Wakano Ura included both Japanese and Chinese cuisine. This decision was based on his experience in San Francisco, where he saw white San Franciscans visiting Chinatown primarily to eat in Chinese restaurants. While Americans of the 1920s were mostly unfamiliar with Japanese cuisine, Chinese food was very popular. By offering menus featuring both styles, Nishio could introduce Sacramento diners to the cuisine of Japan after attracting them with Chinese food. His early menus featured both chop suey and sukiyaki, with Chinese

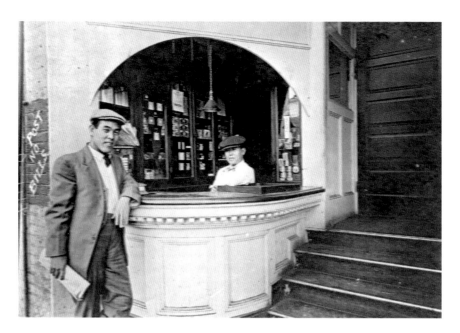

Yusuke Nishio (*left*) at the candy counter of the Nippon Theatre, circa 1915. *Priscilla Ouchida.*

items prepared by a Chinese cook and Japanese items by a Japanese cook. Eventually, diners became more familiar with Japanese styles. While both halves of the menu were based in their individual food traditions, they were also influenced by the availability of ingredients. Utilizing local produce became a way of improvising, creating a uniquely Californian cuisine based on the traditions of both immigrant communities—jazz for the palate.

During Prohibition, Wakano Ura served sake, Japanese rice wine manufactured on Sacramento River Delta rice farms and smuggled to customers in Sacramento. The basement at the Nishio home became a storehouse for bootleg sake. To avoid suspicion, Nao Nishio transported the bottled sake to the restaurant in a baby carriage. One day, Sakaye, the Nishios' second-youngest daughter, accompanied her mother to the restaurant. As they crossed the street, Sakaye noticed a police officer nearby. She was young but old enough to realize that the contents of the carriage were illegal. As Nao tried to navigate the buggy over the curb, the bottles loudly clinked inside. To Sakaye's horror, the policeman approached them as Nao struggled with the stroller. "Good morning, *mama-san*," said the policeman as he reached for the carriage. Sakaye briefly panicked, worried that her mother was about to be arrested for smuggling liquor. Instead, the

policeman helped Nao lift the carriage, clearly laden with loudly clinking bottles rather than a baby, up onto the curb, tipped his hat and continued on his patrol. After her panic subsided, Sakaye realized that the policeman probably knew perfectly well what was in the baby carriage but either did not care or was paid to look the other way.[112]

THE TOKYO CLUB

The Tokyo Club started as a loose network of Japanese-owned illegal gambling clubs that originated in San Francisco around 1910. In 1920, this organization consolidated into a statewide syndicate with branches in every major city on the West Coast, with its headquarters in Los Angeles, where California's largest Japantown was located. Gambling among the Japanese American community in Sacramento was controlled by the Tokyo Club and featured traditional Japanese games, including siko, gaham and bakape, all popular with Issei (first-generation) immigrants who had played these games in Japan, in addition to Western games like poker and blackjack. The Tokyo Club was a criminal enterprise, and the group's activities included kidnapping, extortion and murder, using violence and intimidation to force out competitors and ensure their organization's secrecy.

The Tokyo Club was probably involved in bootlegging and speakeasies; the taste of sake was an element of Japanese cultural tradition as much as a round of gaham and was perhaps welcomed by Issei gamblers as a reminder of their culture in addition to their recreational value.

The club also functioned as a charitable organization and informal bank, limiting criticism from law-abiding members of the community by funding events and cultural organizations—including sumo tournaments held at Ancil Hoffman's L Street Arena, the Sacramento *Taiiku* football team and kabuki theater—and providing student scholarships and relief for the poor. Because Japanese Americans were often refused loans at U.S. banks, the Tokyo Club filled a necessary (if extralegal) need for financing loans. As with other immigrant groups, racism was a frustrating barrier to economic success, and criminal organizations provided opportunity, albeit with legal and physical risk. Gamblers' desire to "strike it rich" filled the Tokyo Club's coffers, but as long as a proportion of those funds were returned to benefit the community, their existence was tolerated and kept private. The children of Issei immigrants, American-born Nisei, had little involvement with the

Sumo wrestlers at a tournament in Sacramento. The Tokyo Club sponsored annual sumo tournaments in Japantown—these were often held at the L Street Arena. *Center for Sacramento History.*

Tokyo Club except as recipients of its charitable donations. By the time they came of age, there were other avenues of opportunity.[113]

NISEI JAZZ

The Nisei generation grew up immersed in American culture. As jazz became America's popular music, young Nisei musicians, often trained at Sacramento High School, formed their own bands. Nisei jazz bands like the Night Hawks performed at informal venues, including the Okabe family's M Street Café at 318 M Street. Because jazz was still associated with vice and drinking, conservative Issei parents often frowned upon their children's interest in jazz, but this was no deterrent to young lovers of popular music. In 1933, nineteen-year-old Sacramento native Fumiko Inada, better known as Betty, a well-known flapper and popular singer in Sacramento's Nisei jazz scene, relocated to Los Angeles in search of fame. She quickly learned that due to racial prejudice, even Los Angeles was not a suitable place for a Japanese American singer to achieve stardom. She decamped to Japan, where she became a nationally recognized jazz singer and star of *Whispering*

Agnes Miyakawa, Sacramento native, returning from France via steamship after her triumph on the stage of Paris's Opéra Comique. *Gary Miyakawa.*

Betty Inada was a Sacramento native and icon of the Nisei jazz scene. Seeking fame, she immigrated from the United States to Japan, where she became a popular jazz singer and movie star. *Pacific Film Archive.*

Sidewalks, Japan's first jazz musical. Betty was not the first Sacramento Nisei girl to make this transcontinental move, and she may have been inspired by Yoshiko Miyakawa, better known as Agnes.[114]

Born in 1911 in Florin, a farming community south of Sacramento, Agnes was the daughter of druggist Tsunesaburo Miyakawa, owner of the New Eagle Drugstore. She began her voice training at thirteen, including studies of French and Italian, while a student at Sacramento High School, with additional training via Stewart W. Tulley, a music instructor at Sacramento Junior College. Agnes was already well known to Sacramentans by the time she was sixteen, singing soprano on Sacramento's Kimball-Upson Radio Station, later known as KFBK. In October 1928, Agnes was one of two candidates selected to represent Sacramento in the National Radio Audition contest.

At age nineteen, Agnes departed the United States to perform at the Opéra Comique in Paris. She performed in a Parisian production of *Madama Butterfly* in 1929, where her studies of French and Italian languages, as well as her fluent Japanese, facilitated her operatic career. She briefly returned to the United States in 1931. Newspaper articles covered her return to the United States from the East Coast back to her home in Sacramento, where she was welcomed by a large crowd of local fans. She stayed at her parents' home at Fifteenth and X Streets before returning to Europe and then to Japan. Agnes remained in Japan during World War II but came back to the United States in 1946, finally settling in Florida, where she died in 1995. It is unknown whether she ever recorded an album, although she has one credit as a backup singer on an Eartha Kitt record.[115]

Agnes was less bold and brash than Betty Inada and preferred classical opera, but her skills also included jazz. While Betty left for Japan without the ability to speak Japanese, Agnes was fluent in Japanese in addition to her training in European languages. Were Betty and Agnes friends? In a community the size of Sacramento's Japantown, it is likely that they knew each other. The most intriguing hint is a copy of a musical score titled *Senow Yamada Gakfu*—sheet music from Yogaku Kensei Sha (meaning "The Association for the Study of Occidental Music"), a Japanese publisher specializing in Western musical styles. The cover is signed, "To dear Betty, from Yoshiko Miyakawa, Tokyo 1932."[116]

Businessmen like Dunlap, Hoffman and Nishio adapted to the changing circumstances of Sacramento's business climate, using their skills, creativity and connections to succeed. Success in the restaurant business often meant the right combination of food and marketing, and each of them briefly

stepped outside the law. For the young musicians of Japantown, the once-forbidden sinful music of the West End became inspiration for their own musical endeavors and, sometimes, a method of escape from the West End and a path to greater success.

SACRAMENTO NOIR

\mathcal{T}he late 1940s are often represented as the age of film noir, a school of cinema that emphasized cynical attitudes, crime, sex and urban settings, frequently including elements of tragedy and betrayal. After the turbulent eras of Prohibition, the Great Depression and World War II, the American public turned away from escapist drama to gritty, hard-boiled settings and morally ambiguous themes. This reflected city life in the United States, including in Sacramento. Housing shortages and labor crises made headlines, and many veterans returned from a war ostensibly fought against racial prejudice to a nation where prejudice was still evident. Internment of Sacramento's Japanese population and the migration of African American, Mexican and Filipino laborers to Sacramento meant an even more diverse and crowded West End, especially after the Japanese population returned.

Powerful economic forces took an interest in the future of downtown during this postwar recovery. The Progressive Era was over, but the subsequent generation of Sacramento business leaders coveted the prime real estate at the gateway to the capitol and used the same language of wickedness and social evil to critique the booming nightlife and cultural amenities of the waterfront. Victorian rhetoric against prostitution and liquor was recycled and reused to close businesses owned by Black and Japanese residents, just as in the Progressive Era. The rhetoric of racial exclusion, discredited after its use by Nazi Germany, was now transformed into the language of urban blight.

Capitol Avenue at night, circa 1950. The energetic nightlife of the West End attracted visitors from around the region but was also used to justify redevelopment. *Center for Sacramento History.*

During this era, Sacramento's business and political leadership included many who grew up during the Progressive Era. In 1948, Belle Cooledge became Sacramento's first female mayor. As part of the transition from the 1911 commission charter to the 1921 council-manager charter, councilmembers were elected at large, and the council designated one member as mayor following each election. Cooledge, an educator whose Sacramento career began in the same year that Luella Johnston was elected to the city commission, was a popular figure in Sacramento and received the most votes of any council candidate. The council unanimously supported Cooledge to serve as mayor, making her Sacramento's first female mayor and replacing the previous mayor, mortician George L. Klumpp. The "manager" in the council-manager system was Bartley Cavanaugh, who served as Sacramento's city manager from 1946 to 1964.[117]

Belle Cooledge, Sacramento educator, served on the Sacramento city council from 1947 to 1951 and became Sacramento's first woman mayor in 1948. *Center for Sacramento History.*

THE LAST GASP OF THE ANTI-JAPANESE MOVEMENT

Following the 1924 Immigration Act, Valentine McClatchy and Joseph Inman renamed the Japanese Exclusion League to the more general-sounding California Joint Immigration Committee, or CJIC. Their efforts against Japanese Americans continued, including the extension of California's Alien Land Law (the law prohibiting Japanese and Chinese immigrants from owning land in California) into other states and even removing passages from school textbooks that were insufficiently critical of the Japanese. They also targeted other immigrant groups, undertaking unsuccessful efforts to make Mexicans and Filipinos ineligible for American citizenship under the Alien Land Law despite the Philippines's status as an American territory. Hiram Johnson, McClatchy's longtime ally and fellow supporter of Japanese exclusion, served as a U.S. senator from 1917 to 1945 and was instrumental in passing the Immigration Act, providing CJIC with political support at the federal level.

After Valentine McClatchy's death in 1938, his son, H.J. McClatchy, took over leadership of the CJIC. The Japanese attack on Pearl Harbor on December 7, 1941, became an opportunity for this racist organization to renew its attack on Japanese Americans. According to committee member and eugenics advocate Charles Goethe, "This is our time to get things done that we have been trying to get done for a quarter century." The CJIC actively advocated for the internment and removal of Japanese Americans, even before Executive Order 9066, and fought efforts to repeal the Chinese Exclusion Act. Anti-Japanese groups like the CJIC accused the federal government of treating interned Japanese Americans too kindly, filed lawsuits to confiscate their land and even tried to prevent them from returning to their homes after the camps were closed. These views were supported by local governments; in May 1943, the Sacramento City Council and Mayor Tom B. Monk passed Resolution 207, which declared that the City of Sacramento was formally "opposed to the return of any Japanese from concentration camps to their former locations, and we endorse the orders made…that all Japanese be confined in concentration camps and that they not be returned to any Pacific state."[118]

In 1946, the CJIC supported a proposition that sought to make the Alien Land Law part of California's constitution. Despite strong anti-Japanese sentiment in the wake of World War II, this measure was soundly defeated, marking a turning point in legal support for racial laws in California, and court cases—culminating in *Fuji vs. State of California*—led to the declaration

of the Alien Land Law as unconstitutional in 1952. Just as the Klan was too overt for the McClatchy family in the 1920s, while anti-Japanese activism was not, overt racism after the defeat of Nazi Germany had to be concealed from public scrutiny under the guise of civic reform and redevelopment. The racial composition of California also changed during the war, as national migration patterns affected the West End in dramatic ways.

THE SACRAMENTO RENAISSANCE ON CAPITOL AVENUE

Unlike during the "settled years" of the early 1900s, Sacramento's post–World War II Black community was stronger in numbers, economic power and professional representation. New residents who arrived during and after World War II were drawn by wartime jobs, military careers and postwar migration and were seeking economic opportunity. This led to the rebirth of a Black-owned business district in downtown Sacramento that was supported by greater numbers of Black residents, a new professional class and the availability of real estate. In many cases these were sites previously occupied by Japanese Americans displaced by internment.

In the late 1930s, the Eureka Club relocated from 328 L Street, above the old Nippon Theatre, to 1109 Fourth Street. The club was still managed by Charles Derrick, assisted by Ira Fletcher Flood, grandson of chiropodist Robert Fletcher. The Eureka was regarded as one of the finest jazz clubs in California in the late 1930s, reputable enough to be the sole African American–owned nightclub listed in the *Sacramento Guide Book*, published in 1939 for visitors to Sacramento's centennial celebrations and the California State Fair.

Derrick opened a new club at the former Eureka Club site at 328 L Street in 1940, naming it the Jitterbug Café and partnering with William C. Dansby. Derrick was arrested in 1941 for possession of dice and paraphernalia for dice games found at the Jitterbug and fined $200. He appealed the charge with the help of J.M. Inman, the former state senator who helped Ancil Hoffman beat his bootlegging charge, and former president of the Japanese Exclusion League. Inman asked the Superior Court judge to throw out the case against Derrick because of a typographical error in the wording of the law: the law was intended to read "any card, dice or any device" but the letter of the law as published read "any card dice, or any device." Because the dice seized at the

Jitterbug were not "card dice," Inman argued, the law did not apply. Based on this error, Derrick was cleared of the gambling charge. Both the Jitterbug and the Eureka nightclubs vanish from city directories after 1941; the reasons for their closure are not known, but they may have been related to the closure and sale of the Nippon Theatre after the arrest of its owner, Soichi Nakatani.[119]

FBI RAIDS AND INTERNMENT IN JAPANTOWN

The operator of the Nippon Theatre, Soichi Nakatani, was arrested by the FBI in March 1942 as part of a statewide sweep; he was a suspected member of a "dangerous secret society" believed by the FBI to be associated with efforts by the Japanese government to turn Japanese Americans against the United States. Thirty-eight people were arrested, including five Sacramentans. A week after Nakatani's arrest, the *Sacramento Bee* reported that the Nippon Theatre changed ownership on January 5 and was reopening as the Valley Theater, owned by Edith Francis. The Valley name did not last; by November 1942, it was renamed the Alameda.

Later in March 1942, the FBI arrested Sacramento card room owners Katsutaro Sera and Gonshiro Tomita, both suspected of involvement with the Tokyo Club and a group called "Sons of the Black Dragon," a Japanese nationalist organization. A 1942 FBI report considered these organizations likely means of infiltration by agents of Imperial Japan and identified Sera as the Tokyo Club's representative in Sacramento. The report also claimed that Sacramento attorney and city councilmember Ray T. Coughlin, recently appointed a Superior Court judge, managed legal aspects of the Tokyo Club syndicate in Sacramento. Police seized films stored at the Nippon Theatre and searched them for pro-Japanese propaganda; the suspect films were revealed to be documentary newsreels about the Japanese invasion of China and not considered dangerous. This hysteria regarding Japanese saboteurs, later determined to be almost entirely fictional, drove the U.S. government to call for the removal or imprisonment of Japanese Americans during the war, and anti-Japanese groups did all they could to promote this racist reaction.

This government action and the resulting anti-Japanese propaganda marked the beginning of a disaster. In May 1942, all Japanese American residents of California were forcibly imprisoned, emptying homes and businesses, in accordance with Executive Order 9066. This enormous disruption of the West End triggered great changes in the neighborhood.[120]

THE ZANZIBAR CAFÉ

Founded in late 1941, the Zanzibar Café became an icon of West End jazz and a home away from home for African American soldiers serving at Sacramento's military bases. Owned by Louise and Isaac Anderson and their business partner William C. "Nitz" Jackson, the Zanzibar was located at 530 Capitol Avenue, which had been renamed from "M Street" a few years earlier. Jackson, born in Oakland in 1910 but a Sacramento resident since 1929, was a graduate of Sacramento City College who worked as a postal carrier prior to establishing the Zanzibar. Due to his colorful style and outgoing personality, Jackson quickly became the public face of the Zanzibar and also provided the club's unique revolving stage, which was adapted from a piece of surplus equipment from the nearby Sacramento Army Signal Depot.

Jackson's business partners, the Andersons, moved to Sacramento in 1924 and were struck by the diversity of the West End. As Louise Anderson told the *Sacramento Observer*, "I used to go to town and you wouldn't see a Black face. You'd see Hindus in their turbans, Filipinos, Chinese, Japanese and a few Mexicans. You didn't see many whites…Black people lived in the lower end due to the fact that they couldn't buy anywhere that they wanted…some of the best people lived there, too." Due to discrimination, Isaac Anderson was unable to find a job on the police force, despite having been a police officer in their hometown, or even a job as a night watchman. He instead worked for the City of Sacramento in the maintenance department.

After taking the opportunity to purchase a Japanese-owned liquor store in 1941, the Andersons became partners with Jackson at the Zanzibar when another potential partner was inducted into military service. The Andersons had no experience with business, but Jackson's savvy in the entertainment world and their own willingness to learn while doing made the Zanzibar the hottest club in the West End. The Zanzibar's popularity transcended previous racial boundaries, becoming Sacramento's first truly integrated nightclub.[121]

Nationally recognized touring performers shared the Zanzibar stage with local musicians for regular weekly shows, Sunday jam sessions and after-hours events. Lacking the capacity of large venues like Memorial Auditorium, the Zanzibar hosted acts with a mixture of styles, from popular swing and New Orleans traditional to Afro-Cuban styles and far-out bebop. One of the Zanzibar's first performing acts was "Babe" Williams, formerly of the Eureka Club, and Eureka manager Ira Flood found a job at the Zanzibar as a bartender.[122]

The Zanzibar, converted from a Japanese-American–owned liquor store, was on the ground floor of a nineteenth-century apartment building located at 630 M Street. *Keith Burns collection.*

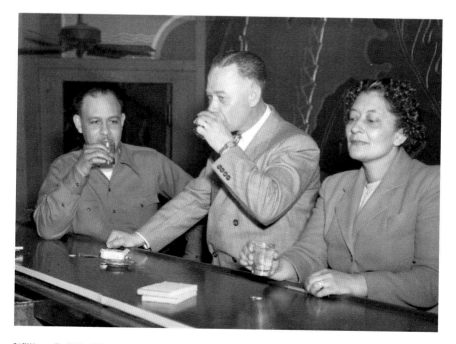

William C. "Nitz" Jackson, Isaac Anderson and Louise Anderson (*left to right*), owners of the Zanzibar Café. *Keith Burns collection.*

During World War II, off-duty soldiers filled downtown Sacramento's bars and nightclubs, seeking entertainment and romantic company. Just as during World War I, military commanders became concerned with prostitution and pressured the City of Sacramento to crack down on the solicitation of soldiers in an effort to reduce venereal disease. In response to army directives, Sacramento police chief Alec McAllister began a coordinated effort to "quarantine" prostitutes in 1942—similar to efforts made during World War I. Because many prostitutes operated in and around West End bars and nightclubs, the police applied pressure to nightclubs and hotels where prostitutes were most frequently identified by police investigators, revoking the business licenses of offenders. Local military authorities praised Sacramento's cooperation.

In 1944, Chief McAllister created a special vice squad to address prostitution and gambling. After the end of the war, these efforts continued, in part due to a rapid rise in venereal disease rates on the Pacific Coast that was blamed on the return of thousands of discharged soldiers, quasi-transient war workers and agricultural workers, all of whom were regulars in Sacramento's West End. In the view of Sacramento officials, because houses of prostitution were effectively wiped out by 1945, their next target was transient prostitution in nightclubs and bars. The Zanzibar, the West End's most popular and successful nightclub, became the prime target for raids based on factors outside of the club owners' control.[123]

In May 1949, eight undercover liquor control officers testified before state hearing officer Raymond Williamson that they were approached several times by prostitutes at the Zanzibar during their visits to the club. The officers' testimony was intended to demonstrate that the bartenders at the Zanzibar directly facilitated customers looking for prostitutes. A personality conflict between Nitz Jackson and the Andersons resulted in Jackson's withdrawal from the partnership by 1949, so the Andersons had to answer to the charges.

At the hearing, two Sacramento policemen testified that they observed prostitutes at the Zanzibar but admitted they had never arrested them. They also testified that they previously criticized the club owners, including Jackson, for permitting a local interpretive dancer, Tondalayo, to dance on the bar. Tondalayo was a popular attraction at the Zanzibar known for her wild dancing and sometimes billed as "The Body Beautiful." Louise Anderson denied any knowledge of prostitution at the club via direct interaction, reporting by her staff or official notification by Sacramento police, despite regular visits by Chief McAllister's vice squad. "I never have

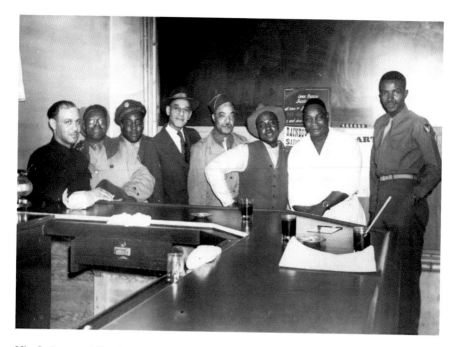

Nitz Jackson and Zanzibar customers, including soldiers from nearby army bases. *Keith Burns collection.*

permitted any known prostitutes to patronize the Zanzibar, but I know of nothing I can do about it if I do not know if they are prostitutes," she said. She also reported that two of the women identified as prostitutes by the liquor officers were state employees with good reputations for morality.[124]

On June 28, 1949, the State Board of Equalization decided to revoke the Zanzibar's liquor license, but the Andersons' attorney, Benjamin Frantz, was able to block the revocation, delaying the closure of the club. Frantz claimed that the inspectors had no evidence that the management or employees had any knowledge of or participation in immoral activities at the club. At the Board of Equalization hearing, another attorney representing the Andersons, Fred Pierce, argued that solicitation in Sacramento clubs was not a factor that could be controlled by staff, stating, "I venture if you send the same group of liquor control officers to any large hotel in town over a period of a month, they would be solicited—only more subtly....There are certain women of easy virtue who patronize this place, and I'll bet they patronize every other lower-end nightclub." This testimony implied that pressure on the Zanzibar was unfairly applied by the state when compared to white-owned establishments in Sacramento. The state board refused to rescind

its decision to revoke the Zanzibar's license, and in November, a Superior Court judge confirmed revocation of the Andersons' liquor license, finally closing the Zanzibar.[125]

However, the stage at 530 Capitol did not remain quiet for long. On July 1, 1950, the club reopened as the Paradise Steak House under the ownership of Martin L. Vann, a Black entrepreneur who moved to Sacramento in 1947 and began his own small business empire. Originally opening the Crystal Palace Hotel and Barbershop at 1317–21 Sixth Street, half a block from the Zanzibar, Vann seized the opportunity to purchase and reopen the Zanzibar under a new name. Advertising for the opening night mentioned "Bertha's Pit Barbecue" as the kitchen operator, with entertainment by "Thompson's Quality Four," possibly referring to local saxophonist and mortician Vincent "Ted" Thompson. While Vann may have lacked Nitz Jackson's flair, he was obviously aware of the Zanzibar's success and tried to replicate it whenever possible, including bringing back exotic dancer Tondalayo to the club. Advertising for the Paradise mentioned bartenders K.K. Armstrong and Oscar Williams, billed as "Barticians" for their mixology skills. Despite the apparent success of the Paradise under new ownership, the building itself was doomed by redevelopment; the first building demolished in the official redevelopment of Capitol Mall was 526 Capitol, immediately west of the Paradise Club. Faced with redevelopment, Vann joined the exodus of Black-owned businesses from the West End, reopening the Paradise at 2730 Stockton Boulevard and remaining in operation until the 1960s. Isaac Anderson died in 1955, but his wife, Louise, operated the A&J liquor store on Fourth Street until that building was demolished in 1962, when the liquor store was relocated to Stockton Boulevard.[126]

Nitz Jackson remained in Sacramento for several years after his departure from the Zanzibar Club, opening the Congo Club at Third and Capitol and a drugstore at 331 Capitol before relocating to Los Angeles in 1953. The Congo Club was owned by a Japanese American and operated by an African American; after Jackson's departure, the club's hosts were listed in advertisements as Carl Buckner and Henry Taketa. Taketa, an attorney, was a major figure in efforts to save Japantown from redevelopment. In July 1955, just as the block where the Zanzibar stood was being demolished, the Congo Club came under fire for the same reasons as the Zanzibar; investigators from the state's Department of Alcoholic Beverage Control claimed they were solicited by prostitutes in the Congo Club. In his defense of the Congo Club, Taketa provided testimony by two Sacramento police officers that the Congo Club was "one of the best managed places in the west end," refuting

After he left the Zanzibar, Nitz Jackson operated the Congo Club at Third and Capitol Streets with Henry Taketa. *Center for Sacramento History.*

On Fourth Street, a row of cherry trees in bloom were an important symbol of Japantown. The three-story building in the center of the photo is the Catalina Hotel, owned by Mexican immigrant Catalina Haro. *Ouye family.*

and denying the charges that prostitution was tolerated on the site. After a two-year court battle, revocation of the Congo Club's license was upheld in Superior Court in February 1957, which led to the permanent closure of the Congo Club. By 1957, demolition of Capitol Avenue was further along, and the Congo Club was demolished not long after it closed. In March 1958, Nitz Jackson died in Los Angeles at the age of forty-seven. His body made a final trip back to Sacramento for services at St. Andrew's AME Church, which had been relocated in 1950 to Eighth and V Streets in Southside Park. Even the historic gold rush–era church could not survive redevelopment.[127]

BUSINESSES OF THE WEST END

African American travelers in the early twentieth century often used a national publication called *The Negro Motorist Green-Book* (known as the "Green Book") to locate hotels throughout the United States where they could find accommodations in an era of segregation. In Sacramento, the Hotel Center, at 420 ½ Capitol Avenue, was frequently listed in the Green Book, but there were also other hotels open to Black travelers and musicians. In approximately 1944, Catalina Haro purchased the Mall Hotel at 1210 Fourth Street and renamed it the Catalina Hotel. An immigrant from Mexico, Haro arrived in Sacramento with her husband, Tereso, around 1930 and became a U.S. citizen in 1944. According to Sacramento resident Marion Uchida, Catalina took particular pride in telling every visitor that when Duke Ellington came to Sacramento, he stayed at her hotel; he could perform in the Hotel Senator's grand ballroom but could not rent a room. However, this openness to Black musicians also came with its risks; like the Zanzibar and the Congo Club, in 1951, the Haro family was accused of harboring prostitutes at the Catalina Hotel, and city authorities attempted to padlock the building. Fortunately, Catalina challenged the charges, and the hotel remained open until the early 1960s, when redevelopment claimed the building. By that time, the Haro family transitioned to real estate development, constructing new apartment buildings along Sutterville Road.[128]

The Green Book listed other Sacramento businesses, including Twigg's Beauty Parlor. After arriving in Sacramento in 1944 to buy a partnership in Nitz Jackson's drugstore, Bennie Twigg described Sacramento as "the largest little big city [she] had ever seen." She was impressed with the Zanzibar and the nightclub scene in the West End but dismayed by Sacramento's

small number of Black businesses and rampant discrimination. She secured a room at the Women's Civic Improvement Club, a boardinghouse for single African American women located at 1830 T Street, until her husband, Henry, finished his military service.

In 1946, Bennie Twigg sold her interest in Nitz's drugstore following an incident during which alcohol was sold after hours, threatening the drugstore's liquor license. She purchased 421 Capitol Avenue (formerly 421 M Street), previously the Churchill Dance Hall. After its time as the Churchill, the building was the Okayama Hotel, Aoki Billiard Hall and the Chinese Baptist Church. The property sat mostly vacant after a January 1942 fire damaged the roof. The Twigg family purchased the home from Mrs. U. Seto, repaired the home and moved into the upstairs quarters, and in November 1946, they opened Twigg's Beauty Center on the ground floor. After additional remodeling, Bennie Twigg also opened Twigg's Record Shop, the first Sacramento store specializing in "race records," or recordings by African American artists. In 1959, 421 M Street faced redevelopment, so the Twigg family relocated to Tenth and P Streets. That location lasted only four years, also falling to redevelopment. In 1964, Bennie Twigg opened

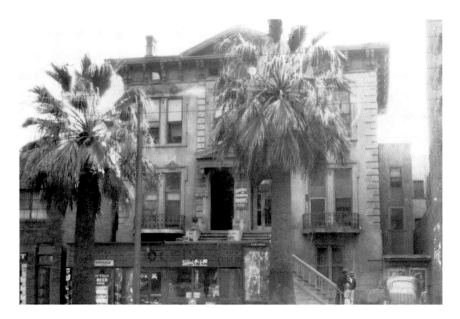

Vacant due to internment of the building's Japanese-American owner, the former Churchill Dance Hall was purchased by Bennie Twigg, who operated a beauty parlor, record store, rooming house and taxi stand in the building until it was demolished by redevelopment. *Center for Sacramento History.*

Wakano Ura Chop Suey reopened in this building after the Nishio family returned from internment. Within a decade, they were again forced to relocate when redevelopment demolished the neighborhood—note the "Quick Removal Sale" sign on the shoe store below. *Ouye family.*

her final shop, Mrs. Twigg's Enchanting House of Elegance, on Fourth Avenue in Oak Park, and closed that business in 1970. After closing the shop, she became a teacher at Collis P. Huntington Elementary School and remarried to Arthur Johnson, an instructor at McClellan Air Force Base. Bennie Johnson died in 2008.[129]

As Sacramento's Issei and Nisei families returned from internment, they crowded into available spaces in Japantown, often re-establishing the same family businesses in different locations, and expanded into nearby neighborhoods. After a brief tenancy at 1323 Fourth Street, Yusuke and Nao Nishio reopened the Wakano Ura restaurant at 1219 ½ Fourth Street in approximately 1949, continuing to offer its hybrid Japanese/Chinese menu. Other Japanese restaurants, including Ariake Chop Suey, owned by the Morita family, also used this strategy. This location of Wakano Ura lasted only about a decade, as the building was demolished due to redevelopment, but the family relocated again, to 2217 Tenth Street, where Wakano Ura, after being sold to the Tokunaga family in 1975, remained in operation until 2013.

This circa 1952 wedding reception took place at Ariake Chop Suey, a Chinese restaurant owned by the Morita family. Note the presence of sushi rolls and sake bottles on the table alongside Coca-Cola bottles. *Priscilla Ouchida collection.*

THE FLOWER GARDEN

Not all of the Black and Japanese businesses in the West End were located in old buildings. Born in 1906 in Charleston, Mississippi, Phelix Flowers arrived in Sacramento in approximately 1937 and worked at the State Printing Office. In November 1952, he opened the Flower Garden Restaurant at 1511 Fourth Street, a unique and contemporary building designed by A.E. Kimmel and Roy Swedin. The Flower Garden had several unusual features, including a roof garden over the main floor that was decorated with potted plants. The building also had two meeting halls to facilitate its social function as a meeting space for African American members of the Elks Lodge, Capital City Lodge 1147, who were not permitted to use the main Elks building at Eleventh and J Streets. Flowers also made the meeting rooms available for other organizations, including the Sacramento NAACP. In 1954, Sacramento hosted a statewide convention of African American Elks. This 1,500-person event far exceeded the capacity of the Flower Garden, but they were still prohibited from holding events at the main Elks tower, so the

festivities were held next door at Sacramento's Masonic Hall at Twelfth and J Streets.[130]

The Flower Garden's menu featured Southern cooking, and the restaurant was well known for its mint julep. In addition to the civic-minded community meetings held at the Flower Garden, the building was also used as a music venue. Unfortunately, the Flower Garden also had difficulty finding success, and the high expenses of the brand-new, architect-designed buildings meant it was difficult to make ends meet. Phelix and his wife, Minnie Flowers, filed for bankruptcy in the fall of 1954 and closed the Flower Garden after less than two years. The Flowers family found longer-term success after opening a print shop, Sav-On Printing, utilizing Phelix's experience working for the state printing plant. However,

The Flower Garden, a Southern food restaurant operated by Phelix Flowers, was the only building in Japantown that was spared demolition after it was purchased by the Japanese American Citizens' League for use as a Veterans of Foreign Wars chapter for Nisei veterans. *Author's collection.*

the Flower Garden building did not remain vacant for long. Due to it having meeting rooms and its location at the heart of Japantown, around the corner from the Buddhist Church and its auditorium, the building was an ideal location for the Veterans of Foreign Wars, Nisei Post 8985.

On December 11, 1955, VFW Post 8985 dedicated their new hall, purchased with the assistance of the Sacramento Japanese American Citizens' League. The dedication ceremony included a memorial honor roll plaque dedicated to Sacramento Nisei who gave their lives in World War II and speakers including Congressman John E. Moss, Assemblymember Roy J. Nielsen, Sacramento mayor H.H. Hedren, Paul Ito of the Florin JACL and Henry Taketa as master of ceremonies. As with the Elks Lodge, Sacramento VFW organizations refused to accept Japanese American veterans as part of their chapters, so Sacramento's Nisei veterans formed their own chapter, which was dedicated on February 7, 1947, at the Buddhist Church recreation hall around the corner from the site where the Flower Garden was built five years later. Over the years following the dedication of the Nisei VFW Memorial, redevelopment took the buildings on all sides, leaving the neighborhood utterly transformed. The Flower Garden–turned–VFW hall became the sole remaining building in Sacramento's downtown redevelopment zone that was directly associated with Sacramento's African American and Japanese American communities. The building is a proud survivor that still serves as the home of VFW Post 8985.[131]

BOYS WILL BE GIRLS

ollowing the Second World War, American society was in transition. The Jazz Age dismantled many of the social restrictions of the Victorian era, and American soldiers returned from war zones with a broader view of the world. Migrants from other parts of the United States flocked to Sacramento following the war, triggering a suburban building boom. Many of these new Sacramentans came from larger cities, creating a demand for big-city entertainment and a workforce to supply that entertainment. This demand created opportunity for women in the postwar equivalent of the *demi-monde*, including burlesque and striptease performers, taxi dancers, B-girls and prostitutes—elements of the sex industry that were on a spectrum that ranged from legal to semi-legal to illegal.

Part of this postwar cultural change included a shift in public perception of sexuality and gender. Fashions and media made greater accommodation for expressions of female sexuality, whether it was based on perceptions of greater female power or as exploitation. Movie advertisements and playbills for all-night "grindhouse" theaters promised shocking, frank subject matter, even if the movies often failed to deliver on expectations of forbidden thrills. Burlesque transitioned from implied bawdiness in leotards to striptease and nudity, at least to the limits of local law enforcement. Drag clubs trampled gender boundaries, subverting an old burlesque trope into a space where gay, lesbian and transgender populations found a tentative place for self-expression. Sacramento was also the home of an American

transgender pioneer who shared her experiences—along with the physical results of her transition—with audiences.

The story of striptease, however, began a half-century earlier with a Sacramento native called Charmion.

CHARMION THE STRONGWOMAN, SACRAMENTO'S FIRST MOVIE STAR

Born on July 18, 1875, in Sacramento, Laverie Cooper, better known as Charmion, became a sensation on the stage in the 1890s with a remarkable trapeze act that drew the eye of inventor Thomas Edison. Describing Charmion's physique as "athletic" was an understatement. She was powerfully muscular and capable of feats of strength that gave her the nickname "The Female Sandow" after famed strongman George Sandow. While strongman acts were common in circuses and vaudeville acts of the late nineteenth century and promoted by early advocates of physical culture and health, strongwomen like Charmion were exceptionally rare due to the highly restricted gender roles and social mores of the era. Her career as a gymnastic performer began in approximately 1894, when she performed at the Oak Park Pavilion. By an account given in 1897, she weighed 107 pounds and had a biceps measurement of thirteen and a half inches. Her great physical strength and agility gave her an enormous level of body control.[132]

Theater critic George Nathan described Charmion's best-known performance, a "disrobing act" in which she stripped from full Victorian garb down to a black net leotard while performing on a trapeze, and declared Charmion the mother of modern striptease.[133] According to *Sacramento Union* reporters, her exceptional skill at acrobatics was discovered in 1896 by a reporter who observed her performance on gymnastic rings at the Oak Park Pavilion. She performed at Sacramento venues, including the Clunie Theatre, under the name "Lavevi Charmion," followed by engagements in San Francisco at the Sutro Baths and the Orpheum. In 1897, she tried to start a family gymnastic act, soliciting for student acrobats in the "Wanted" section of the *Sacramento Daily Record-Union*, that would be trained by Charmion herself in her studio at Thirty-Third Street and Madrone Avenue in Oak Park. However, her efforts to train a team were overtaken by the demands of the stage, and there are no records of her students joining the performance. Later that year, Charmion joined the "Flying Jordan" vaudeville troupe.[134]

Laverie Cooper, a Sacramento native who performed on vaudeville stages under the name Charmion, demonstrates her remarkable muscular development in this single-bicep pose. *Wisconsin Historical Society*.

Charmion occasionally returned to Sacramento for performances at the Clunie Theatre before joining the New York Vaudeville Company, followed by a decade on the vaudeville circuit in the United States and Europe. Charmion's rapid success made her a Sacramento celebrity, and she received exuberant praise from reviewers and reporters whenever she returned home or garnered particularly positive reviews from abroad.

Early newspaper accounts of Charmion's performances describe her acrobatic stunts but not the disrobing act, until 1897, when the *New York Sun* described the disrobing act along with her earlier act based on a suspended ladder. Charmion quickly became the highest-salaried female vaudeville worker on the American stage, receiving over $200 per week. Her husband, Harry Delaney, served as her manager and trainer and shared in her financial success; he was often seen with a diamond pin "of something less than the dimensions—and the general appearance—of a glass brick."[135]

The *Sacramento Union* reported on Charmion's transition from star of the stage to movie star in November 1898: "Charmion, the Sacramento prodigy, in her extraordinary act has been successfully cinematographed." The new medium of motion pictures was in its infancy in 1898, making Charmion's act a pioneering experiment in new media. The final version of the film distributed to Thomas Edison theaters was released in 1901. The two-minute film opened with Charmion on a trapeze and two men in a nearby balcony. Charmion began in full Victorian dress, disrobing on the trapeze and performing acrobatic stunts to the wild applause of the two men. The performance ended with Charmion dressed in a leotard, performing additional stunts unencumbered by her Victorian costume. The response of the men in the balcony was a social signal to Victorian audiences indicating that they should cheer rather than display disapproving silence or disgust—and this was sometimes the response of more prudish audiences.

Charmion's visit to the National Theatre in May 1898 was met with just this sort of disgust and disapproval, according to the Washington, D.C. *Evening Times*. The *Times* theater editor utilized Charmion's act as an opportunity to heap enormous quantities of scorn onto the theaters of New York—in his opinion, an unsalvageable morass of vice and sin. New York audiences who cheered and toasted Charmion were portrayed as characteristic of a city where vicious and crude acts were most celebrated. In the nation's capital, her performance was "revoltingly disgusting, coarse and disagreeable." The fact that Charmion did not completely disrobe became part of the critique, as the advance promotion about her act drew men to her performances out of prurient interest. She shocked virtuous members of

the audience with the quantity of clothing she removed, and disappointed the immoral contingent with the quantity of clothing she retained at the end of her performance.[136]

In 1899, other performers tried to outdo Charmion's stunt. The Wallenda Sisters, better known as the "Flying Wallendas," dove into a tank filled with water, remaining underwater long enough to remove their garments. By the early twentieth century, audiences and reviewers had grown tired of the act as its novelty wore off. According to a reviewer in the *San Francisco Call*,

> *Charmion has become economical. She throws no garters to the audience as she disrobes on the swinging trapeze. The dainty star of vaudeville and the most perfectly developed woman in the world, as she bills herself, is no longer dainty and only her voice is small....Not that her act is what you would call vulgar. After she has completed her reverse toilet she still is clothed as fully as the usual queen of the trapeze. Merely the novelty of the undertaking is gone and the act is just stupid.[137]*

In Los Angeles, a reviewer was even clearer regarding the waning popularity of Charmion's act. In the 1890s, disrobing to a leotard was shocking, even in cosmopolitan New York. By 1908, audiences knew that Charmion would not disrobe past the point of comparative modesty. The same act that made Washington, D.C., audiences gasp in 1898 was, a decade later, considered tame enough for enthusiastically positive press in Salt Lake City, Utah, or Bridgeport, Connecticut.[138] Sophisticated twentieth-century audiences rapidly became used to performers like "Salome," whose veils concealed the point where costume ended and flesh began. The writer also predicted that the "disrobing act" would become self-defeating, reverting to long skirts and greater modesty. This prediction proved inaccurate, as twentieth-century burlesque exposed greater and greater areas of skin until even Salome's act was considered modest.[139]

A separate, earlier account in the *Los Angeles Herald* also credited Charmion with creation of the "undressing act," describing these performances as "all the rage" in New York. As a city that considered itself a bastion of decency and morality, the Los Angeles newspaper criticized New Yorkers' tastes as depraved and indecent. Undaunted by the moralizing of Los Angeles theater critics, imitators unable to match Charmion's strength and skill on the trapeze instead disrobed on the stage. Ziegfeld Follies performer (and attempted claimant of Cherry de Saint Maurice's fortune) Anna Held disrobed behind a screen in a 1908 Los Angeles performance to the tune of

Promotional merchandise, like this pin, was sold at Charmion's performances. *Author's collection.*

"I'd Like to See a Little More of You." In 1913, a dancer in San Francisco's Barbary Coast named "Mazie" undressed behind a translucent white shadowgraph.[140] A New York theater called the Casino even staged a play based on a famous painting, *An Affair of Honor*, depicting two topless women engaged in a sword duel. Jaded New Yorkers were disappointed when the actresses did not strip to the waist, instead performing the duel in their chemises. In 1901, Lubin Studios created a short film based on *An Affair of Honor*, also forgoing the authenticity of topless swordswomen.[141]

In 1905, Charmion's husband Harry died, and in 1912 she married wrestler/strongman William Vallee, a native of Buffalo, New York. As the popularity of Charmion's act waned, she retired from the vaudeville circuit and moved to New York with her new husband. In 1930, she returned to California with William, retiring to Santa Ana in Orange County, where she remained until her death in 1949.

Charmion's Sacramento origins were generally not advertised during her career. Promoters billed her as "Right from Gay Paree," implying that Charmion was French, but Sacramento audiences knew better. In the Sacramento press, she was celebrated as a native daughter, and the decency or propriety of her act was never questioned. Her career became a turning point in American entertainment, even as she challenged Victorian ideas about decency and womanhood through her remarkable abilities. Charmion became the mother of striptease and Sacramento's first movie star.[142]

"Vau-Devil-Le"

Not every Sacramentan approved of the display of female limbs on local stages. Reverend Edwin Smith of Oak Park Methodist Church, one of the major campaigners against ragging in 1912 and a supporter of the Bliss Ordinance regarding public dancing, also protested vaudeville performances. Presenting a report about his study of local shows and moving pictures to his congregation, Reverend Smith stated that "vaudeville as it is presented

in Sacramento should be spelled with two hyphens—vau-devil-le." This conclusion was based on a small percentage of shows that included low, vile, dirty content: "Always, just a little devil is thrown in between." He echoed the sentiments of other civic reformers who felt that local tolerance of immorality and vice were major reasons behind Sacramento's failure to keep pace with other California cities in terms of economic and population growth. In Smith's opinion, tolerance of brothels, saloons and "vau-devil-le" inevitably led to corruption of city government. Smith was certain that economic prosperity would follow civic morality:

> *That we feel under the present administration the laws regarding morality have been enforced as never before, and that their efforts in this direction is making Greater Sacramento one of the bright spots upon the map of California, instead of the opposite, and where honesty and integrity are held in high esteem.*[143]

The line drawn between vaudeville and burlesque was often fine—or arbitrary. Burlesque was often intended as social commentary, presenting a lofty subject with vulgarity or an inconsequential one with mock dignity. Double entendres and props indirectly conveyed sexual innuendo. Vaudeville was more closely associated with musical comedy, while burlesque typically resembled a variety show combining comedy with dancing. Comedians slowly transitioned to performing in comedy clubs, while striptease grew to dominate burlesque. Burlesque performers typically organized in circuits, or "wheels," of cities where they performed at regular intervals. J. Herbert Mack established the Columbia Circuit, operating in northern California cities between Shasta and Sacramento, before eventually becoming manager of the Capitol Theater in Sacramento.[144]

TASSEL TIME AT THE ALAMEDA

In the 1920s and 1930s, the Mission Theatre (at 310–312 K Street) and the Lyric (at Second and K Streets) were Sacramento's burlesque theaters of choice. In 1942, after a short life as the Valley Theatre under its new ownership, the building that once housed the Nippon Theatre at 328 L Street became the Alameda Theatre, purchased by Edgar Salazar. Advertisements from this era included showings of *Sepia Cinderella*,

Above: The Nippon Theatre became the Alameda after its owner, Soichi Nakatani, was arrested and interned in 1942. In 1955, the Alameda became a burlesque theater. *Center for Sacramento History.*

Right: Sande Marlowe was a popular Sacramento burlesque and striptease performer in the 1950s and 1960s. She lived in Sacramento and performed at the Alameda and other local burlesque houses. *Author's collection.*

Sandé Marlowe, *Come-up and see ME, Daddy o!!*

featuring an all–African American cast (except for a cameo by former child star Freddie Bartholomew), including an actress named "Tondaleyo" as a nightclub owner. Whether or not this was the same dancer as the semi-legendary "Body Beautiful" performer at the Zanzibar Club is unknown, as several performers used variations on the name. When the Lyric closed in 1955, theater manager Nadra "Ned" Hakim relocated his burlesque performers to the Alameda. In the 1950s, burlesque combined elements of comedy and striptease, with male comedians often appearing between the acts of the female dancers.[145]

The Alameda was far from the only burlesque club in Sacramento in the 1950s and 1960s, but it became the most iconic of its era, and for many young men growing up in Sacramento, their first visit to the Alameda was a rite of passage. Ouye's Pharmacy, which had relocated to Third and L Street after the Ouye family's return from internment, became the Alameda dancers' destination of choice for purchasing stage makeup. According to the Ouye family, the dancers regularly greeted Harold Ouye with a friendly "Hello, Harold!" when visiting the pharmacy.[146]

DOWNTOWN DRAG

Drag performances, including female impersonation, were already a longstanding element of burlesque and nightclub acts dating back to Sam Raber's drag performances at the Oriental Café in 1913, but the 1940s marked the first known time that Sacramento clubs specialized in drag performances advertised to a general audience. In her book *Mother Camp*, anthropologist Esther Newton categorized drag performers, or drag queens, as, generally, gay men performing as women as a form of entertainment, as differentiated from cross-dressing, or transgender persons, but these groups did intersect. Drag of this era took place in gay bars or straight nightclubs; based on the relative secrecy of gay bars, the drag clubs advertised in Sacramento newspapers were probably the latter. Like Black jazz musicians performing in front of white audiences, which led to "black and tan" integrated clubs, gay performances before a straight audience provided economic opportunity and opened a door to greater social acceptance. The drag performer carried on the burlesque tradition, lampooning and challenging social norms through dance, singing, celebrity impersonation and comedy. Generally, younger

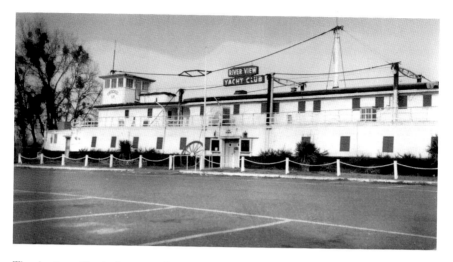

The riverboat *Cherokee* became a floating clubhouse for the Riverview Yacht Club, located in Yolo County north of the I Street Bridge, and an early venue for the "Boys Will Be Girls" revue. *West Sacramento Historical Society.*

performers emphasized glamour and beauty, while older drag queens utilized comedy—from ribald humor to devastating sarcasm—after youth faded.[147]

The sarcastic, sometimes self-deprecating style of the drag queen reflected the internal struggles of a community forced into a secret life by still-extant Victorian moral codes reinforced by eugenic classifications of mental illness and social deviance. In the 1940s and 1950s, homosexuality was still considered a mental illness, and homosexual activity was a prosecutable offense. The drag club was an early connection between the hidden world of early twentieth-century LGBTQ existence and the larger world of entertainment.

In 1944, the Capital City Yacht Club purchased the riverboat *Cherokee* from the City of Sacramento for sixty dollars, converting it into a floating club room at their yacht harbor on the Yolo County side of the Sacramento River, about eight hundred feet upstream of the mouth of the American River near West Sacramento. For the next few years, the riverboat served as a floating restaurant and nightclub, featuring music by bandleader Evan Selby and his "Debonnaire Trio." On September 2, 1948, the Yacht Club changed its star attraction to a new revue entitled "Boys Will Be Girls: 7 Acts of Fun & Frolic." Three weeks later, advertisements announced a completely new "Boys Will Be Girls" drag show featuring Frank Doran, the Belle of the Barbary Coast; Ray Saunders, the Toast of San Francisco; and Bunny Daye,

the Body in a Million, for three nightly floor shows. Because of its location outside of Sacramento city and county limits and its distance from the Yolo County sheriff's office, West Sacramento became an early haven for gay bars in the 1960s; the Yacht Club may have been a predecessor of those clubs. When the Yacht Club changed restaurant operators in 1948, the "Boys Will Be Girls Revue" leapt the Sacramento River and landed on K Street at the farthest end of the West End.[148]

The building at 1422 K Street, which formerly housed a loan office, became the Casablanca Club, with a Moroccan theme, in 1943. By 1944, the Casablanca had closed, and new owner Frank Giordano opened the Silver Dollar in its place with an Italian menu. The Silver Dollar featured a unique form of entertainment, a Mills "Panoram," a sort of film jukebox that showed three-minute short films called "soundies" for a dime. Most soundies were musical performances, often featuring African American jazz performers like Fats Waller and Count Basie, while others featured burlesque dancers or cartoons. The popularity of the soundie was brief, as wartime rationing limited production of new machines. By 1947, the distribution of soundies had ended, and most were rapidly replaced by new devices, including the television.[149]

In 1947, the Silver Dollar changed ownership again and was renamed the "Hat Club" and then "Silver Dollar Tops Club," with a Southern menu based on fried chicken and steak. The new owners experimented with different musical formats, including Western swing by Tex Link and his Pioneer Valley Boys and Latin jazz by Pepe Delgado and his Solid Jive Orchestra, changing the menu again, this time to Mexican food. In 1948, the new owners tried an "All-Girl Review" floor show and closed the kitchen but quickly came under fire from state liquor authorities, as their liquor license required the sale of food. In May 1948, they tried yet another new formula—instead of an all-girl revue, he brought in a new show featuring an all-drag revue. Through the summer of 1948, Tops featured touring and local drag performers introduced by mistress of ceremonies Ray Saunders, previously a featured performer at the Yacht Club. Through the end of 1949, drag was queen at 1422 K Street.

In 1950, the club again changed its stride, trading in heels and gowns for another ill-fitting cowboy hat; Bud Hobbs's Round-up Club and his musical attraction, Trailherders, lasted only about six months. By August 1950, the club announced another name change, to the Ron-D-Voo Club, and another all-girl revue. Advertisements described whirling tassels and interpretive dance, suggesting a burlesque-focused stage show, but by

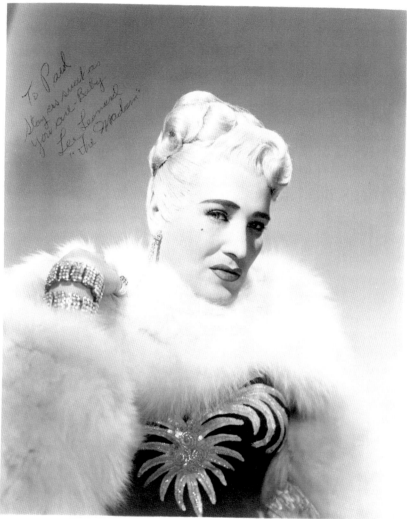

THE GREAT PRETENDER THE FABULOUS LEE LEONARD

Lee Leonard was one of many traveling drag performers who visited Sacramento venues, including the Ron-D-Voo Club's "Boys Will Be Girls" revue in the 1950s and the East Sacramento club the Driftwood in the early 1960s. Leonard continued performing until the 1970s and released comedy albums of her drag routine. *JD Doyle.*

1952, Ray Saunders once again donned an evening gown for a "Gala Boys Revue" featuring Tommy Baker and Ricky Reynolds. Eventually, Tommy Baker, a popular blonde performer who had previously toured with the Jewel Box Revue, took over Saunders's duties as mistress of ceremonies. Club advertising often specified the gender of the performer either by starting their stage name with "Mr." or through a description like "The Male Marlene Dietrich," while other performers were identified as female, and in some cases, the public gender of the performer was indeterminate. In 1953, the Ron-D-Voo was cited for failing to serve food despite advertisements proclaiming, "NOW OPEN! Our Wonderful ITALIAN KITCHEN! Featuring Italian Pizza—Spaghetti and Meat Balls—Pasties and Fried Chicken." According to the state liquor board, the only pasties were those adhered to the burlesque dancers' breasts, but the club managed to avoid closure, transferring their liquor license to another new owner in October 1953 with a promise to reopen the kitchen. However, this promise was quickly broken, and the Ron-D-Voo went out of business in 1954. The building became an Arthur Murray Dance Studio in 1956.[150]

Other Sacramento nightclubs and burlesque theaters occasionally featured drag performers, like Pierre Dubois, advertised at the Mo-Mo Club. The Mo-Mo, located across Capitol Avenue from the Zanzibar, usually featured Black performers, suggesting that Dubois may have been African American. The Nu Lyric burlesque house (the old Lyric Theatre reopened under a new name) challenged its audiences with a showing of Ed Wood's transgender-themed film, *I Changed My Sex* (also known as *Glen or Glenda*) in 1958. The Alameda Theatre, ordinarily a burlesque house, sometimes featured revues that included burlesque strip and drag performances, like 1949 New Year's Eve midnight show, "Featuring the Most Gorgeous Girls and the Most Beautiful Boy of Hollywood, Paula Lee." In July 1955, an Alameda ad replaced its more typical "GIRLS! GIRLS! GIRLS!" banner with "GIRLS? GIRLS? GIRLS?" and a performer lineup including popular stripper Sande Marlowe, implying a mixed revue that would leave patrons guessing.[151]

THE DANGERS OF TRANSGENDER EXPRESSION

Performing in drag was a potentially risky occupation, as many U.S. cities had laws against dressing in the clothing of the opposite gender—in Sacramento, the specific charge was called "masquerading," and drag

performers who failed to change their clothes after a performance risked arrest and imprisonment. For transgender persons and cross-dressers, this meant the risk of arrest was part of their daily lives. On November 17, 1952, Fred Jackson, bleeding from the nose, approached police while dressed in a two-piece women's suit, stockings and high heels. Jackson reported that he was attacked by a man near Fourteenth and K Streets, about a block from the Ron-D-Voo Club. Instead of pursuing the attacker, the police arrested Jackson. Jackson worked as a janitor, wearing male clothing on the job, but wore women's clothes when away from work. He was sentenced to ninety days in jail for the crime of "masquerading" because he sought help from the police.

On October 14, 1953, Charles Lindsay, a twenty-four-year-old Sacramento drag performer, was arrested for masquerading and assault and battery in an altercation with Bessie Bibbs. According to the *Sacramento Bee*, Bibbs realized that Lindsay was wearing her skirt and that he had visited her room at 421 Capitol Avenue (in a rooming house at the former Churchill dance hall, which was then owned by Bennie Twigg) the previous night with a mutual friend. When Bibbs accused Lindsay of stealing the skirt, he drew a knife and cut Bibbs. Lindsay pled guilty to the charge and was given a suspended sentence on the condition that he would leave Sacramento for two years.[152]

Transgender prostitution was present in Sacramento and carried great risks, especially for persons of color. As reported in the *Sacramento Bee* on November 7, 1952, police officer Edward Domich picked up twenty-seven-year-old Jimmie Curtis, a transgender woman, who solicited Domich at 1:00 a.m. Domich let Curtis into his car, later stating that he planned to arrest Curtis for prostitution. Shortly after Curtis left Domich's car at her residence and asked him to wait before letting him into her home, Domich realized his wallet was missing and attacked Curtis, who defended herself with a piece of picket fence. Domich, who was six feet tall, was surprised by Curtis's strength considering her size (approximately five-foot-six) and beat her until other police units arrived a few minutes later. Curtis suffered severe cuts and bruises, a skull injury and rib fractures and was sentenced to a year in the county jail. Like Charles Lindsay, Curtis was given a two-year banishment from Sacramento by the municipal judge for the crime of "wearing a disguise in conjunction with the commission of a crime," referring to the dress, wig, painted fingernails and toenails Curtis was wearing when she was attacked.[153]

Transgender Pioneer Tamara Rees

Tamara Rees became Sacramento's most unique burlesque performer of the 1950s due to her status as the United States' third recipient of gender reassignment surgery. Following Christine Jorgensen in 1952 and Charlotte McLeod in early 1954, Rees' journeys brought her to Sacramento, where she lived both prior to and after her transition. Born in Kansas City, Missouri, in 1924, her family relocated to Montgomery, Alabama, where Tamara, whose name at birth was Robert Egan Rees, first recalled having her earliest wishes for a doll house and dresses. In 1931, her family moved to California, living in Los Angeles and Fresno, where she felt growing discomfort, shame and isolation from other young people due to her mannerisms and lack of mutual interests. She often experienced depression and alienation as a result of her feeling that she was born in the wrong type of body, a condition later called "gender dysphoria."

At fifteen, she ran away from home, reuniting with her family in Oakland in 1940. She briefly served in the Civilian Conservation Corps and the navy but was discharged from both services. She relocated to Reno, Nevada, studying psychology and working in a tuberculosis ward at Washoe General Hospital. During this period, she met a fellow psychology student named Ray. At the end of the semester, following the United States' entry into World War II, both Rees and Ray enlisted in the army, volunteering to become paratroopers because, in her words, "My only motivation for this enlistment was my feeling that in joining an outfit noted for its rugged training and manliness, that I would be more generally accepted by society and would thus remove the ridicule and accusations of homo-sexualism."

Despite her small stature and previous disinterest in athletics, Tamara successfully completed jump school and shipped out as a combat paratrooper with Ray, who, according to Tamara's autobiography, *Reborn*, fully accepted her as she was. As combat paratroopers, they both shipped out to North Africa, where they were assigned to the Eighty-Second Airborne Division, Fifty-Fourth Parachute Regiment. They participated in the U.S. landing at Anzio, for which Tamara was awarded a Bronze Star and Presidential Unit Citation. Their next jump was part of Operation Market-Garden, where they participated in a daring river assault across the Waal River at the border between Holland and Germany to capture a critical bridge. After completing the river crossing, an artillery shell landed near Tamara and Ray. Tamara was dazed by the explosion. When she regained consciousness, Tamara realized that Ray was critically injured.

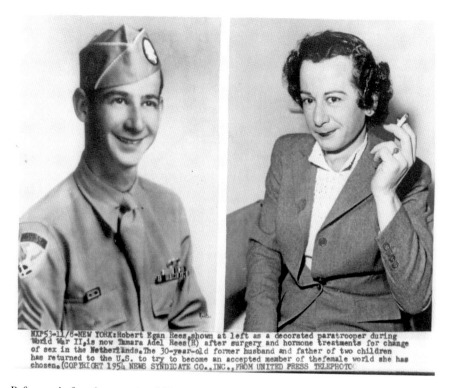

MXP53-11/8-NEW YORK: Robert Egan Rees, shown at left as a decorated paratrooper during World War II, is now Tamara Adel Rees (R) after surgery and hormone treatments for change of sex in the Netherlands. The 30-year-old former husband and father of two children has returned to the U.S. to try to become an accepted member of the female world she has chosen. (COPYRIGHT 1954 NEWS SYNDICATE CO., INC., FROM UNITED PRESS TELEPHOTO)

Before-and-after photographs of Tamara Rees, army paratrooper during World War II and the third person in the United States to undergo gender transition surgery. *Transas City.*

As she tried to dress the wound, Ray said to her, "Tell my mother I love her," and died. Rees continued the battle in a daze, having lost the person she considered her only true friend.

Corporal Rees continued her service through the Market-Garden campaign and the Battle of the Bulge, receiving the Dutch Order of Orange and Belgian "Fourragere" medals, but suffered a serious head injury in January 1945. She returned to California to recuperate from the injury, which caused partial paralysis of the right side of her face, and was discharged from the army. After the war, her travels began again, with stops in Bakersfield, Mendocino County and Oakland. In 1947, she visited Sacramento and decided to stay.

Finally, in an unexplainable urge, I went to Sacramento, California in the early spring, and here I decided to purchase a home. It was spring and the trees were all leafed out. The town appeared so peaceful and serene that I

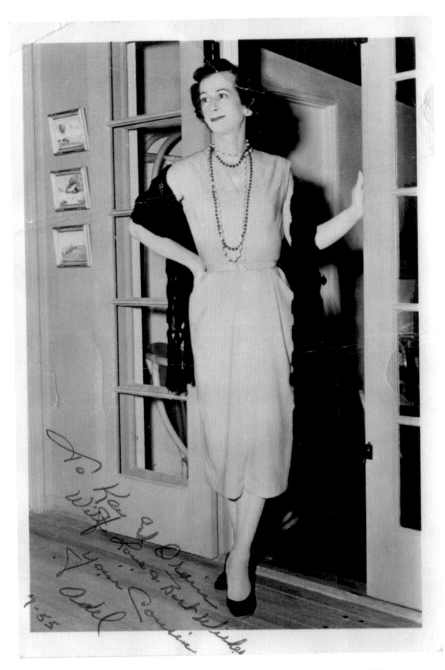

Autographed photo of Tamara Rees signed in 1955; Adel was Tamara's middle name. *Chris Egan.*

again thought I had found the answer. The city at this time of year was beautiful. A few days after my arrival I saw and fell in love with a typical California ranch style home situated in the suburbs of town.[154]

Tamara found work as a parachute instructor and, partnering with a fellow paratrooper, founded a parachute school at Sacramento Airport (now Sacramento Executive Airport). In addition to teaching, they developed different styles of exhibition stunt jumping. Tamara became a licensed pilot, and they regularly performed as pilots and parachutists at air shows throughout California. In 1949, during her 527th jump, Tamara's parachute failed to open when the rip cord was pulled. She was able to extract the chute by yanking it out of the pack but broke her leg when she hit the ground. The following week, at an air show in Perkins, east of Sacramento, her partner's chute failed to open during a risky low-altitude jump, and he struck the ground, dying instantly. Tamara immediately lost all desire to continue her career as a parachutist. After a sojourn to Los Angeles, where she worked in interior design, Tamara prepared for yet another leap into the unknown after a psychiatrist recommended gender reassignment surgery.

After extensive consultation and hormone therapy, Tamara returned to Holland in November 1953 for the first time since the war and underwent the still-experimental and risky surgeries and therapies necessary for her transition, followed by recuperation and additional therapy. She came back to the United States in November 1954; Congressman John E. Moss, of the Third District of California, assisted in her return to the United States as a woman. Since Tamara Rees was the third American to receive gender reassignment surgery, media response was subdued compared to the reception given to Christine Jorgensen, but Tamara's arrival in New York and Los Angeles airports drew significant press attention.

After a brief stay in Los Angeles, Tamara returned to Sacramento and reunited with her family, beginning a new career as an entertainer. She made regular appearances at the Alameda Theatre on L Street, developing an act that incorporated dance, striptease and education. Several of her matinee appearances at the Alameda were limited to female audiences only. Sharing the Alameda's marquee with performers including dancer Sande Marlowe, Tamara's act included lectures on "straight psychology" and stories about her experiences in addition to her striptease performance. In 1955, she married Hollywood hairstylist James Courtland in what was probably the first registered marriage of a transgender person in the United States. Their marriage lasted less than a year, as Courtland was uncomfortable with

TAMARA REES

After her transition, Tamara became a burlesque performer whose act included frank discussion about her life story and her surgery during her lectures on "straight psychology." *Chris Egan.*

Tamara's career choice as a stage performer and preferred that she stay at home. While Tamara also professed a great satisfaction with domestic life, the call of the stage was stronger, and she took her show on the road, performing at burlesque clubs around the country. Within a few years, she settled down again, marrying Robert Stevenson in the late 1950s and relocating to Youngstown, Ohio, where she settled down and adopted children. After Robert's death in 1997, Tamara returned to the Sacramento area, living in Elk Grove until she died on August 12, 2000, at age seventy-six.[155]

Despite her travails and tragedies, Tamara Rees expressed gratitude for and satisfaction with her transition and made a deliberate effort to educate others about her experiences via her autobiography and stage performances.

GAMBLERS, JAZZ AND B-GIRLS

The cops, the government was always against this, not because they thought gambling was bad, but because they weren't getting their cut. They knew they couldn't control it, they couldn't legalize it, they just wanted to make sure that nothing really bad happened around it. So they might raid a bookie joint once in a while but they were fully in operation the next day, or a day or two later.
—*Ted Pantages*

By the 1940s, the West End included many venues notorious for vice, including the taxi dance halls of Big Nick Matcovich and the legendary Equipoise Café, owned by Sacramento gambler Frank "Butch" Nisetich. For jazz aficionado Al Oxman, the Clayton Club became a venue to celebrate traditional jazz and an intimate performance space for some of America's greatest jazz legends. For disgraced nightclub owner Frank Sebastian (born Fenolio Sebastiano), his Sacramento nightclub became a path to success. Many of these nightclub owners were European immigrants whose ethnic identities fell away in the era following World War II, and they benefited from this transition to whiteness. While they often received police attention for the same infractions as Black-, Chinese- and Japanese-owned clubs, they were rarely shut down for long, even if the illegal behavior was far more obvious. Sometimes, this selective enforcement led to criticism of the police by local media, city government and other nightclub owners. Selective enforcement may have been racially motivated, or perhaps some club owners simply failed to

bribe the right city official. Young gambler Ted Pantages grew up amidst the gambling scene of the West End in the 1930s and learned how club operators interacted with city government.

> *It was almost impossible to make any money selling just food, as you had to give a cut off all your business to the owner of the building. You made all the money selling booze, or providing drugs for your best customers, or allowing the "girls" to ply their trade in exchange for a cut of the action. Beat cops were almost all on the take. Why not? It was going to go on anyway. You might not take money directly, but you provided protection by going there after work with your buddies. Four or five cops sitting in the bar was going to keep the other bad guys away.* —*Ted Pantages*

Taxi dance, or dime-a-dance, halls, where men paid by the minute to dance with women employed by the hall, were legal venues on the outer edges of the sex industry that were often associated with prostitution by implication.

The corner at Ninth and K Street, facing southeast. Sacramento's central city became an increasingly crowded place during the 1940s due to an influx of soldiers and workers, but wartime rationing limited construction of new housing. *Center for Sacramento History.*

B-girls, women who provided company for men in bars in return for drinks (and who received a percentage of drink sales from the bar), worked outside the law but served a role similar to that of taxi dancers—pretending to be interested in men in return for money.

TAXI DANCERS AND "BIG NICK" MATCOVICH

Nicholas Nikolin Slavo (N.N.S.) Matcovich, better known as "Big Nick," was born in Croatia in 1878, came to the United States in 1895 and arrived in Sacramento around 1916. By 1919, Matcovich called himself "Nicholas Matco" and operated the St. George Hotel and Free Labor Bureau (later called the St. Nicholas Hotel) located at 1007 ½ Fourth Street. Sacramento labor bureaus were hiring halls for migrant and seasonal workers. By providing housing and employment under one roof, Matcovich collected both room and board and a percentage of the wages earned by the Filipino men who lived at the St. Nicholas.

In 1911, he married Florence Begley in nearby Folsom. In 1926, Florence filed for divorce, citing extreme cruelty. In the divorce proceedings, Florence testified that since 1916, Nick had been violent, abusive and controlling, forbidding her from visiting friends or relatives, with a vicious temper, frequently telling her that he would "shut her mouth for good." In 1930, he remarried, but his second wife, Delia, divorced him in 1940, also due to extreme cruelty.[156]

In 1933, Matcovich acquired additional properties, including a billiard hall at 318 K Street, a candy shop at 1118 Fourth Street and the Bon Ton dance hall, a taxi dance hall, at 426 K Street, renaming them with the same "St. Nicholas" as his hotel. Taxi dancers were an innovation from San Francisco's Barbary Coast, popularized nationally during the 1920s in many American cities. Single men purchased ten-cent tickets from a window near the building's entrance, with each ticket entitling them to one dance with a female employee, who earned five cents for each ticket they received. The house band played medleys of popular songs, changing the tune every minute or so, and the change in tune indicated when the dancer collected another ticket from the customer. Taxi dance halls met a social need for lonely men seeking companionship and an economic need for single women. Many customers assumed, incorrectly, that taxi dancers were otherwise sexually available, either as willing dates or via prostitution. In some cases,

The Hotel St. Nicholas, owned by "Big Nick" Matcovich (often shorterned to "Nick Matco"), was home to a Filipino workforce consisting of people who were also hired out to work via an employment agency on the ground floor. Matcovich later opened a taxi dance hall here, which drew official ire for its toleration of interracial dancing. *Sacramento Public Library.*

women who started as taxi dancers were hunted by procurers in the dance halls. In October 1933, city manager James Dean considered closing the Bon Ton after procurer Joe Frank and dancer Mabel Wortman attempted to induce sixteen-year-old Marianna Field, a dancer at the club, to become a prostitute. However, most taxi dancers' activities were limited to the dance hall itself. Big Nick's place was one of many Sacramento taxi dance halls, including the Pythian Castle, Dreamland and Joyland.[157]

As in the other dance clubs of the West End, interracial dancing was forbidden by city decree. The hotel residents were Filipino, but due to the laws regulating immigration from the Philippines, only men could migrate to the United States, thus there were no Filipina dancers available to work in the dance hall. Matcovich hired white women as dancers, arousing the ire of the Sacramento City Council, which closed the hall in August 1933. A few weeks later, Matcovich and the city council came to an agreement that he would operate two dance halls on different floors: one floor for white men

Dreamland Dance Hall was one of many taxi dance halls where men paid ten cents per ticket to dance with a club employee, who received half of the ticket's cost as a salary. *Center for Sacramento History.*

with white dancers, and another "separate but equal" floor for Filipino men with Latina dancers.

In 1934, Matcovich asked the Superior Court for a writ of mandate requiring the city council to grant a license for the Santa Lucia Dance Hall, a "black and tan," or, as the *Bee* sometimes described it, a "white and tan," in the former candy store on Fourth Street. The term "black and tan" originated with early Republicans who advocated for racial integration, but by the 1930s, the term was used to refer to mixed-race nightclubs. Matcovich claimed that because the Santa Lucia was a private club for Filipino men, it was not subject to the same regulation as a taxi dance hall that was open to the public. Later dance halls opened by Matcovich in 1935 and 1936 still sought the "black and tan" status, but these later clubs were open to the public.

City council members and the public recoiled at accounts that Black men, in addition to Filipinos, were dancing with white women at Big Nick's halls, and his new permits were flatly refused. Matcovich continued to operate dance halls until his death in 1948, and the reasons for his insistence on

Jazz drummer Ernesto Crudo and Johnnie Arriba, wife of Filipino bandleader Jerry Arriba, circa 1939 at Third and M Streets. *Center for Sacramento History.*

"black and tan" halls are unclear. Matcovich was no civil rights crusader, and if his personal life is any indication, he was a foul-tempered, angry, cruel person with no respect for women. He appears to have persisted in his efforts to open integrated dance halls simply because he was stubborn and determined to get his way. In 1936, after finally giving in to Matcovich's demands to provide him a permit, Sacramento mayor Thomas Scollan instructed city manager Charles Dean to do what he could to ensure the place was well managed and said of Matcovich, "When they wrote that song, 'I'll Be Glad When You're Dead, You Rascal You' [a Louis Armstrong song recorded in 1932], I think they had Big Nick in mind."[158]

TAXI DANCERS ORGANIZE FOR LABOR RIGHTS

Matcovich's dance halls came under scrutiny again for a labor dispute. In 1939, a former dancer at the Rio Ballroom applied for unemployment insurance but was denied. Since the establishment of federal

The Rio Dance Hall on J Street was a taxi dance hall owned by "Big Nick" Matcovich. *Center for Sacramento History.*

unemployment insurance in the mid-1930s, Nick's dancers paid 6 percent of their nickel per dance—presumably a deduction for unemployment insurance. Matcovich claimed the 6 percent was to cover the cost of free, non-ticketed dances given to patrons and stated that the dancers at his hall were independent contractors, not employees. The state unemployment commission found for the employees, but Superior Court judge Peter J. Shields ruled for Matcovich, leading Nick to apply for a refund of Social Security taxes filed in the interim. An anonymous taxi dancer sent a letter to the *Bee* making the case for their status as employees:

> *If we dancers are in business for ourselves and do not work for Nick Matcovich, why are we obliged to be to work by a certain time and not be allowed to leave or go home before closing time from this place of business? We work under and within house rulings, and in our eyes this makes "Mr. Nick" our boss.*

After several appeals, the final decision in 1945 established that taxi dancers were employees, not independent contractors—a victory for the rights of female workers.[159]

In the midst of this court battle, Matcovich also came under scrutiny for his use of "B-Girls," a charge applied frequently to his dance halls starting in the mid-1930s. A *Sacramento Bee* journalist identified as "The Rounder" visited the Rio Dance Hall in June 1943 but never got to dance. His evening began when a dancer, Marie, joined him and a friend for a drink at the Rio's bar, and the men discovered they charged sixty cents per bottle in an era when the going rate for a bottle of beer was fifteen cents. Marie also discussed her reasons for working in a taxi dance hall:

> *I used to work in a cannery, but that's too tough, so I got a job here five years ago, and I like it fine. You don't have to dance or drink with anybody you don't want to. Once in a while a guy gets pretty fresh, but that doesn't happen too often....Some people think men are foolish to come here and spend 60 cents for a beer just to talk to a girl. But what I always say is: It's better than talking to yourself...I don't think the men who come in here are suckers. They get companionship, and good conversation, and get to meet nice girls, and it only costs them 60 cents a beer.*

When asked why Marie seemed more interested in conversation than dancing, she replied, "I really can't dance. I'm pretty tall, you know, and all my weight seems to be in my feet." The reporter noted that more of the dancers present were conversing at the bar with those paying for sixty-cent beers, and only a few were present on the dance floor, implying that the profit a dancer received for a sixty-cent beer was more than for a ten-cent dance ticket. However, no matter whether soldiers and other patrons preferred expensive beer and conversation to dancing, the practice was illegal. Just four days later, on June 30, the *Bee* reported a statewide investigation into the use of B-girls in taxi dance halls—paying a percentage of receipts to a hostess, waitress or entertainer was prohibited by state alcohol regulations. The Rio Dance Hall was called out as the primary example of the practice; being in the shadow of state government often meant statewide investigations were applied to Sacramento violators with extra vigor. Despite these statewide efforts, Matcovich's clubs remained open until his death in 1948.[160]

AL OXMAN'S CLAYTON CLUB

Located at 1126 Seventh Street, the Clayton Hotel was completed in 1911 and built by Hattie Clayton Gardiner in honor of her parents, Dr. Marion Clayton and his wife, Sarah Clayton. The five-story hotel was designed by architect Charles W. Dickey and featured furniture by Breuner's, which had a main showroom directly west of the hotel. The hotel replaced the Claytons' Pacific Water Cure, a "sanitarium" where they advocated better health through bathing and hydrotherapy. Marion and Sarah were prominent in Sacramento Progressive circles as advocates of alcohol prohibition, improved sanitation and water systems and public health. Sarah helped establish Sacramento's county hospital on Stockton Boulevard (later UC Davis Medical Center) and the Protestant Orphan Asylum. Marion died in 1892, and Sarah died on October 28, 1911, just a few weeks after women gained the right to vote in California. The clean-living, Progressive Claytons might have been disappointed by the revelry and debauchery of the hotel's nightclub named in their honor—the Clayton Club.[161]

The Clayton Hotel, later renamed the Marshall Hotel, was home to the Clayton Club, which was owned by traditional-jazz aficionado Al Oxman. *Center for Sacramento History.*

Born in 1910 in Toporov, Russia, Albert Oxman took over operation of the Clayton Hotel's ground floor restaurant and bar in 1939. By the late 1930s, jazz had transformed into diverse styles, but Oxman had the greatest affection for the original New Orleans sound of traditional jazz, his preferred format for the club. In August 1940, Oxman remodeled the lounge in a nautical theme and announced the opening of the S.S. Clayton Club. While traditional jazz was Oxman's love, the club initially featured a two-man "Hawaiian orchestra," Walter Kalani Lane and Walter Perry, playing steel guitar and Spanish guitar for a year-long run from 1943 through 1944. When nearby West End jazz clubs like the Zanzibar featured touring jazz acts, Oxman followed suit, but with the growing popularity of tiki culture, Hawaiian-themed acts still played the Clayton Club, including Salome McIntyre, a Hawaiian performer whose best known act was a comedy/dance routine called "The Cockeyed Mayor of Kaunakakai." When other Sacramento jazz clubs advertised their free-form jam sessions, the Clayton Club also followed suit with a Sunday jam from 2:00 to 6:00 p.m.[162]

Disaster struck on Sunday, April 4, 1948, when fire seriously damaged the Clayton Hotel, killing one person and seriously injuring fifteen others, including bandleader Dick McIntyre, who leapt to safety from a second-floor window. Despite extensive damage to the hotel and its ground-floor stores, including the Hof Brau Café, Clayton Barber Shop, Clayton Club and Aquarium Fish Grotto, the Clayton Club reopened on July 9. The hotel was renamed the Hotel Marshall, and the remodeled Clayton exterior had a contemporary, mid-century look, but Oxman still focused on traditional jazz, drawing acts including Pee-Wee Russell and, in 1952, an exclusive engagement with Louis Armstrong. That year, 1952, also saw another jazz legend, Billie Holiday, performing at the Clayton Club in an exclusive engagement. Dan Winkelman, who was only six years old at the time, saw Holiday's performance at the Clayton Club, as he was brought to the club by his parents. Dan was only allowed into the club for a short while before management noticed that Dan was far too young to visit a bar, so his parents enjoyed what they could of the show from the sidewalk. According to Dan, "When she wasn't singing, it was like she really wasn't there," which he learned much later may have been due to her ongoing issues with heroin addiction, but her extraordinary talent clearly shined through in her performance. At the end of the show, she exited the club past Dan and his parents and handed Dan the white flower from her hair before entering a waiting car and departing the club.[163]

Dan was not the only minor who snuck into the Clayton Club. Sacramento jazz musician Burt Wilson, who was nineteen years old in 1952, was present for jazz legend Louis Armstrong's engagement at the Clayton:

> *How they made music! It was dazzling. And right there in Sacramento! They played all kinds of tunes and after listening to Jack Teagarden play "Basin Street Blues," I wanted to rush over to the Southern Pacific train yard and throw my trombone under the first switch engine that came along.*[164]

Unfortunately for the Clayton Club management, following state alcohol rules was sometimes a problem. Despite his restaurant background, regular advertisements for a "businessman's lunch" and dinner specials, in 1948, Oxman was charged by a state liquor administrator because food was not served after the lunch hour, violating their restaurant-type liquor license. This became a recurring problem at many Sacramento venues, because a restaurant/bar license was less expensive and easier to obtain than a "full bar" license with no requirement to serve food—an ongoing issue since the days of Ancil Hoffman and the "cheese sandwich" controversy.[165]

Advertising for the Clayton Club took a different turn in the mid-1950s, when Oxman hired graphic designer George Louie to design angular, eye-catching ads for Clayton Club shows, which featured performers ranging from legendary jazzman Cab Calloway and comedian/tap-dancer Gene Bell to R&B/jump blues combo The Treniers. In 1952, Oxman added striptease to the mix of entertainment at the Clayton in shows considered risqué enough to tout as "OUT OF BOUNDS TO MILITARY AND NAVAL PERSONNEL AND UNESCORTED WOMEN" in newspaper advertisements. This resulted in more legal trouble for Oxman in August 1953, when police arrested dancer Cherri Lee at the end of her performance for "indecent motions" and insufficient coverage by her stage costume, which, according to the arresting officer, was small enough to fit into an envelope. Lee was charged with indecent exposure, and Oxman was arrested for pandering.[166]

The Clayton Club encountered its final bout of trouble in 1955, when Alcoholic Beverage Control agents arrested Oxman for employing B-Girls in his establishment, like those at Nick Matcovich's dance halls. Oxman appealed the decision, claiming that the women were dancers furnished by a theatrical agency and not his employees. After several appeals, the Clayton Club lost its liquor license and ultimately closed in November 1957. Oxman made several attempts to apply for another liquor license

but was repeatedly denied. After eighteen years, Sacramento's home for traditional jazz closed its doors, and perhaps the ghosts of the Claytons could finally get some rest.[167]

"BUTCH" NISETICH AND THE EQUIPOISE CAFÉ

From 1918 to 1919, West End gambler Frank "Butch" Nisetich (the older brother of Kitty Nisetich—see chapter four) served in the U.S. Army's American Expeditionary Force in Battery B of the 145th Field Artillery in France during World War I. Already an experienced gambler and arrested more than once in West End social clubs for dice games, Butch became skilled enough at cards while stationed in Europe to build a nest egg large enough to become a professional gambler and bookmaker when he returned.[168]

> [Nisetich] *had started playing cards when he was in France during the first war. He would send his wife home his winnings as he didn't know if he was coming back or not. That was the stake he used to open up his first card room. He used to get raided all the time, when he was younger, before he had the shop, but I don't think he was ever convicted....The story was that a police captain offered him "patronage" for a cut of the business and protected him.* —Ted Pantages

Butch's profession was still listed in city directories as a butcher from 1919 until 1933, although he was already involved in gambling and bookmaking and owned a dog racing track on Lower Stockton Road. In 1932, he opened the Sacramento Social Club at 415 K Street and renamed it the Equipoise Club, after a champion racehorse, in 1935. Raids on Butch's club began almost immediately, averaging about one raid every three months. None resulted in a conviction, but they did spur Butch to temporarily relocate to San Francisco, leaving management of the club to his nephews, Stanley and Lawrence Nisetich. In 1940, Attorney General Earl Warren's statewide campaign against illegal bookmaking targeted clubs like the Equipoise by removing their phone lines. Cutting the lines deprived gambling rooms from learning who the winners were in regional horse races, slowing or stopping their business; to operate, gambling halls had to use nearby pay phones to report on races. Under pressure from Warren, Butch and approximately nine

hundred other defendants agreed to a "consent decree" preventing them from placing bets on horse races. Butch used this temporary interruption in his business to build the Alhambra Bowl bowling alley on the corner of Alhambra and Folsom Boulevard in 1942.[169]

Police chief Alec McAllister was directed by the Sacramento City Council on February 2, 1943, to rid the city of all forms of gambling. This directive was part of citywide efforts to eliminate vice from the West End during World War II and thus avoid having Sacramento declared "off limits" to military personnel stationed nearby. The next day, Chief McAllister reported that all gambling activity in Sacramento had ended, and special squads were assigned to ensure that no cards were turned or dice were rolled in the West End. Despite this glowing report, the *Sacramento Bee* vice reporter,

The Equipoise Café, located at 415 K Street and owned by "Butch" Nisetich, was raided regularly by police for illegal gambling. *Center for Sacramento History.*

the "Shortender" described an already-recovered gambling industry a few days later. In June 1943, the Equipoise was raided again, revealing four new telephone lines and a telegraph in a basement office next door at 419 K Street, which could be accessed via a secret entrance from the Equipoise. A blackboard seized in the basement raid listed other phone numbers, including two registered to El Marteen, a stage magician who occupied the ground floor above the basement hideout. The magician told detectives he only ordered one phone line, but a second line, used by the Equipoise bookies, was ordered in his name. Charges against the Equipoise staff were dismissed because they were charged with vagrancy, not bookmaking.[170]

Nisetich operated the Equipoise Card Room for many years. The card room included a bar and restaurant. Everyone used to go there—lobbyists, politicians, policemen, you name it. —Ted Pantages

In December 1943, the Equipoise again came under scrutiny, this time for purchasing black-market butter and ham, which were tightly rationed during the war. Investigators discovered that military personnel at an Army Signal Corps base in Davis stole food items from military stocks and, through an intermediary named Lewis Gage, sold them to James Burich, operator of the Equipoise restaurant. Gage, Burich and the soldiers were arrested on December 31, 1943. Burich was fined $250, Gage received a sentence of five years and the soldiers were dishonorably discharged and imprisoned.[171]

By the summer of 1944, the Shortender had resumed writing about racetrack betting and gambling in Sacramento, including at the Equipoise. On June 21, 1944, Chief McAllister reported to the city council, stating that "there is no doubt bookmaking is being practiced to some extent in Sacramento as well as in every other sizable city. We never have been able to obtain a conviction for bookmaking in Sacramento. The most effective way to handle this problem, we have found, is to discourage bookmaking in every possible way. This is being done," he reported, via his special vice squad. The Shortender reviewed these statements with a skeptical eye, and his muckraking resulted in another short-term closure of the Equipoise. In response, racehorse gambling temporarily relocated from Sacramento to North Sacramento, especially to the Rex Grill at 2217 Del Paso Boulevard. However, the police sweep was far from comprehensive; an August 24, 1944 story about gambling in North Sacramento by the Shortender was bracketed by a story about a stabbing in a Chinese-owned gambling club at 300 I Street. While reporters indicated that the location was a known card room operating lottery and fantan games, detectives Otto Dahl and Henri Warren of Chief McAllister's vice division reported finding no evidence of any gambling whatsoever immediately after the arrest of a customer who stabbed a card dealer at the club. North Sacramento police seemed similarly myopic regarding reports of gambling. When a customer at the Rex Grill called police to report a nickel slot machine that never paid out, police replied that slot machines were for amusement only, and no payout was expected or required. The Equipoise was back in operation by December 1944.[172]

Police reacted far more quickly when cheaters visited the Equipoise. On November 12, 1945, police apprehended Otis Carter of Reno, Nevada, after he won $111 in ten minutes at the Equipoise's poker table. Patrolman Virgil Wells immediately responded to the club's report of a cheater—when Wells arrived, Carter strolled back to the card table and tossed his chips to the gamblers he had just fleeced, remarking, "Here, boys, divide them up!" At the city jail, Carter was searched, revealing a mechanical "holdout device"

allowing him to retain cards from the deck, a device used to palm poker chips, an assortment of dice and a deck of marked cards. When asked why he left Reno, Carter remarked, "It got too warm in the snow country."[173]

Enforcement at the Equipoise and other downtown gambling spots was a mixed bag of myopia and pinpoint accuracy. In February 1946, police seized pinball machines that paid off in cash from the Equipoise and seven other Sacramento area bars. Unlike the North Sacramento nickel slot machine that never paid off, these gaming machines were illegal because they *didn't* steal the customer's money 100 percent of the time. By June, the Shortender sounded another alarm about wide-open gambling in his own sarcastic manner: "It was wonderful! I did not have to sneak in alleys, give passwords, or rap furtively on doors.

Frank "Butch" Nisetich, circa 1960. *Center for Sacramento History.*

I just walked in with the rest of the gambling public, made my bets and lost my money." His conclusion was confusion based on the stark differences between what was visible at clubs like the Equipoise and what was stated in police reports.

> *I read in the paper the next day that* [Officers] *Lincecum and Rooney had reported no evidence of bookmaking had been found. That sort of baffled me…am I nuts, or do the coppers need bifocals? —The Shortender*[174]

Again, city officials responded to the Shortender's needling with renewed promises from city manager Bartley Cavanaugh to crack down on gambling and continued denials by police that any gambling equipment was present at the Equipoise. Finally, in March 1947, Cavanaugh fired Chief McAllister, primarily for his failure to control gambling in the West End. Cavanaugh also proposed expanding the vice unit from three officers to a new police division with its own captain and promised redoubled efforts to shut down gambling halls, appointing James V. Hicks as the city's new police chief.[175]

A few weeks later, on April 1, 1947, a delivery driver dropped a case of whiskey and an envelope containing $3,000 at the home of Bartley

Sacramento city manager Bartley Cavanaugh gained a reputation for incorruptibility after a clumsily offered bribe from a card-room owner. This led to local gambling interests calling for his removal from office. *Center for Sacramento History.*

Cavanaugh, along with a note asking that Chinese clubrooms closed by the recent police department shake-up be allowed to reopen. District attorney John Quincy Brown identified Dong Haw, owner of the club at 300 I Street, as the party responsible for the bribe. This bribe resulted in a grand jury investigation but provided a temporary reprieve to clubs like the Equipoise, as attention was diverted to the prosecution of Haw for the attempted bribe. This incident gave Cavanaugh a reputation for incorruptibility to the point where gambling interests called for his removal, but he had the support of city council and retained his job until 1964.[176]

By January 1948, City Manager Cavanaugh and Chief James Hicks reported that no bookies were operating in Sacramento. Police pressure had increased enough that, in the following month, the Equipoise owners tried a new method to disguise their gambling operation: providing education in methods of probability and statistics.[177] As the Shortender reported in the *Bee*:

It's just like they say down at headquarters—there isn't any bookmaking going on in this man's town. But you can get a membership in The West End Study Club For Improving The Minds Of Turf Followers. Then you can sit around in the back rooms of such spots as…the Equipoise Card Room at 415 K Street and improve your mind by study and concentration. And if you work real hard, the teacher is likely to give you a prize. These conclusions are the result of a cultural mission I went on Saturday in order to find out whatever happened to the wily bookies who are supposed to be so far undercover they get the bends when they come up for air.[178]

In the end, redevelopment, rather than police action, finally resulted in the closure of the Equipoise at 415 K Street. However, the club did not remain closed for long, as it reopened at 1126 Seventh Street, the former location of the Clayton Club, in 1959. The Equipoise relocated again a

decade later to Alhambra Boulevard, ending up in a building that was still a card room as recently as 2019—the Limelight. The Equipoise outlived Butch, who died, frequently tried but never convicted, in 1975 at eighty-nine years old.[179]

FRANK SEBASTIAN, FROM THE COTTON CLUB TO THE EL DORADO

Born in 1896 in Bagnolo, Italy, Fenolio Sebastiano arrived in the United States via Seattle in 1917, immediately heading south to Los Angeles, where he opened the Venice Café and renamed himself Frank Sebastian. By 1925, he had renamed the café after his assumed name and featured local and touring jazz musicians. On February 18, 1926, he opened the Cotton Club, a larger and more ambitious jazz venue, in Culver City. While the name was inspired by the Cotton Club in New York, there was no relationship between the two. Because it was located outside the Los Angeles city limits, the club was not subject to the citywide 2:00 a.m. nightclub curfew and stayed open all night. Patrons who remained all night were rewarded for their tenacity with a free ham-and-eggs breakfast in the morning. The Cotton Club featured exclusively Black musicians performing for a white audience and featured the greatest jazz talents of the 1920s and 1930s, including Louis Armstrong and Fats Waller. Armstrong's engagement at the Cotton Club lasted for nine months and included multiple record releases on Okeh Records featuring "Louis Armstrong's Sebastian New Cotton Club Orchestra." Sebastian's club became one of the best known and most successful nightclubs in southern California.[180]

Despite operating what was undoubtedly a speakeasy during Prohibition, Sebastian's legal trouble with liquor control officers came in 1935, after Prohibition ended. A special Senate committee investigating liquor control in California called Sebastian and his floor manager Walter Pollock to testify regarding raids during Prohibition, gambling at the club and contributions to campaign funds. Both refused to answer and were charged with contempt of court. Sebastian continued operating the Cotton Club until it closed in 1938, after which he relocated to Sacramento. In 1940, he opened his first Sacramento nightclub at 1020 Tenth Street: Café Donovan. While Sebastian may have wished to bring the "Cotton Club" name to Sacramento, there was already a club in Sacramento with that

Frank Sebastian, born Fenolio Sebastiano, was an Italian immigrant whose legendary Cotton Club was the toast of Los Angeles during Prohibition. After losing the club, he relocated to Sacramento and created another entertainment empire. *Center for Sacramento History.*

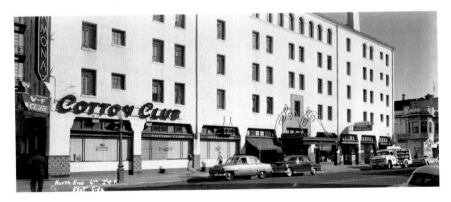

The Cotton Club, located in the Ramona Hotel at Sixth and J Streets and owned by local entrepreneur Joe Cotton, was a jazz club with a predominantly African American clientele. *Center for Sacramento History.*

name: Joseph Cotton's Cotton Club, which was located inside the Ramona Hotel at 604 J Street and dated back to at least 1935, with a predominantly African American clientele.[181]

Located in a space formerly occupied by Hart's Restaurant, Café Donovan was far smaller than the Cotton Club, and Sacramento was a smaller town than Los Angeles, but Sebastian's reputation and Hollywood connections promised first-class entertainment. After five years of growing business, Sebastian prepared to sell Café Donovan to Borrah Minovitch and Monroe Goldstein, but the sale was marred by a raid in February 1945 following reports of illegal gambling at the café. Based on the reports of the arresting officers, this was no mere back-room game but a *de facto* illegal casino operation. This charge was continued and shifted to Tom and Judy Bunch, the organizers of the game, who pled guilty. Police chief Alec McAllister agreed to have the case continued because the new owners were unfamiliar with city policy and because the Bunches claimed responsibility for the game. A subsequent charge of employing minors in a bar—in this case, two young musicians hired as part of the Café Donovan orchestra—was apparently too much to bear, and Café Donovan was closed in the spring of 1945, and its fixtures and appliances were sold at auction.[182]

Using proceeds from the sale of Café Donovan, Frank Sebastian, along with partner George Artz Jr., purchased the lease of the Hotel Senator. Given a higher-profile property and ballroom, Sebastian launched a new restaurant inside the Senator, the Centennial Grill, in 1948, anticipating the centennial of California's statehood in 1949. He also made use of the larger stage in the Hotel Senator's grand ballroom to draw bigger acts to Sacramento. However, as Sacramento's middle class began its postwar flight into the eastern suburbs and rumors of redevelopment cast doubts about the future of downtown, Sebastian and Artz began plans for a new venue outside the Sacramento city limits, like the old Cotton Club. This new project, the El Dorado, was a modern garden-style hotel featuring 260 rooms, air conditioning, televisions and a banquet hall. Unlike the Senator, which was built before the era of the automobile, the El Dorado had parking for more than one thousand cars. The site opened in 1958 and remained under the direction of Sebastian until 1964, when he held a five-year anniversary event featuring Louis Armstrong, his featured performer from the Cotton Club. Sebastian stepped back from direct control of the El Dorado in November 1968, but the property fell into foreclosure in March 1969, and in 1971, it reopened as the Woodlake Inn.[183]

FRANK SEBASTIAN'S Cafe DONOVAN

Sacramento's Only Theatre Restaurant

PRESENTS A NEW SHOW

— STARRING —

"The Host of the Coast" Frank Sebastian

★ **THE 3 SHERWOODS**
Direct from Hollywood!
A RARE TREAT!

also

★ **RUTH PRYOR**
Direct from the Panther Room—Chicago's Sherman Hotel—Ballerina Star of the Chicago Grand Opera!

★ **ARCHALEE**
New Dance Creations!

★ **PAUL PUTNAM**
Singing Maestro and his G-I jives and his orchestra!

★ **3 SHOWS NIGHTLY**
DANCING STARTS 7 P. M. EVERY NITE.

NO COVER CHARGE—NO MINIMUM
POPULAR PRICES

The Talk of the Town!

ADDED FEATURE!

COCKTAIL DANCING
SUNDAY AFTERNOON
2 to 6
FIRST COCKTAIL FLOOR SHOW
SUNDAY 5 P. M.

Popular Prices
CHOICE OF LIQUORS

SPECIAL DINNERS
A la carte service—Charcoal broiled steer beef steaks, squab and chicken stuffed with wild rice and other sumptuous foods in the Sebastian manner.

SEBASTIAN'S CAFE DONOVAN
SACRAMENTO'S ONLY THEATRE RESTAURANT
10th Street, Between J and K Dial 2-1903
FRANK SEBASTIAN Will Greet You in Person and Says:
"BUY BONDS FOR SPEEDY VICTORY"

Advertisement for Café Donovan highlighting the Hollywood talent Frank Sebastian brought to Sacramento. *Sacramento Public Library.*

Nick Matcovich, Butch Nisetich, Al Oxman and Frank Sebastian were all European immigrants whose ancestry transitioned from "ethnic" to "white" during the twentieth century. This transition was facilitated by the Anglicization of their names and their embrace of American culture. Each operated businesses with elements inside and outside the law in an era when police were paid to look the other way. As Sacramento's government modernized, and earlier systems of patronage came under scrutiny, the business owners who were able to transition to more legitimate business models—or at least less obvious forms of wickedness—faced less scrutiny and experienced greater success.

THE WEST END BLUES

"Any city that doesn't have a Tenderloin isn't a city at all."
—*Herb Caen,* San Francisco Chronicle *writer and Sacramento native*

he greatest crime in the West End was the framing and execution
of a neighborhood for offenses it did not commit. This crime
was justified by a long-standing civic dream of an orderly, clean
downtown that would attract orderly, clean citizens to Sacramento and help
it regain its lost status as California's second-largest city. From its early days
as the tenderloin through the postwar re-emergence of the West End, this
neighborhood did experience serious social problems. Instead of addressing
those problems, the neighborhood was removed from Sacramento's urban
core and its businesses and populations were scattered and replaced with
the tidy and antiseptic Capitol Mall. The Progressive dream was finally
achieved, in some respects, but it did not return Sacramento to its previous
position among California cities, and the absence of the West End limited
the city in other ways by destroying important elements of the city's
working-class culture.

The second-greatest crime in the West End was the theft of a
neighborhood's legacy. The contributions of the people of the West End,
from the jazz of the Zanzibar to the Chinese/Japanese cuisine of the
Wakano Ura restaurant, were gifts to the people of Sacramento in the
form of cultural production intended to appeal to the local market. This
included the sex trade of the *demi-monde*, the brothels of the tenderloin,

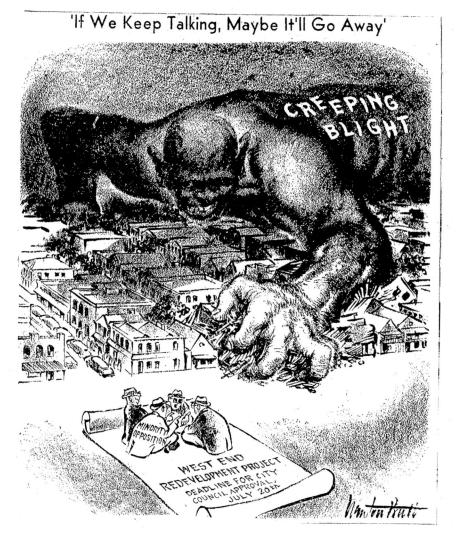

'If We Keep Talking, Maybe It'll Go Away'

This *Sacramento Bee* editorial photo demonstrates how racial fearmongering was used to promote redevelopment; a sinister, dark-skinned figure looms over downtown Sacramento while businessmen opposed to redevelopment are portrayed as blind or ignorant. *Sacramento Public Library.*

B-girls and taxi dancers, burlesque dancers, strippers and drag performers, who drew the dimes and dollars of Sacramento workers and businessmen, travelers and city residents purchasing fantasy, titillation and sexual release. The neighborhood's alcohol trade before, during and after Prohibition, and its legal and illegal gambling houses, were gathering places for the working class and the wealthy. The diversity of the West End, its mixture

of nationalities and languages, was a gift that was anathema in an era that encouraged separation, regularity and standardization. These gifts were ignored, appropriated and sometimes stolen or used as examples of why the neighborhood should be removed.

Redevelopment documents characterized the diverse cuisine and energetic nightlife of the West End as crude "greasy spoons and grog shops" unworthy of inclusion in Sacramento's future. In 1949, the *Sacramento Bee* ran a series of lurid articles by Hale Champion detailing the horrors of the West End and using disease metaphors similar to those used by vice crusaders and eugenicists as the Progressive crusade became a redevelopment crusade:[184]

> *Disease crawls out of the rooming houses and flophouses and chicken shacks of Sacramento's blighted areas into shocking statistics on tuberculosis and infant deaths into the city health records of scabies and impetigo and diphtheria and scarlet fever. Crime and vice and their junior partner, juvenile delinquency, loot cars and roll drunks and pull knives in the asphalt jungle of Sacramento's west end.*[185]

By the 1950s, following the Great Depression and material shortages of World War II, the West End was definitely a neighborhood in need of renovation and reinvestment, but the City of Sacramento's solution was demolition and displacement for the people who lived in that neighborhood instead of improvement of their homes and retention of their communities. Using federal redevelopment programs, only "blighted" neighborhoods received the matching federal funds necessary to acquire the land. Officially, blighted properties were not slums but were considered likely to *become* slums—and, as with redlining, the primary factor considered in assessing blight was the race of the people who lived in the neighborhood. Any attempts to reinvest, repair or otherwise detract from the image of the West End as Sacramento's wickedest neighborhood sabotaged the city's efforts to obtain those funds. This is why civic leaders like Henry Taketa, civil rights attorney Nathaniel Colley and advocates for West End businesses and residents were ignored by the city's redevelopment agency when they asked for less destructive alternatives to total redevelopment. Only Mayor Clarence Azevedo dissented in the final November 1954 vote to redevelop the West End, resigning from the redevelopment board after the deciding vote. Despite the construction of new buildings, rehabilitation of older buildings and concerns that most residents of the West End were prohibited

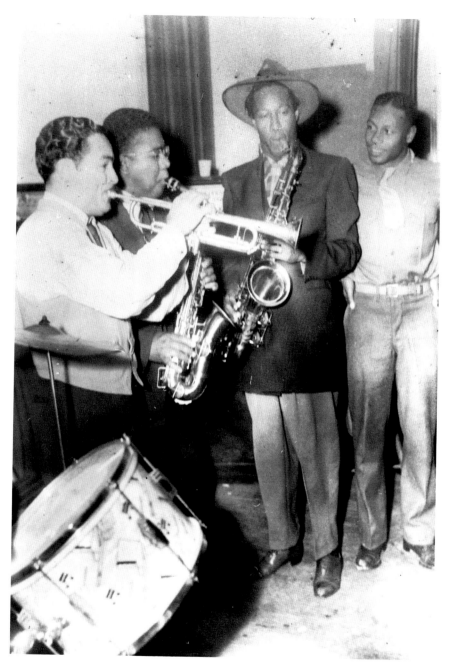

Local musicians perform at a Zanzibar jam session, including (*from left to right*) Harrell Wiley, Vincent "Ted" Thompson and Ray Jenkins. *Center for Sacramento History.*

Sacramento mayor Clarence Azevedo was the guest of honor at an Obon festival in 1956. Azevedo disagreed with the heavy-handed way that redevelopment was used to demolish the West End. *Ouye family*.

from buying or renting homes in Sacramento's racially restricted suburbs, there was no stay of execution for the neighborhood.[186]

The song "West End Blues," written by Joe Oliver and recorded by Louis Armstrong, refers to a New Orleans neighborhood, not Sacramento's West End, but the residents of the West End understood the sentiment of melancholy for a lost neighborhood that was far from perfect but whose cultural riches meant something to them, if not to those in positions of power. The West End represented Sacramento's urbanity and diversity in an era when U.S. cities sought a civic ideal that was anti-urban and pastoral, and based on the ideal of whiteness. Many American cities had neighborhoods like the West End, and most used similar methods to eliminate them, with varying levels of success. Sacramento's success was so complete that even the memory of these neighborhoods was erased from the city's popular culture, surviving only in the memories of those who lived there. The evidence was buried under Interstate 5 and Capitol Mall. However, methods of exploring the historical record have changed, and technology increases the ways that investigators can discover the counter-narratives and hidden stories that were previously concealed. In a manner similar to how the fingerprints and

This view of Capitol Avenue shows the West End and Japantown as the neighborhood appeared around 1950. After construction of the Tower Bridge, this street became a heavily traveled automobile route. *Center for Sacramento History.*

tape found at the scene of Cherry de Saint Maurice's murder revealed the identities of her assailants, new technologies and careful detective work help to reveal the story of a city that was once lost. Like the lost music of the West End, the full story of Sacramento—including its wicked dance halls, gambling dens and brothels, civic reformers and bartenders, multicultural riches and the thousands of men and women who sought opportunity, a better life, or just tried to make a living—deserves to be heard.

NOTES

Introduction

1. Kassis, *Prohibition in Sacramento*.

Chapter 1

2. Gerald Woods, "A Penchant for Probity," *California Progressivism Revisited*, ed. William Deverell and Tom Sitton (Berkeley and Los Angeles: University of California Press, 1994), 100.
3. Dwight Dutschke, *Five Views: An Ethnic Historic Site Survey for California*, Office of Historic Preservation, California Department of Parks and Recreation (Sacramento: 1988), 118–120.
4. Daniels, *Politics of Prejudice*, 31–36; Dutschke, *Five Views*, 170–71.
5. Peter Vellon, *A Great Conspiracy Against Our Race: Italian Immigrant Newspapers and the Construction of Whiteness in the Early Twentieth Century* (New York and London: New York University Press, 2014), 77–78; Salvatore LaGumina, ed., *The Italian Experience: An Encyclopedia* (New York: Garland Publishing Inc., 2000), 480.
6. Daniels, *Politics of Prejudice*, 90–94.
7. Ibid., 83–86, 91–92.

8. Goethe biographical information via http://henri.eisenbeis.free.fr/gene/goethe/Henry_John_Goethe.html; "Systematic Fight on Vice Planned," *Sacramento Union*, August 6, 1917; Mary Odem, "City Mothers and Delinquent Daughters," in *California Progressivism Revisited*, 175–77.

9. "Dig into Grave Caretaker Trust," *Sacramento Union*, April 12, 1910.

10. Russell Fehr, "Notes on the Commission System in Sacramento" (unpublished paper, Sacramento State University, spring 2007).

11. Nicholas Heidorn, "Luella Johnston," Parts I–III, https://sacramentality.com/2017/10/13/californias-first-councilwoman-part-i/.

12. "Up-to-Date Spooning," *Sacramento Union*, Sunday, July 28, 1912.

13. "No Resolution Passed on Ragging Question," *Sacramento Union*, January 3, 1912; "Agitation Against 'Ragging' Is a Tempest in Teapot, Say Clubwomen," *Sacramento Union*, January 7, 1912; "Ministers Report on School Dancing," *Sacramento Union*, March 29, 1912.

14. "Bliss to Regulate City's Dance Halls," *Sacramento Union*, August 19, 1912; "Commission Board Praised by Church," *Sacramento Union*, August 19, 1912; "Bliss Presented with Turkey Legs," *Sacramento Union*, December 1, 1912.

15. "Death a Dancer at 'Devil's Ball,'" *San Francisco Call*, June 18, 1913; "Wild Ride Claims Lives of Two," *Sacramento Union*, June 18, 1913.

16. "Probe Is Begun into County's Dance Halls," *Sacramento Union*, June 19, 1913.

17. Jack Jungmeyer, "'Twas a Devil's Ball and the Devil Ruled: Two Persons Meet Death," *Tacoma Times*, Tuesday, July 8, 1913; "Promoter of 'Devil's Ball' Sentenced to 30 Days in Jail," *Sacramento Union*, July 1, 1913; "Carraghar's Hands Will Be Tied," *Sacramento Union*, July 1, 1913.

Chapter 2

18. Clarence Caesar, "An Historical Overview of the Development of Sacramento's Black Community, 1850–1983" (unpublished thesis, Sacramento State University, 1985), 91.

19. Ibid., 49–88.

20. Ibid., 78; Delilah Beasley, *The Negro Trail Blazers of California* (Los Angeles: California Historical Society, 1919), 280.

21. "Another Milestone Passed," *Herald* (Los Angeles, CA), October 24, 1895; family history research via ancestry.com, California County Birth, Marriage, and Death Records, 1849–1980; "Sacramento City, August

20," *Elevator*, August 23, 1873; "Sumner Guard," *Elevator*, May 30, 1874; "Sacramento," *Pacific Appeal*, April 20, 1878; "Colored Voters!" *Sacramento Daily Union*, February 25, 1879.

22. "Alleged Garroting," *Sacramento Daily Record-Union*, November 10, 1893.

23. Sushell Bibbs, "The Hyers Sisters," https://www.susheelbibbs.com/the-hyers-sisters.

24. Caesar, "An Historical Overview," 101–15, 113–14; Reverend J.M. Collins, "Race Segregation in Public Schools," *Sacramento Union*, January 21, 1915.

25. Letter from P.J. Clyde Randall to Theodore Roosevelt, April 29, 1917, Theodore Roosevelt Center, Sagamore Hill National Historic Site, Dickinson State University, accessed via http://www.theodorerooseveltcenter.org/Research/Digital-Library/Record?libID=o279493.

26. Eddie Boyden, "The Legislature Viewed from the Gallery," *San Francisco Chronicle*, March 17, 1917.

27. "Claims Family Resemblance to Sutter Club," *Sacramento Bee*, February 14, 1910.

28. Walton Hanes, *Black Republicans* (Metuchen, NJ: Scarecrow Press, 1975), 30–44.

29. "West End Club Out for Tango and Beer; Negroes Enjoy Themselves at Candidates' Expense," *Sacramento Union*, May 13, 1914; "West End Club Asks Liquor Privilege," *Sacramento Union*, August 17, 1914.

30. "Sporting House Raided by Police," *Sacramento Union*, April 10, 1914.

31. "West End Club Asks Liquor Privilege," *Sacramento Union*, August 7, 1914; "Refuse License to Club," *Sacramento Union*, August 22, 1914; "Nine Men Caught in Gambling Raid," *Sacramento Union*, February 6, 1915; "Sells Liquor, Loses License," *Sacramento Union*, January 27, 1915; "Salvationists Dedicate New Army Headquarters," *Sacramento Union*, June 8, 1915.

32. "Extend Dance Hall Inquiry," *Sacramento Union*, June 18, 1915; "Forfeiture of Dance Hall License Again Demanded," *Sacramento Union*, June 23, 1915; "License of Dance Hall Is Revoked," *Sacramento Union*, June 30, 1915.

33. "Negro Club Given a Liquor License," *Sacramento Union*, July 16, 1915; "Protest of W.C.T.U. Falls on Deaf Ears," *Sacramento Union*, October 13, 1915; "Police Raid Gambling Den," *Sacramento Union*, September 19, 1915.

34. "Women Sentenced," *Sacramento Union*, January 9, 1912.

35. "Colored People Will Not Protest," *Sacramento Union*, November 12, 1908.

36. "Negroes Protest 'Clansman' Drama," *Sacramento Union*, July 4, 1911; "*The Clansman* by McRae Company," *Sacramento Union*, July 9, 1911.

37. Reverend John M. Collins, "The Clansman," *The Western Review*, June 1915; "Negroes Ask City to Bar 'Clansman,'" *Sacramento Union*, May 27, 1915; "Clansman to Be Expurgated by Censor," *Sacramento Union*, May 28, 1915; "Clansman Resumes Its Place at Clunie," *Sacramento Union*, June 3, 1915.

38. "Will Hold Services," *Sacramento Union*, October 15, 1916; "Church Cornerstones Laid," *Sacramento Union*, April 23, 1919; Caesar, "An Historical Overview," 115–16.

39. Stephen Magagnini, "Sacramento NAACP Celebrates a Century of Civil Rights," *Sacramento Bee*, July 19, 2016, http://www.sacbee.com/news/local/article88818807.html; Caesar, "An Historical Overview," 117–18; "Restaurants Must Serve Colored Folk," *Sacramento Union*, July 26, 1918; "Colored Soldiers Are Given a Reception," *Sacramento Union*, March 29, 1919; "Negro Talks of Crimes Against Race," *Sacramento Union*, May 30, 1919.

40. "Reverend Allen Harvey Willing to Become City Commissioner," *Sacramento Union*, March 18, 1919.

41. "They're Off, Count 'Em: Seven After Commissionership," *Sacramento Union*, April 14, 1919.

42. "Gebhart and Brown to Fight It Out at Final Election," *Sacramento Union*, May 4, 1919; "Colored Troops to Have Club," *Sacramento Union*, August 8, 1919; "Fourth Parade Great Affair," *Sacramento Union*, July 6, 1920.

43. Death certificate of William Snow, Sacramento County, September 22, 1921; "Dead Negro May Have Fortune in Safe Box," *Sacramento Union*, September 29, 1921; "Safe Box Yields $2600" *Sacramento Union*, September 30, 1921; "10 Negroes Freed by Police Court Judge," *Sacramento Union*, June 7, 1922.

44. "YMCA Romps Away with Relay," *Sacramento Union*, January 2, 1921; "Lose First Game in Two Years of Play," *Sacramento Union*, February 7, 1921; "Kid Reese Decides to Take No Change," *Sacramento Union*, December 21, 1921; "North Win Has No Terrors," *Sacramento Union*, March 9, 1922.

45. "He's in the Movies Now!," *Sacramento Bee*, May 23, 1923.

46. Death certificate of Grant Cross, San Joaquin County, October 20, 1930; Department of Mental Hygiene, Stockton State Hospital Records, California State Archives, series 3, Synopsis of Commitments, patient no. 28859.

47. Bayard Taylor, *Eldorado: Adventures in the Path of Empire* (London: Richard Bentley, 1850), 218.

48. Stoddard, *Jazz on the Barbary Coast*, 189–93.

Chapter 3

49. Walter Frame, "Scenes in Sacramento, 1910–1920," *Golden Notes*, 25, no. 2, summer 1979 (Sacramento, CA: Sacramento County Historical Society), 6.

50. Barnhart, "Working Women," 82–88.

51. "Musical Items," *Sacramento Union*, February 4, 1906.

52. "Pianos Used to Further Underworld Profession," *Sacramento Union*, September 28, 1913.

53. "Murder of Tenderloin Queen Baffles Sleuths," *Sacramento Bee*, July 9, 1913.

54. "Lost—Found," *Sacramento Union*, April 13–May 5, 1907.

55. "Revenge or Fear! Which?," *Sacramento Star*, July 9, 1913.

56. Abbott, *Sin in the Second City*, 280–84.

57. "Another Unfortunate," *Sacramento Daily Union*, November 9, 1889; "Woman Drinks Fatal Poison," *Sacramento Union*, February 24, 1909.

58. "Francisco Files Suit," *Sacramento Union*, April 26, 1911.

59. "Five Years for Burglar," *Sacramento Union*, August 17, 1811.

60. "Verdict in Resort Case Is 'Guilty,'" *Sacramento Union*, December 5, 1911.

61. "Strangled to Death, Fate of Woman," *Sacramento Union*, July 9, 1913.

62. "Two Men Sought in Murder Case," *Sacramento Union*, July 10, 1913.

63. "Murder Developments Expected," *Sacramento Union*, July 12, 1913.

64. "Anna Held Wants Tenderloin Money," *Goodwin's Weekly*, vol. 22, 15.

65. "Woman Led Them, Assert Raber and Drumgoole," *Sacramento Sunday Leader*, August 3, 1913.

Chapter 4

66. "Bliss Saloon Ordinance," *Sacramento Union*, September 4, 1913; "New Saloon Law Effective Monday," *Sacramento Union*, October 11, 1913.

67. 1930 U.S. Federal Census, Sacramento, California, District 0051; 1910 U.S. Federal Census, Sacramento, California, Ward 3, District 0105; U.S. World War II Draft Registration Cards, 1942, Frank Joseph Nisetich,

accessed via ancestry.com; "General Notices," *Sacramento Union*, March 22, 1907.

68. "Six Gamblers of Serra Hall Fined," *Sacramento Union*, February 11, 1915; "Woman Drowns Self," *Sacramento Union*, September 25, 1915; "Suicide Certain in Nisetich Case," *Sacramento Union*, September 26, 1915.

69. "Kitty Nisetich Murdered, Says Coroner's Jury," *Sacramento Bee*, September 29, 1915; "Grand Jury to Take Up Nisetich Case," *Sacramento Union*, October 9, 1915; "Nisetich Girl a Suicide, Holds Grand Jury," *Sacramento Union*, October 16, 1915.

70. Abbott, *Sin in the Second City*, 154–55, 207–08, 290–91; Sara Kaplan, "Jack Johnson, World's First Black Boxing Champion, Was Jailed under Jim Crow. Will He Get a Posthumous Pardon?.," *Washington Post*, February 5, 2016; http://www.pbs.org/unforgivableblackness/index.html.

71. "Maury I. Diggs and Drew Caminetti Vainly Sought," *Sacramento Union*, March 12, 1913; "All Four Elopers Arrested in Reno," *San Francisco Call*, March 15, 1913.

72. "McNab, Hindered, Resigns," *San Francisco Call*, June 22, 1913.

73. "Lola Norris, Head Erect, Survives Grill on Stand," *San Francisco Call*, August 15, 1913; "Verdict in Diggs Case," *Sacramento Union*, August 22, 1913.

74. "Cherry Club Now Occupied by Carmen Grey," *Sacramento Union*, November 11, 1915; "Vice Hearing Jams Clunie to the Doors," *Sacramento Union*, March 16, 1916; "Decency Scores Another Victory," *Sacramento Union*, January 27, 1918.

75. "Fighting Leads to Act of Kindness," *Sacramento Union*, November 12, 1914.

76. "Where Brown's Men Work," *Sacramento Union*, May 15, 1918; "Joe Fuski Handed Verbal Lacing at Court," *Sacramento Union*, September 15, 1918; "Jury Trial Asked by Resort Owner," *Sacramento Union*, February 18, 1914.

77. "Women Found Not Guilty," *Sacramento Union*, September 19, 1918.

78. "Indictment of Joe Fuski Is Predicted," *Sacramento Union*, December 9, 1919; "Indictments Filed, Bail Heavy," *Sacramento Union*, December 10, 1919.

79. "Fuski's Ally Turns On Him," *Sacramento Union*, January 13, 1920.

80. "Fuski Is Saved by Two Jurors," *Sacramento Union*, January 14, 1920; "Fuski Case Will Be Probed by Grand Jury," *Sacramento Union*, January 15, 1920.

81. "Fuski's Friends May Face Charge," *Sacramento Union*, January 16, 1920; "Fuski in Hospital, Seeks More Delay," *Sacramento Union*, January 27, 1920; "Fuski Is Found Guilty by Jury," *Sacramento Union*, February 27, 1920.

82. "Open Season on Vice Declared," *Sacramento Union*, April 13, 1920.

83. Edwin W. Grant, "Scum from the Melting-Pot," *American Journal of Sociology* 30 (1925): 641–51.

84. *People vs. Laine*, 171 P. 941 (Cal. 1918), California Supreme Court, filed March 19, 1918; "Art Dance Hall Must Close Doors," *Sacramento Union*, December 11, 1919.

85. "Acts Part of Fallen Women to Make Arrests," *Santa Cruz Evening News*, January 22, 1918; "Defense Fails to Impeach Woman," *Sacramento Union*, March 20, 1918; "Dry Raiders Menaced with Death," *Sacramento Union*, October 7, 1921.

86. "Last Rites Held for Mrs. Daisy Sinkins," *Sausalito News*, November 21, 1940; Alexandra Szoenyi, "The Crazy Life of Federal 'Lady Hooch Hunter' Daisy Simpson," December 7, 2017, https://brokeassstuart.com/sf/2017/12/07/sfcentric-history-the-crazy-life-of-federal-lady-hooch-hunter-daisy-simpson/.

Chapter 5

87. John Henshall, "A Message to the Housewives of Sacramento," *Screen News*, January 12, 1924–May 24, 1924, 16–17.

88. "George Dunlap: Success Was No Stranger," *Sacramento Observer*, November 14, 1973; Thomas Fleming, "90 Year Old Restaurant Owner Honored in Sacramento," *San Francisco Sun-Reporter*, February 23, 1974; Raymond J. Pitts, National Register of Historic Places Registration Form, "Dunlap's Dining Room," November 20, 1991, 6–9.

89. "Transporting Booze into Dry Territory," *Sacramento Union*, April 6, 1919; "Indictment at Fault and Case Is Dismissed," *Sacramento Union*, May 9, 1919.

90. California Railroad Employment Records, 1862–1950, results for George Dunlap accessed via ancestry.com.

91. Rudy Hickey, "From Bloomer Girl to Ring Wizard," *Fresno Bee*, July 13, 1941.

92. Ancil Hoffman and Tom Arden, "I Remember…Sacramento of the 1890s Was Great Place for Kids," *Sacramento Bee*, December 2, 1973; "Boston Bloomer Girls to Play at Snowflake Park Tomorrow," *Sacramento Record-Union*, October 30, 1897.

93. Hype Igoe, "Leather-Stocking Tales," *New York Journal of American Sports*, January 4, 1940.

94. Advertisements, *Sacramento Union*, April 20, 1919; May 16, 1919; July 4, 1919.

95. "Ragging on River Is Rough Revelry," *Sacramento Union*, May 26, 1913; "Picnic Boat Will Peddle No Liquor," *Sacramento Union*, June 5, 1913.

96. "Barbary Coast Revived in Hof Brau," *Sacramento Union*, October 6, 1916.

97. "Hof Brau Still Sells Liquor without Food," *Sacramento Union*, October 13, 1916; "Commission to Try 3 Cafes Today," *Sacramento Union*, October 17, 1916; "Cheese Sandwich Meal, Rules City Commission," *Sacramento Union*, Ocober 18, 1916.

98. "Hoffman to Build Open Air Arena for Fights," *Sacramento Union*, April 16, 1916; "Warehouse to Be Made Over into Fight Arena," *Sacramento Union*, November 10, 1916.

99. "Jim Corbett Has Praise for Local Chinese Bantam," *Sacramento Union*, December 22, 1920; http://boxrec.com/en/boxer/28589; Joel Franks, *Crossing Sidelines, Crossing Cultures: Sport and Asian Pacific American Cultural Citizenship* (Lanham, MD: University Press of America, 2010), 31.

100. Lee's Chinese Exclusion Act case files via https://chineseexclusionfiles.com/tag/george-washington-lee/.

101. Ben Swesey, "Georgie Lee Is Rated as One of Top Boxers in His Day by Hoffman," *Sacramento Bee*, January 25, 1970; Conlin, Bill, "Ex-Fighter Lee Thrives Locally," *Sacramento Bee*, October 11, 1977.

102. "Union's Big Boxing Benefit Show Nets $1.347.73 for Fund," *Sacramento Union*, November 13, 1921.

103. A.J. Waterhouse, *Sacramento Union*, March 1, 1920.

104. Police register, City of Sacramento, January 24, 1924; Superior Court of the County of Sacramento, Indictment for John Doe and Richard Roe, January 4, 1924; Superior Court of the County of Sacramento, *The People, Etc., vs. John Doe and Richard Roe*, January 30, 1924.

105. "Boxing Men May Be Freed from Liquor Charges," *Sacramento Union*, January 25, 1924; C.K. McClatchy, "Some Private Thinks," *Sacramento Bee*, January 24, 1924.

106. "Hoffman Buys Nippon Theater Property on L Street," *Sacramento Bee*, January 5, 1924.

107. Buddy Baer, *Autobiography of Buddy Baer* (Claremont, CA: Rhino Records, 2003), 62–63.

108. "Science and Violence" (blog), http://dementia-pugilistica.tumblr.com/post/52498422339/max-baer-vs-max-schmeling-june-8-1933-there.

109. "Hoffman Opens New Ancil Café," *Sacramento Bee*, December 14, 1912; "Business Group Back Hoffman for Supervisor," *Sacramento Union*, January 7, 1950; Vincent Stanich, "Hoffman Dinner Was Huge Success," *Sacramento Union*, October 27, 1963; "Civic, Boxing Figure Hoffman Dies," *Sacramento Bee*, January 8, 1976.

110. "Proceedings of the Lawmaking Body of the City," *Sacramento Union*, April 21, 1908; "Fire Trap Goes Up in Flames," *Sacramento Union*, April 21, 1908; "Japanese Theater," *Sacramento Union*, July 15, 1908.

111. "Theater Not Dive, Says Police Chief," *Sacramento Union*, March 20, 1911; "Takahashi Defeats Michael Athens," *Sacramento Union*, February 8, 1917.

112. Priscilla Ouchida, oral history interview with author, May 11, 2018.

113. Maeda, "Changing Dreams and Treasured Memories," 137–38; Isami Arifuku Waugh, "Hidden Crime and Deviance in the Japanese-American Community, 1920–1946" (unpublished doctoral dissertation, University of California, Berkeley, 1978), 77–89.

114. Yoshida, *Reminiscing in Swingtime*, 67–78.

115. Eartha Kitt, *Eartha-Quake* reissue box set, Bear Family Records, 1994.

116. "The Lavenberg Collection of Japanese Prints," www.myjapanesehanga.com.

Chapter 6

117. Terry Cook and Kathleen Paparchontis, "Sacramento Women Past and Present," *Golden Notes*, 44, no. 2 (summer 1998): 31; "Council Seats Mayor, Fills Board Posts, *Sacramento Bee*, January 3, 1948; Arthur Murray Studios advertisement, *Sacramento Bee*, April 18, 1956.

118. Sacramento City Council minutes, May 28, 1943.

119. "Comma Omission Saves Derrick from Paying $200 Gambling Fine," *Sacramento Bee*, October 25, 1941; "William C. Dansby (obituary)," *Sacramento Bee*, December 31, 1954.

120. "FBI Launches Raids on Aliens," *Sacramento Bee*, March 6, 1942; "Former Nippon Theater Is No Longer Japanese," *Sacramento Bee*, March 10, 1942; "Two More Local Nipponese Are Taken by FBI," *Sacramento Bee*, March 31, 1942; Maeda, "Changing Dreams and Treasured Memories," 181–82; "Japanese Tokyo Club Syndicate, with Interlocking Affiliations," Office of Naval Intelligence, December 24, 1941, accessed via http://www.mansell.com/eo9066/1941/41-12/TokClub.html.

121. "Mrs. Louise Anderson: Business Became One of Her Pleasures," *Sacramento Observer*, November 14, 1973.

122. Stephen Magagnini, "Faint Echo of Jazz Mecca at Sixth and Capitol," *Sacramento Bee*, June 5, 2005; "William Jackson (obituary)," *Sacramento Bee*, March 31, 1958; "Ira Fletcher Flood (obituary)," *Sacramento Bee*, August 24, 1953.

123. "Police Department Reports on Prostitution," *Sacramento Bee*, August 8, 1942; "Police Chief Acts Wisely in Creating Vice Squad," *Sacramento Bee*, August 23, 1944; "Officials Approve Plan for Venereal Disease Control," *Sacramento Bee*, August 24, 1945.

124. "Zanzibar Club Is Rapped as Call House for Prostitutes," *Sacramento Bee*, May 21, 1949.

125. "Zanzibar Charges Are Under Advisement," *Sacramento Bee*, June 1, 1949; "State Unit Stands Firm in Revoking Zanzibar License," *Sacramento Bee*, July 22, 1949.

126. Advertisements, *Sacramento Bee*, July 1, 1950; March 27, 1953; March 19, 1960.

127. "Capital Bars Are Closed as Vice Hangouts," *Sacramento Bee*, July 21, 1955; "Congo Club Loses Appeal on Closure," *Sacramento Bee*, February 5, 1957.

128. "Red Light Abatement Padlocking Is Asked," *Sacramento Bee*, December 27, 1951; "Citizenship Rights Are Bestowed on 20," *Sacramento Bee*, January 24, 1944.

129. "Pharmacy Is Named in Liquor Sale Count," *Sacramento Bee*, March 5, 1946; "Mrs. Bennie Johnson: She Chose to Teach," *Sacramento Observer*, November 14, 1973.

130. "Restaurant and Roof Garden Project Is Ready," *Sacramento Bee*, November 22, 1952; "NAACP Will Seat Officers Sunday," *Sacramento Bee*, January 22, 1953; "1500 in Order of Negro Elks Are Arriving for Convention," *Sacramento Bee*, June 23, 1954.

131. "Nisei Memorial Ceremony Will Be Held Sunday," *Sacramento Bee*, December 9, 1955; "Institution Ceremony and Installation of Officers of Nisei Post No. 8985," event program, personal collection of Ouye family.

Chapter 7

132. "Amusements," *Sacramento Daily Record-Union*, July 18, 1897.

133. Rhoda Koenig, "Tearing Off a Strip," *Independent*, March 29, 2005, https://www.independent.co.uk/arts-entertainment/theatre-dance/features/tearing-off-a-strip-5350302.html; George Jean Nathan, *The Entertainment of a Nation: Or, Three-sheets in the Wind* (Cranbury, NJ: Associated University Presses, 1942), 218–20.

134. "Charmion, the Trapezist," *Sacramento Daily Record-Union*, January 10, 1899; "Wanted," *Sacramento Daily Record-Union*, May 6, 1897.

135. "Amusements," *Sacramento Daily Record-Union*, February 1, 1897; "Green Room Gossip," *Sacramento Bee*, December 24, 1897; "Charmion in Europe," *Sacramento Daily Record-Union*, December 25, 1899.

136. "At the Theaters," *Evening Times, Washington*, May 10, 1898; "The Stage," *Evening Times, Washington*, May 15, 1898.

137. "Perfect Woman Is Growing Fat," *San Francisco Call*, September 14, 1908.

138. "Music and the Theatres," *Truth: The Western Weekly*, October 31, 1908; "The Theatres," *Bridgeport Evening Farmer*, April 29, 1909.

139. "Observations by a First Nighter," *Los Angeles Herald*, October 18, 1908.

140. Corio, *This Was Burlesque*, 71–72.

141. "At the Theatre," *Los Angeles Herald*, December 11, 1898.

142. "Right from Gay Paree," *Sacramento Bee*, December 11, 1897; family records retrieved from ancestry.com, March 20, 2018.

143. "Commission Board Praised by Church," *Sacramento Union*, August 19, 1912.

144. Dave Reingold, "Burlesque in Sacramento" (unpublished notes), 2014.

145. "Cigaret Is Blamed for Theater Roof Fire," *Sacramento Bee*, July 15, 1952; Advertisement, *Sacramento Bee*, July 7, 1954.

146. Gail Yoshioka Ouye, oral history interview with author, August 28, 2015.

147. Esther Newton, *Mother Camp: Female Impersonators in America* (Upper Saddle River, NJ: Prentice Hall, 1972), 3–7, 43–45.

148. "Old River Steamer Is Sold for $60," *Sacramento Bee*, August 19, 1944; Advertisement for Yacht Club, *Sacramento Bee*, December 30, 1946.

149. "Council Plans Hearing on Closing of Alley," *Sacramento Bee*, June 4, 1943; Richard Harrington, "Soundies Speak Volumes About 1940s America," *Washington Post*, June 8, 2007; "Soundies," UCLA Film and Television Archive, accessed via https://www.cinema.ucla.edu/collections/soundies; "License Applicants Will Be Questioned," *Sacramento Bee*, August 12, 1944.

150. "Three Liquor Violation Charges Are Studied," *Sacramento Bee*, May 12, 1948; "Way Is Cleared for 1250 New South State Bar Permits," *Sacramento Bee*, September 18, 1953.

151. Mo-Mo Club advertisement, February 12, 1949; Nu Lyric advertisement, November 14, 1958.

152. "Female Impersonator Is Sentenced to Jail," *Sacramento Bee*, November 19, 1952; "Police Book Man on Charges of Battery and Masquerading," *Sacramento Bee*, October 15, 1953; "Man Dressed as Woman Gets Term on Battery Count," *Sacramento Bee*, October 17, 1953; Alameda advertisements, *Sacramento Bee*, December 31, 1949; July 2, 1955.

153. "Police Officer, Man Posing as Woman Are Hurt in Fight," *Sacramento Bee*, November 7, 1952; "Jail Term Halts Female Career of Impersonator," *Sacramento Bee*, November 13, 1952.

154. Tamara Rees (published as "Tamara Reese"), *Reborn: A Factual Life Story of a Transition from Male to Female* (Los Angeles: Irene Lipman, 1955), 1–57.

155. James J. Brown, "'Of Course I Can Marry' Says Ex-GI, Now Woman," *Sacramento Bee*, November 15, 1954.

Chapter 8

156. *Florence Matcovich vs. Nicholas N.S. Matcovich*, Judgment Roll, Book 50 Page 117, no. 21083, June 5, 1926, Center for Sacramento History archives; "Divorce Suit Is Filed," *Sacramento Bee*, June 25, 1940.

157. John N. Wilson, *Brief Stories About Music and Musicians in Sacramento, 1919–1930* (self-published, 1980) 25–26; "Dean Undecided on Dance Closing," *Sacramento Bee*, October 26, 1933.

158. "Big Nick Dance Permit Provokes United Protest," *Sacramento Bee*, August 24, 1934.

159. "State Will Appeal Tax Decision on Dance Hall Girls," *Sacramento Bee*, January 30, 1940; "Protest from Taxi Dancer," *Sacramento Bee*, January 31, 1940; "Dance Hall Proprietor Is Upheld in Tax Case," *Sacramento Bee*, May 9, 1942; "Matcovich Is Denied Retrial of Tax Suit," *Sacramento Bee*, June 29, 1945.

160. The Rounder, "Man About Town Finds Dime a Dance Game Is Just Beer and Talking," *Sacramento Bee*, June 26, 1943; Herbert L. Phillips, "State Probe of B Girls, Dance Halls Is Ordered," *Sacramento Bee*, June 30, 1943.

161. Paula Boghosian and Don Cox, *Hyatt Boutique Hotel, Final Environmental Impact Report*, 2015 (City of Sacramento), 30–32, 183–85.

162. "Hotel Clayton Cocktail Lounge Is Remodeled," *Sacramento Bee*, August 31, 1940; Advertisement, *Sacramento Bee*, May 20, 1943; "Cockeyed Mayor," *Santa Cruz Sentinel*, July 29, 1951.

163. "One Dies, 14 Are Hurt in Hotel Clayton Fire," *Sacramento Bee*, April 5, 1948; Advertisements from *Sacramento Bee*, November 1, 1947; July 9, 1948; August 16, 1950; Louis Armstrong ad, February 16, 1952; Billie Holiday ad, January 30, 1952.

164. Wilson, "A History of Sacramento Jazz," 12.

165. "Tavern Is Charged with Liquor Law Violation," *Sacramento Bee*, September 16, 1948.

166. Advertisement, *Sacramento Bee*, April 21, 1956; "Dancer's Strip Tease Results in Arrest of Pair," *Sacrament Bee*, August 19, 1953.

167. "Clayton Club's Liquor License Is Ordered Voided," *Sacramento Bee*, October 20, 1955; "State Reports Closing of 4 Capital Bars," *Sacramento Union*, November 16, 1957.

168. "House Raided by Police" and "Drug Distributors' King Under Arrest," *Sacramento Union*, December 7, 1916; "Frank Nisetich, Sporting Figure," *Sacramento Bee*, July 21, 1975; Maryellen Burns, oral history interview with Ted Pantages, October 12, 2017.

169. "Warren Plans to Extend His Bookies Drive," *Sacramento Bee*, March 27, 1940; "Bookie Closings Follow Charge Against Nisetich," *Sacramento Bee*, May 7, 1940; "Nisetich Joins Bookies in Compromise with State Attorney General," *Sacramento Bee*, July 8, 1940.

170. "Council Orders Chief of Police to Rid City of All Forms of Gambling," *Sacramento Bee*, February 2, 1943; The Shortender, "Shortender Finds Illegal Bookies Are Doing Thriving Business," *Sacramento Bee*, March 13, 1943; "Cancellation of Phones Tabbed in Raid Is Sought," *Sacramento Bee*, June 7, 1943; "City Court Frees Nisetich and Aide of Vagrancy Charges," *Sacramento Bee*, June 22, 1943.

171. "Truck Driver Gets Probation in Army Food Theft Case," *Sacramento Bee*, January 17, 1944.

172. The Shortender, "They Take You Coming, Going at Rex Grill, North City Book," *Sacramento Bee*, August 24, 1944; "Dealer Is Stabbed in Local Chinese Gambling House," *Sacramento Bee*, August 24, 1944; "North City Police Chief Can't Seem to Find Bookies," *Sacramento Bee*, August 28, 1944.

173. "Phenomenal Luck at Cards Leads to Jail." *Sacramento Bee*, November 13, 1945.

174. The Shortender, "Bookies Are Operating Openly in West End Establishments," *Sacramento Bee*, June 14, 1946.

175. "Council Delays Decision on Vice Captain," *Sacramento Bee*, March 8, 1947.

176. "Local Chinese Is Arrested in Bribery Case," *Sacramento Bee*, April 4, 1947; "Councilmen Back Manager Amid Talk of Ouster," *Sacramento Bee*, February 9, 1949.

177. "City Launches Drive Against Bookmakers," *Sacramento Bee*, June 17, 1946; "Cavanaugh, Hicks Say No Bookies Are Operating," *Sacramento Bee*, January 9, 1948.

178. "Study Clubs Bring Culture to West End Horse Bettors," *Sacramento Bee*, February 24, 1948.

179. "Frank Nisetich, Sporting Figure," *Sacramento Bee*, July 21, 1975.

180. "Makes Vaudeville Weekly Café Event," *Los Angeles Times*, July 8, 1925; "Where to Dine," *Los Angeles Times*, May 15, 1925; "Café Notes," *Los Angeles Times*, June 4, 1926; "Grand Opening of Frank Sebastian's Cotton Club Café," *Los Angeles Times*, February 18, 1926; "Sebastian's Cotton Club, Culver City, California, 1926–1938," http://www.blackpast.org/aaw/sebastians-cotton-club-culver-city-california-1926–1938; "Frank Sebastian's Cotton Club," https://martinturnbull.com/2014/05/23/frank-sebastians-cotton-club-corner-national-and-washington-culver-city/; "Louis Armstrong and His Sebastian New Cotton Club Orchestra," http://www.redhotjazz.com/sebastian.html.

181. "Night Club Men Held on Rum Inquiry Charge," *Los Angeles Times*, July 10, 1935; "Rum Inquiry Policy Fixed," *Los Angeles Times*, July 23, 1935.

182. "Café Donovan Gaming Case Is Continued," *Sacramento Bee*, March 7, 1945; "Employment of Minors Is Laid to Café Man," April 24, 1945.

183. "Sacramento Men Buy Lease of Hotel Senator," *Sacramento Bee*, September 14, 1946; Lance Armstrong, "North Area's Radisson Hotel Has Unique History," *Valley Community News*, March 10, 2011.

Chapter 9

184. Howard B. Leonard, *Relocation Profile: The Final Relocation Report on Project No. Calif R-18—Capitol Mall Extension* (Sacramento, CA: Redevelopment Agency of Sacramento, 1964).

185. Hale Champion, "Filth, Vice, Crime Crawl Out of Blighted Areas," *Sacramento Bee*, November 29–December 3, 1949.

186. Robert Fogelson, *Downtown: Its Rise and Fall, 1880–1950* (New Haven, CT: Yale University Press, 2004), 329–47; "City Council Votes for Slum Cleanup," *Sacramento Bee*, November 25, 1954.

BIBLIOGRAPHY

Abbott, Karen. *Sin in the Second City: Madams, Ministers, Playboys, and the Battle for America's Soul*. New York: Random House, 2008.

Barnhart, Jacqueline Baker. "Working Women: Prostitution in San Francisco from the Gold Rush to 1900." Doctoral dissertation, UC Santa Cruz, 1976.

Corio, Ann. *This Was Burlesque*. New York: Grosset & Dunlap, 1968.

Daniels, Roger. *The Politics of Prejudice*. Berkeley: University of California Press, 1962.

Deverell, William, ed. *California Progressivism Revisited*. Berkeley: University of California Press, 1994.

Donovan, Brian Lane. "The Sexual Basis of Racial Formation: Crusades Against Forced Prostitution, 1887.1917." Doctoral dissertation, Northwestern University, 2001.

Kassis, Annette. *Prohibition in Sacramento*. Charleston, SC: The History Press, 2014.

Maeda, Wayne. *Changing Dreams and Treasured Memories: A Story of Japanese Americans in the Sacramento Region*. Sacramento, CA: Sacramento Japanese American Citizens League, 2000.

Stoddard, Tom. *Jazz on the Barbary Coast*. Berkeley, CA: Heyday Books, 1982.

Wildie, Kevin. *Sacramento's Historic Japantown*. Charleston, SC: The History Press, 2013.

Wilson, Burt. "A History of Sacramento Jazz 1948–1966." Canoga Park, CA: Self-published, 1986.

Yoshida, George. *Reminiscing in Swingtime: Japanese Americans in American Popular Music, 1925–1960*. San Francisco, CA: National Japanese American Historical Society, 1993.

INDEX